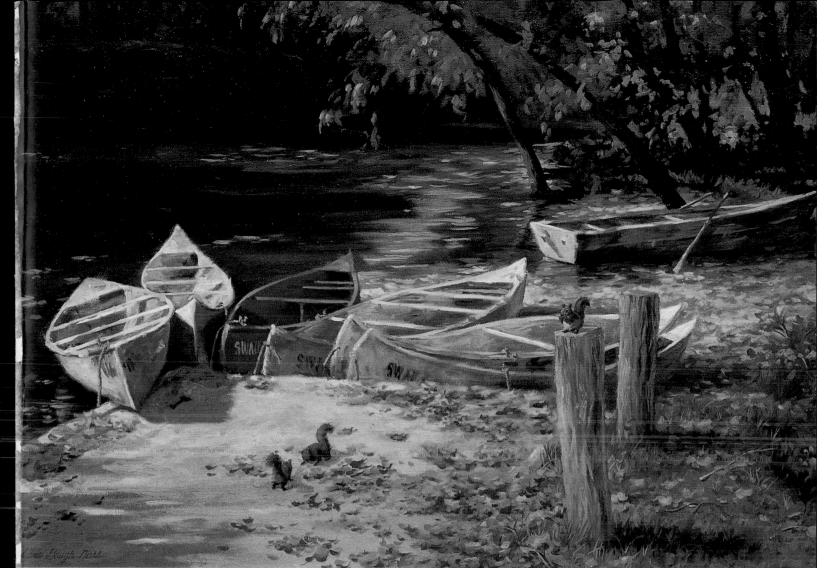

# 14 FORMULAS
## *for* PAINTING
# FABULOUS LANDSCAPES

### BARBARA NUSS

**NORTH LIGHT BOOKS**
CINCINNATI, OHIO
www.artistsnetwork.com

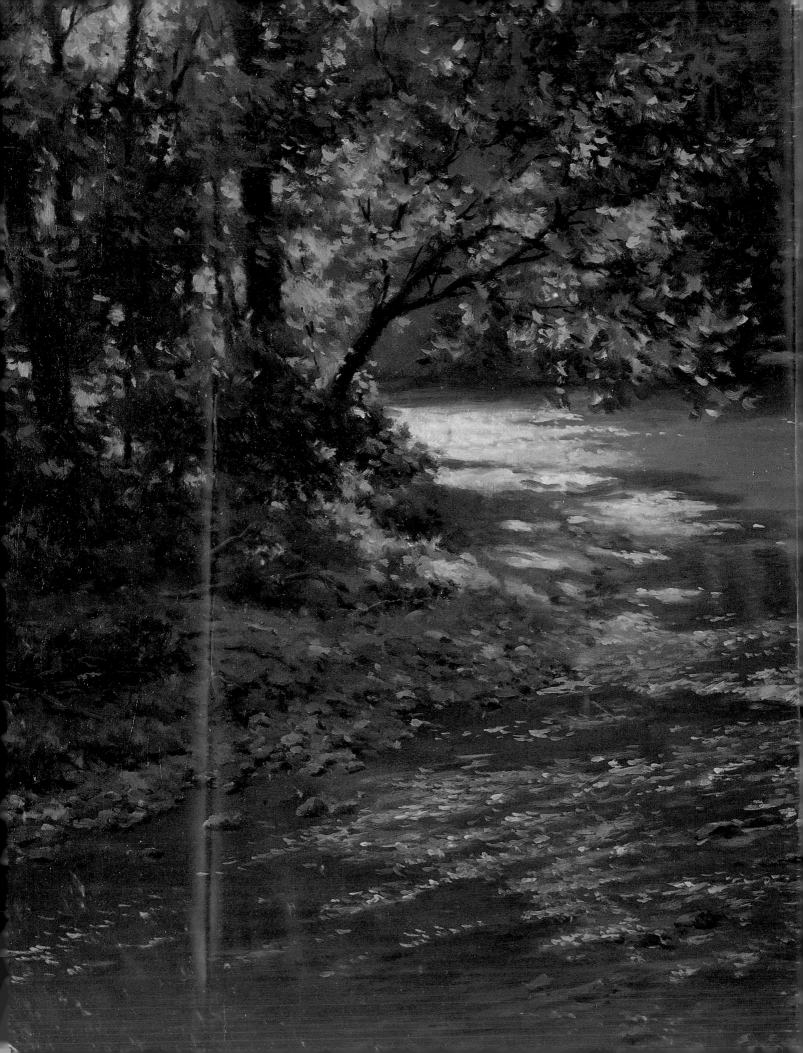

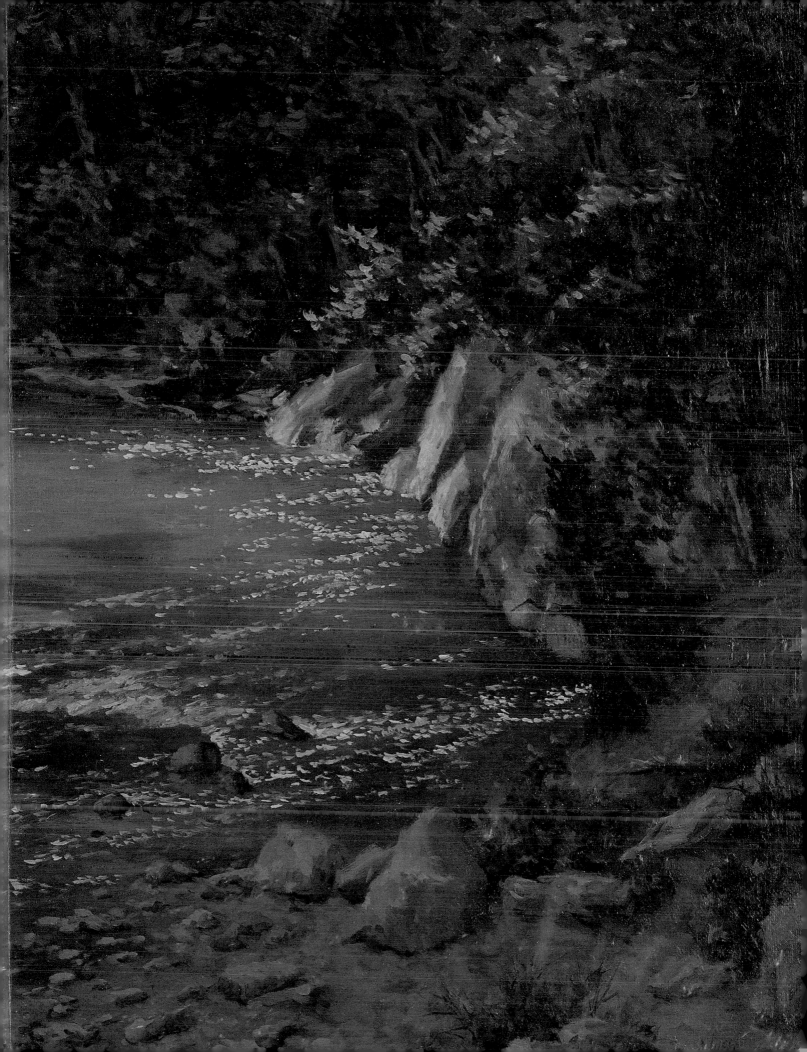

## About the Author

Barbara Nuss, an experienced painter and teacher, finds constant inspiration in the gently rolling landscapes and gracefully aging structures near her home and studio. In this Maryland countryside, she perfected her skills painting directly from nature, capturing the accurate effects of light and color. Barbara now teaches these skills in outdoor painting workshops.

Her landscape paintings have received national recognition with appearances in the National Arts for the Parks Top 100 (1989, 1991, 1992 and 2001) and Top 200 (1990, 1993 and 1996); Oil Painters of America national exhibitions (2000 and 2001); Salmagundi Club open exhibitions (1991 and 1995), and two images included in North Light Books' *Art From the Parks* (2000).

Barbara credits her artistic development to many sources, including her B.F.A. from Syracuse University, the Schuler School of Fine Arts in Baltimore, various workshop instructors, her experience as a graphic artist and illustrator, instructive art books, her students, camaraderie with other artists, and her membership in the Washington Society of Landscape Painters.

She is a member of the Salmagundi Club, Oil Painters of America and the Baltimore Watercolor Society, and she is past president of the Washington Society of Landscape Painters. Several galleries in Maryland and Virginia represent her work. She is also listed in *Who's Who of America*.

Barbara and her husband, Fred, live in Woodbine, Maryland, with their cats Leo and Cammie. Visit her web site at www.barbaranuss.com or contact her via e-mail at barbara@barbaranuss.com.

Art from page 1:
**The Red Canoe**
Oil on linen
16" × 22" (41cm × 56cm)
Collection of the National Park Foundation

Art from pages 2-3:
**Rock Creek**
Oil on linen
20" × 27" (51cm × 69cm)

**14 Formulas for Painting Fabulous Landscapes.** Copyright © 2004 by Barbara Nuss. Manufactured in China. All rights reserved. No part of this book may be reproduced in any form or by any electronic or mechanical means including information storage and retrieval systems without permission in writing from the publisher, except by a reviewer who may quote brief passages in a review. Published by North Light Books, an imprint of F&W Publications, Inc., 4700 East Galbraith Road, Cincinnati, Ohio 45236. (800) 289-0963. First edition.

Other fine North Light Books are available from your local bookstore, art supply store or direct from the publisher.

08  07  06  05  04    5  4  3  2  1

**Library of Congress Cataloging-in-Publication Data**

Nuss, Barbara.
14 formulas for painting fabulous landscapes / Barbara Nuss—1st ed.
    p.        cm.
Includes bibliographical references and index.
ISBN 1-58180-385-0 (hc. : alk. paper)
1. Landscape painting—Technique. I. Title: Fourteen formulas for painting fabulous landscapes. II. Title.

ND1342.N87 2004
751.45'436—dc21                    2003051304

Editors: Stefanie Laufersweiler and Christina Xenos
Designer: Wendy Dunning
Layout artist: John Langan
Production coordinator: Mark Griffin

### Metric Conversion Chart

| To convert | to | multiply by |
| --- | --- | --- |
| Inches | Centimeters | 2.54 |
| Centimeters | Inches | 0.4 |
| Feet | Centimeters | 30.5 |
| Centimeters | Feet | 0.03 |
| Yards | Meters | 0.9 |
| Meters | Yards | 1.1 |
| Sq. Inches | Sq. Centimeters | 6.45 |
| Sq. Centimeters | Sq. Inches | 0.16 |
| Sq. Feet | Sq. Meters | 0.09 |
| Sq. Meters | Sq. Feet | 10.8 |
| Sq. Yards | Sq. Meters | 0.8 |
| Sq. Meters | Sq. Yards | 1.2 |
| Pounds | Kilograms | 0.45 |
| Kilograms | Pounds | 2.2 |
| Ounces | Grams | 28.4 |
| Grams | Ounces | 0.035 |

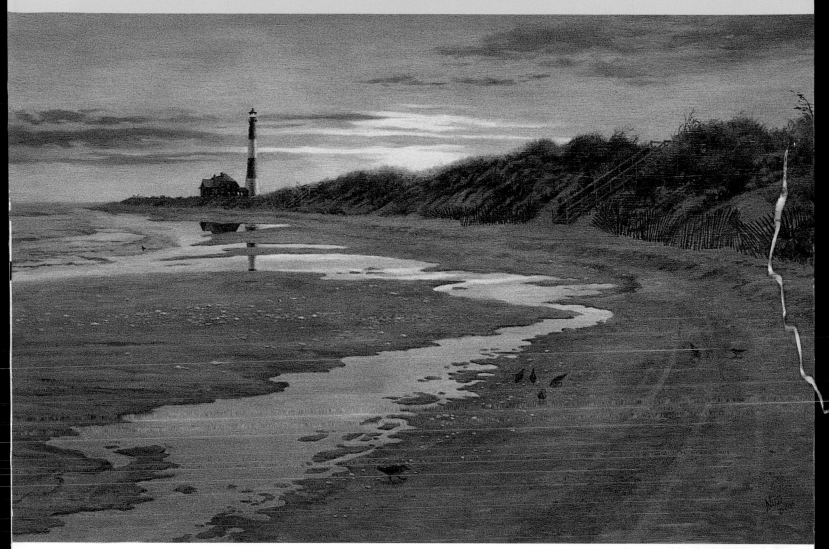

**Sunset Harmony**
Oil on mahogany panel
16" × 24" (41cm × 61cm)
Private collection

## Acknowledgments

First I want to acknowledge all of my students over the past twenty years who have required me to articulate and effectively convey my artistic philosophy, theories and techniques, enabling me to discover what works best for me as well as them. The learning process is ongoing, both for me and for my students in the workshop experience.

I also wish to acknowledge a diverse group of painting and workshop instructors from whom I have learned so much and am forever grateful: Ann Schuler, Guy Fairlamb, Daniel E. Greene, Fritz Briggs, John Osborne, Ross Merrill and Bill Schmidt.

Finally, I want to thank the editors at North Light Books who have advised me through this challenging process: Rachel Wolf and Stefanie Laufersweiler. This book would not be a reality without their invaluable guidance and input.

## Dedication

*To my husband, Fred, who has made the last twenty years of my life the best ever. Without his support, patience and encouragement, my artistic journey as well as this book would not have been possible. Also to my son, Mark, who is my reality check, reminding me that there's more to life than art.*

# Table of Contents

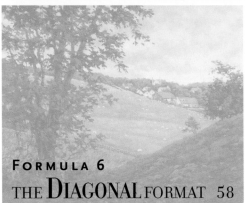

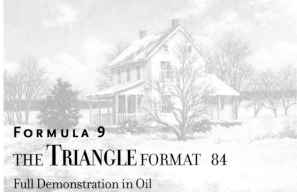

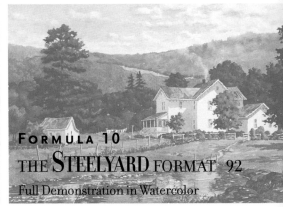

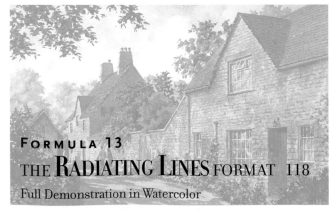

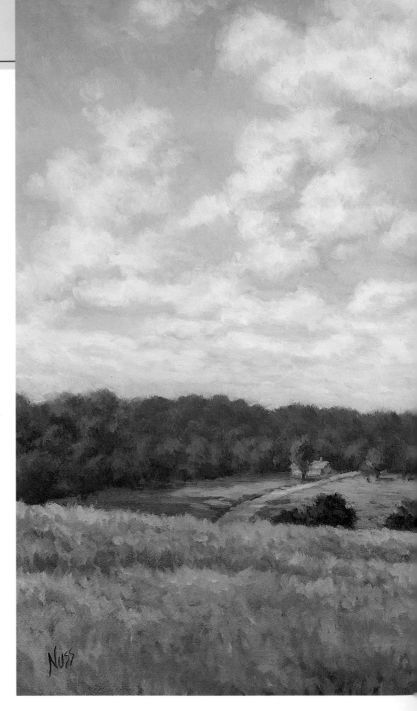

Ever since I could get my little fingers around a pencil, I have been drawing. As a child, I was never bored. I happily amused myself for hours with nothing more than a pad of paper, pencils and crayons, much to my family's delight.

My father, a "Sunday painter," often took me to the Mellon Gallery, now the National Gallery of Art, to see the paintings of the Impressionists and Post-Impressionists. Degas, Monet, Renoir, Toulouse-Lautrec and van Gogh were among his favorites. With these excursions, he passed on to me his love and appreciation of art.

At the age of eight, with my father's paints, brushes and patient guidance, I struggled through my first oil painting. Using the grid method, he taught me how to enlarge a *Saturday Evening Post* illustration onto a canvas panel. The importance of using a grid in drawing and painting has stayed with me.

During my teenage years, I decided that I would pursue a career as an artist, but had no specific direction in mind. After floundering around at college with different majors in a variety of subjects, I finally focused on a major in illustration where I could learn the fundamentals of design and drawing. At that time, the fine art painting curriculum emphasized abstract expressionism, which was of no interest to me. I ultimately earned a degree in illustration.

After graduation, I worked as a merchandise illustrator in a department store, rendering shoes, handbags, jewelry, towels and draperies for its daily newspaper ads. For several years I worked under a memorable, dynamic and talented art director. As he frequently paced the aisle along the artists' cubicles ranting, "Sparkle plenty! Sparkle plenty!" to the strains of Wagner's *Tristan and Isolde* emanating from the radio, I quickly learned the importance of values and contrast in illustration art. With India ink for the linework and Lamp Black for shades of gray, I was drawing and painting eight hours a day, five days a week. Within a day or two of completing each piece of advertising art, I was able to see the results in the newspaper, where I anxiously checked to see if the ads "sparkled."

Not only was this a tremendous learning experience, but I also absorbed a lot of tricks, some of which I share in this book. The importance of value has stayed with me all these years. I still aim to have my paintings sparkle.

The journey from then to now is a long and convoluted one that involved graphic design, illustration, art directing, painting in other mediums and learning still life, portraiture and landscape. For nearly three years, I spent one day a week at the National Gallery of Art, copying landscapes by John Constable, George Inness and Willard Metcalf. I even had the privilege of a private showing of thirty-five watercolors by Winslow Homer where I learned up close that no technique was off limits or taboo. He did whatever was necessary to achieve the result he wanted.

During these years, I amassed an extensive library of art instruction books. The ones that I learned the most from are included in the bibliography. I began teaching drawing and oil painting twenty years ago and have learned even more from my students. Currently, I teach only outdoor landscape painting workshops.

In this book, I am delighted to share my knowledge of drawing,

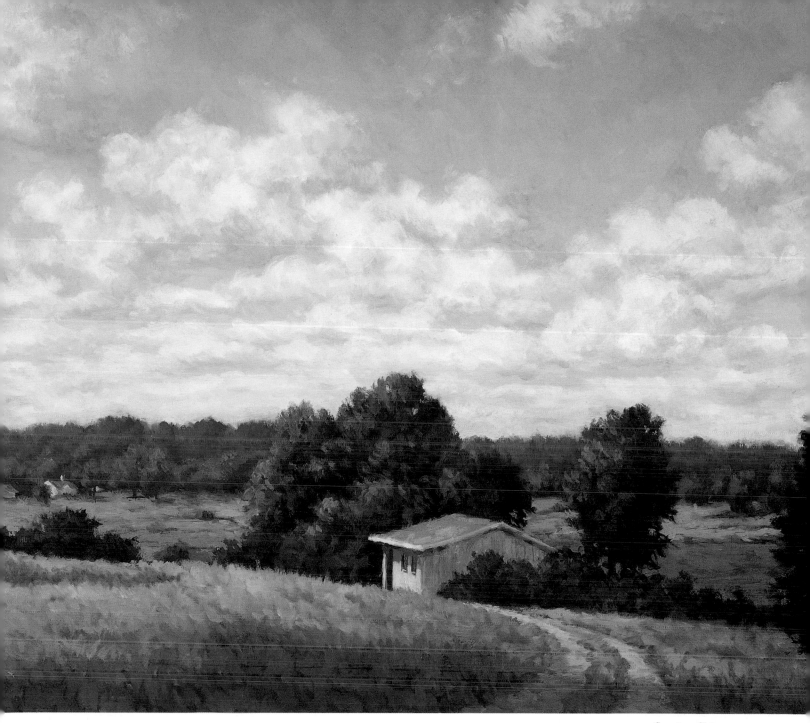

painting and particularly composing landscapes. My paintings that have been included in national shows have validated my efforts, methods and techniques. These methods and techniques are what this book is all about.

Perhaps not everyone can be a terrific landscape painter. But guidelines and formulas for placing elements in a painting will help you be a better landscape painter, regardless of whether you are a beginner, an intermediate or an advanced painter. Design and composition are the backbone of any painting, and you can learn it.

# Getting Started

*Before you set off to make a landscape painting, start with a plan. Following are some specifics to keep in mind as you determine your subject matter and the approach you want to take to paint it.*

## GATHER INFORMATION ON THE SPOT

As a landscape painter setting out to paint field sketches, your intent is to gather particular information about a scene as efficiently as you can: light, shadow, shapes, color, atmosphere and perspective. Think of the landscape elements as a starting point for a successful composition.

Because of the changing light, you may have two hours in the morning and two hours in the afternoon when the sun remains fairly constant and the shadows are interesting. When the sun is at its daily apex, the light is cool and flat and the shadows are barely existent—not good lighting for an interesting composition.

If you want real drama and excitement (and stress!), paint sunrises and sunsets when you have limited time to capture the quickly changing light. Some artists prefer the sunrise so that they can still see and continue to paint from memory after the dramatic moment is over. To paint at a less frenzied pace, choose an overcast day when all the light is reflected from the clouds and the lighting stays consistent all day.

## WHAT INSPIRES YOU ABOUT THE SCENE?

Depending on your destination, you have already decided what you want to paint—a vista, a street scene, maybe a mountain overlook. Once you arrive there, you need to determine exactly what inspires you about that scene. Lighting is critical. Just the way a streak of sunlight strikes the leaves of a tree or highlights a flower garden can turn you on.

Isolate possible scenes with your viewfinder and keep an open mind. You never know what you might find. Be prepared to change your mind and be flexible. Discover what inspires you about the scene so you can in turn inspire the viewer.

Be aware of what you want to say. Know your feelings and your emotional reaction to a place or situation. Do you like expansive scenes or cozy, secluded spots? What do you respond to? Keep your options open. Explore and have fun!

What you paint is your statement. It's all about you and how you react to visual stimuli. For instance, some landscape painters are staunch environmentalists and paint the disappearing landscape. This is their way of conveying the importance of conservation and protecting it from suburban sprawl. Winslow Homer and George Inness were among these conservationists.

## ARRANGE (AND REARRANGE) FOR A PLEASING COMPOSITION

Imagine yourself controlling all the elements in front of you. Once you have found a source of inspiration, then you must decide how to best present it. Place the elements where they will best show off your source of inspiration. Introduce elements that aren't directly in the scene, like moving a tree from behind you and putting it into your sketch. Record this information with a thumbnail sketch in your sketchbook and then in color with a field sketch.

Often you have to be content to settle on a scene that needs to be modified or simplified in some way. Perhaps there are too many rocks or boulders. If you painted each one, you'd quickly lose your way and the painting would lose its impact. Figure on eliminating at least a third of what you see in front of you.

You will make some composition changes on location, but you will save others for revisions in the studio. Keep in mind that what you see should serve as a source of inspiration. You need not take the actual scene literally. As a friend of mine once said, "Don't let the truth get in the way of a good painting."

## Plein air painting tips

- Begin your compositional sketch at a point at least fifty feet (15m) from where you are standing. Pace off the distance if necessary. Starting any closer will often cause distortion and place too much emphasis on uninteresting areas.

- If you don't have the requisite artist's umbrella, then situate yourself under a foliage-friendly tree or in the shadow of a building. It is important to paint in the shade; direct sunlight on your painting will wash out the colors. You may even have to face the opposite direction from your painting subject.

- Oil painters should wear nonreflective shirts to avoid glare. Gray and denim blue are good. White, hot pink, orange, yellow and lime green are bothersome.

## Make Thumbnail Sketches

Use a viewfinder to help you determine initial composition ideas on location. Once you have found a potential composition, use a sketch template to outline a sketching area with grid marks in your sketchbook. Keeping the viewfinder at a constant distance from your eye, use its grid as a guide to quickly capture the essence of the composition in your sketchbook. (See "Make a Viewfinder and Sketch Template.")

Transfer these initial impressions and ideas quickly into value sketches. Make changes or start new ones easily. Use a 2B or 4B pencil that can effectively produce dark values. A thumbnail sketch should take no more than two minutes. It is not a drawing; it is a concept in values. The details are unimportant.

Be creative! This is the time to arrange and rearrange the landscape elements in front of you. Use your sketchbook to make color notations as well. Once you have a thumbnail that pleases you, grid your canvas panel in thirds and transfer your sketch onto it.

## Make a Field Sketch

Following the gridded sketch in your sketchbook, enlarge it rectangle by rectangle to your gridded painting surface. Once you have roughed in the scene on your canvas with charcoal or on watercolor paper with light pencil, fine-tune your drawing before you start to paint.

Once you are happy with your drawing, proceed with the field sketch in oil, watercolor or another medium of choice. My personal preference is oil since what you see is what you get. I have worked in all of the following ways, as there are advantages and disadvantages to both:

1. the field sketch in oil and the final painting in oil

2. the field sketch in oil and the final painting in watercolor

3. the field sketch in watercolor and the final painting in watercolor

4. the field sketch in watercolor and the final painting in oil

It's all based on your preference and what works best for you.

Keep these field sketches for studio reference. On the back of each sketch, note the location, date and other particular details, such as the direction of the sun, the temperature and unusual weather notes. You will find elements or particular colors in these sketches that you can refer to over and over. You can use a sky from one sketch and put it with another sketch for a final painting. See pages 14 and 15 for further guidance on making a field sketch in either watercolor or oil.

## Take Photographs

Take photos before, during and after painting the field sketch. Shoot close-ups and regular shots. Take photos of any other interesting elements that you might use someday.

The 35mm SLR (single lens reflex) manual camera using slide film is the most versatile arrangement. Not only does it allow you to shoot a variety of exposures on location for future reference, but it is the best for shooting slides of your finished work.

When you enter juried exhibitions, you likely will be asked to send 35mm slides of your work. Since slides are the first-generation image, they are the truest and most vivid representation of your work with the best quality of color. Color prints are contrived to achieve "good prints," not necessarily an accurate print of the negative. These "good prints" are color-corrected by the processing equipment to primarily achieve healthy skin colors.

## Make a viewfinder and sketch template

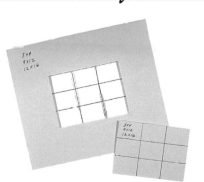

A viewfinder isolates a section of a scene and allows you to easily see composition options. You can easily make a viewfinder that will help you visualize your composition in thirds, horizontally and vertically. Cut a piece of mat board about 8" (21cm) square. Cut out a 3" × 4" (8 cm × 11cm) hole in the middle of it, and tape a piece of acetate over the hole. Divide the space into thirds and ink the grid onto it. Label the viewfinder with the different proportionate dimensions: 3" × 4" (8 cm × 11cm), 9" × 12" (23 cm × 31cm) and 12" × 16" (31 cm × 41cm).

Use the leftover cut-out square to make a sketch template that will make it easy to draw your on-location value sketches in pregridded shapes. On the square, mark a grid that corresponds with the one on your viewfinder acetate. Use this template to first draw a rectangle in your sketchbook. Then make tick marks for the grid and draw that grid on the rectangle. These gridlines that match the ones on your viewfinder will help you pencil the scene accurately and quickly.

# What You'll Need

## GENERAL MATERIALS

For painting on location, whether you work in watercolor or oil, I recommend having on hand the following equipment:

Outdoor easel (French or metal)

Umbrella to attach to your easel

Luggage cart (to lug your equipment around easily)

Pencils (2B and 4B), sharpener and plastic eraser

Sketchbook, 5" × 7" (13cm × 18cm) or 8" × 10" (21cm × 26cm)

Camera with print or slide film

Proportional dividers (I use the Prospek tool, which provides an easy way to judge relative sizes of objects)

Hand mirror for checking your work

Cotton rags and/or paper towels (or facial tissues)

Trash bag

Tote bag for miscellaneous gear

Ruler—12" (31cm) is a good size

Personal essentials: bug spray, sun block, a hat or sun visor and an aluminum lawn chair

Clamps, pliers and assorted sizes of bungee cords

Other special tools you may want to have are:

Viewfinder and sketch template

Value scale

Black peepholes (see sidebar on page 15)

## OIL MATERIALS

For oil painting, you will need the following materials:

Canvas panels or canvas boards, 9" × 12" (23cm × 31cm) or 12" × 16" (31cm × 41cm) toned with a gray or Burnt Sienna middle tone

Palette (the French easels and pochade boxes come with one)

Turpentine or mineral spirits (I prefer odorless turpentine)

Fluid medium (I use alkyd-based Liquin, which speeds the drying time)

Palette cups

Soft vine charcoal

Collapsible mahlstick (for use when you need a steady hand)

Brushes: hog bristle filberts in a variety of sizes (I use Robert Simmons Series 42 brushes); use larger ones for larger areas of color, and smaller ones for smaller areas

Wipe-out tool for removing paint

Dirty-brush carrier (an empty paper towel tube with tape on the bottom works well)

Use the following oil colors, arranged on your palette in the order of their appearance on the color wheel:

Permalba or other Titanium/Zinc White

Cadmium Yellow Light

Yellow Ochre

Cadmium Orange

Cadmium Red Light

Burnt Sienna

Quinacridone Red

Cobalt Blue

Ultramarine Blue

Phthalo Blue

Phthalo Green

Ivory Black

## WATERCOLOR MATERIALS

For watercolor painting, you will need the following materials:

Watercolor pad, 12" × 16" (31cm × 41cm) 14" × 18" (36cm × 46cm) or 11" × 14" (28cm × 36cm); I like Arches 140-lb. (300gsm) cold press

Palette with deep wells, like Robert Wood's or John Pike's

Craft knife (such as X-acto, for scraping highlights and details)

Palette knife (to stir the watercolors in the wells)

Brushes: a variety of flats and rounds (sables or comparable kinds) and a mop; use flats to apply large washes of color, rounds for smaller areas and details, and the mop brush for wetting large areas of paper

Incredible Nib for lifting color, making corrections and creating branches and other hard edges

Salt shaker

Water jug

Water holder (clip a can or other container onto the side of your easel)

Masking fluid

Toothpicks (disposable masking fluid applicators)

Masking tape (for taping borders on your watercolor pad)

Spray bottle

Use the following watercolors, arranged in color-wheel order:

Cadmium Yellow Light or Cadmium Yellow Medium

Yellow Ochre

Raw Sienna

Cadmium Orange

Cadmium Red Light

Burnt Sienna

Quinacridone Red

Winsor Violet

Payne's Gray

Cerulean Blue

Ultramarine Blue

Cobalt Blue

Phthalo Blue

Phthalo Green

Sap Green

Chromium Oxide Green

Permanent White gouache or comparable white for opaque finishing touches

# Explore Your Palette Possibilities

Using a value scale will help you quickly make better choices and evaluations as you paint. Make a value scale on a piece of card stock about 2" × 9" (5cm × 23cm).

For an oil value scale, use white for value 1 and Ivory Black for value 9. Paint the middle value 5 next and then fill in the other values in equal increments. Squint at your finished scale to make sure the jumps from value to value are even. For a watercolor version, use Payne's Gray for value 9 and dilute it for values 8 through 2. Leave the white paper for value 1.

When your value scale is dry, make holes in the center of each square with a three-hole punch. You can then lay your value scale directly on top of a painted area and check the value by squinting to see if the colors blend. Most values in a landscape fall between 2 and 8. Occasionally you can use a value 1 for water sparkles or other highlights.

Variations will occur depending on the local colors, the angle of the sun, time of day and humidity. Treat humid air as a veil between you and your subject; this veil is part of what you are painting.

To use a value scale effectively, paint a swatch of color on scrap paper to see where it falls in the value range, and adjust accordingly. These value assumptions should be used as a starting point since there are many variations and nuances.

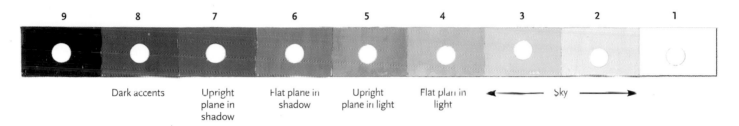

| 9 | 8 | 7 | 6 | 5 | 4 | 3 | 2 | 1 |
|---|---|---|---|---|---|---|---|---|

| Dark accents | Upright plane in shadow | Flat plane in shadow | Upright plane in light | Flat plane in light | ◀ Sky ▶ | |

## VALUE SCALE AND ASSUMPTIONS

Assume the following values for a sunny day and fairly clear atmosphere.
On cloudy days, shadow values are usually one value lighter.

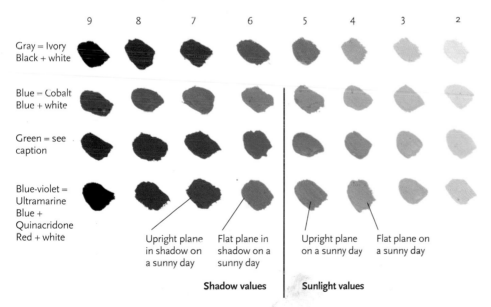

| | 9 | 8 | 7 | 6 | 5 | 4 | 3 | 2 |
|---|---|---|---|---|---|---|---|---|
| Gray = Ivory Black + white | | | | | | | | |
| Blue = Cobalt Blue + white | | | | | | | | |
| Green = see caption | | | | | | | | |
| Blue-violet = Ultramarine Blue + Quinacridone Red + white | | | | | | | | |

Upright plane in shadow on a sunny day

Flat plane in shadow on a sunny day

Upright plane on a sunny day

Flat plane on a sunny day

**Shadow values** | **Sunlight values**

### SAVE TIME BY PRE-MIXING COLORS

These pre-mixed oil colors are a great timesaver in the field since these colors and their variations are used repeatedly. Lay out your palette with these color strings alongside your basic colors. Make them up in large quantities and tube them, or you can mix just enough for a few days.

Mixing the green string is a little tricky. First, make a value 2 green pile with Cadmium Yellow Light, a little white and a bare whisper of Phthalo Green. Second, make a pile of value 5 green in a ratio of 5 parts Cadmium Yellow Light to 1½ parts Ultramarine Blue. Add the value 5 green pile to the value 2 pile to make the value 3 green and the value 4 green. Gradually add the remainder of the value 5 green to the value 9 blue-violet to achieve green values in 6, 7, 8 and 9.

# Oil Painting Procedure

## Making Field Sketches

With a rag in hand to wipe the charcoal drawing off as you go, draw the sketch with a neutral color of paint. Use a blue-gray, cool brown, Cadmium Red Light or whatever you like, but nothing that might overpower a painting. You can use a blue-gray for mountains, a cool brown for tree trunks and Cadmium Red Light for buildings. You want colors that easily blend in with the painting. Try different colors and see what works best and is the easiest for you, and gives you the look you like.

Once you have your drawing in paint, lay in broad color areas by working from dark to light. Pop in a bright spot of your lightest light for a quick comparison of values. Proceed by covering your canvas as quickly as you can. Then refine the areas by painting on top of your initial lay-in.

Usually you have about two hours for this procedure. Using pre-mixed colors will help you accomplish more in less time. Use peepholes to check for color accuracy (see "Use Black Peepholes" on page 15).

## Canvas Options

You can choose between several options for your final canvas. You can buy pre-stretched cotton canvas, preprimed canvas (linen or cotton) to stretch yourself, or unprimed, unstretched canvas that requires complete do-it-yourself preparation.

As your confidence grows, you will want to tackle larger paintings. Some common sizes that the Impressionists used were 20" × 28" (51cm × 72cm), 22" × 28" (56cm × 72cm), 20" × 30" (51cm × 77cm) and 26" × 36" (66cm × 92cm), to name a few that fit well into homes. The popular couch size is larger, more like 24" × 40" (61cm × 102cm) or 30" × 48" (77cm × 123cm). In general, a landscape is best represented by a ratio of about 2:3 height to width.

## Making the Final Painting

Tone the primed canvas with a gray or Burnt Sienna and Liquin, thinned with odorless turpentine, to achieve a middle tone. A gray middle tone like the one Willard Metcalf and other American Impressionists used is easy to work with. The darks look dark and the lights look light.

Since the procedure for oil painting is to paint fat over lean to keep the painting from cracking, begin your first painting layer with thinned Liquin. Dilute the Liquin with a ratio of about 1:1. For the second coat of paint, dilute the Liquin to a ratio of about 2:1. And for the final coat of paint, use straight Liquin. The Liquin not only improves the application of the paint, but also speeds up the drying process. As a temporary finish, coat the entire painting with Liquin.

## Varnishing Your Painting

When the painting is completely dry, which can take between three months and a year depending on how thick the paint is, use an acrylic varnish formulated for oil paintings. Soluvar made by Liquitex comes in gloss and matte finish and can be combined to achieve various levels of gloss. Soluvar is easily removable with mineral spirits. Try different varnishes to see what you prefer.

## Seven ways to soften edges

Since hard edges attract the eye, they should be used sparingly and for emphasis. The following methods are used to soften the edges in oil paintings.

- **Two adjacent wet edges:** Using a chisel-edge brush, zigzag along the edges, going about ⅛ inch (.3cm) into each area. Without wiping the brush, pull it down along the zigzag area to blend them.

- **Two adjacent wet edges (the blot method):** Apply a paper towel on top of the area that you want to blend. Hold it very still and gently rub on top of the towel without moving it. This will result in a controlled smudge.

- **Two adjacent wet edges (partial blend):** With a dry brush, drag paint across the edge very lightly from one side to the other.

- **Two adjacent wet edges (finger blend):** Lightly smear paint with your finger in a zigzag motion.

- **One wet edge (flick method):** Flick paint with the side of your brush from the wet side to the dry side.

- **On a dry surface:** Apply Liquin over the edge and, with a mixture of paint and more Liquin, spread the wet area over the dry surface.

- **Scumble:** Load your brush with paint and drag it softly over the surface of the painting, leaving bits of paint on the high points of the canvas surface.

# Watercolor Painting Procedure

### MAKING THE FIELD SKETCH

Lightly transfer your sketch onto your gridded watercolor paper. Lay in washes of color to form an abstract pattern. Working from top to bottom and from back to front, paint the background, middle ground and foreground, gradually deepening the colors to the desired values. Use your black peepholes frequently to determine if you have the correct value and color.

### STRETCHING YOUR PAPER

I use 140-lb. (300gsm) paper, which needs to be stretched so it doesn't buckle as the painting dries. After trying all methods of stretching watercolor paper, I have found that the following method that I learned in college works the best. No matter how wet your paper gets, your watercolor paper will not buckle.

The materials you will need to stretch your paper are:

Brown paper tape, 2" (5cm) wide
Sturdy drawing board, 30" × 36" (77cm × 92cm)
Paper towels
Wet sponge
Bathtub
Razor-blade scraper
Plastic container

Soak your sheet of paper in the bathtub for about five minutes to remove the sizing. Then, holding the paper by a corner with one hand and a container to catch the drips in the other hand, carry the soaking paper to the drawing board and lay it out smoothly. With paper towels, soak up as much water as possible around the perimeter where the brown paper tape will go.

Cut strips of tape longer than the lengths of the paper. Run the dry tape across the wet sponge and apply it to the edges of the watercolor paper. Press down hard with your hands until you are sure the tape is firmly attached to the paper. This will dry in several hours and be ready for painting.

When you have finished your painting, cut it from the surface next to the tape with a knife. Remove the tape by thoroughly soaking it and scraping it off with a razor-blade scraper. The board is ready for your next piece of paper.

Many watercolor papers are available. If you don't want to stretch your paper, try 300-lb. (640gsm) paper.

### MAKING THE FINAL PAINTING

Decide where you want to save your white paper and apply masking fluid to those areas using a small, old soapy brush or disposable toothpick. (The soap protects your brush so you can reuse it for future masking.) When the masking fluid is dry, you are ready to paint.

With juicy paint that is the consistency of pea soup or ketchup, paint from light to dark. Lay in loose color washes and gradually work into the darker values. Working from back to front is a good method to develop your painting. Place your details last.

### GENERAL TIPS

Fill a deep-welled palette with your watercolors. The night before the day you plan to paint, squirt water over your watercolors. In the morning, stir the wells with a sturdy palette knife, cleaning the knife before stirring each color. By using this preliminary process, you will always have full-strength, juicy color at your fingertips.

Empty your water container frequently and wipe out your palette at the same time to keep your colors clean.

Tape or clamp a piece of scrap watercolor paper to the side of your painting. (Use the backs of old painting exercises.) After mixing a color on your palette, brush a quick stroke on the scrap paper and make adjustments accordingly before actually putting the paint on your paper.

Hold a paper towel or facial tissue in the hand that is not holding the brush. Then you can wipe out mistakes immediately before the color soaks in.

Have salt handy to toss on your painting when you need a grainy texture. Use this technique for textures such as foliage, rock surfaces, dirt and bricks. Make sure the paint is wet and that there is a dry color underneath it. If the new layer is too dry, the salt won't affect it. Wait until the paint is totally dry before brushing away the salt.

## Use black peepholes

Check your color accuracy with black peepholes. To make a pair of peepholes, cut two pieces of black mat board, about 2¾" × 6" (7cm × 16cm). With a hole punch, put a hole in one end of each.

Hold one black peephole in front of a color spot on your canvas and the other in front of the comparable color in the landscape. The peepholes isolate the surrounding colors so you can focus just on these two color spots. Make adjustments on your painting until the two colors are the same.

If you did this over the entire canvas, you would approximate what the Impressionists tried to do—put the exact color spot in the exact location on your canvas.

# Choosing a Compositional Formula

Have you ever gone out to paint a landscape and been overwhelmed by everything? You see a terrific tree but you have no clue as to where to place it in your painting?

These classic fourteen composition formulas or formats are guidelines for organizing and arranging the major and minor pieces of a landscape. Rather than being confounded by a complex scene, you can confidently move or add a tree, change the horizon or even move a mountain. Knowing and understanding these formulas will help you arrange elements for strong, effective, interesting and thereby successful paintings.

Decide which compositional formula best suits your purpose. See how close your inspiration is to one of the formats

and then proceed from there. Rearrange and modify elements as necessary to make a format work.

## CONFIRM YOUR PLAN BEFORE YOU PAINT

A successful landscape painting develops in these two main stages: (1) the field sketch to capture the essence of the scene, and (2) the final painting that incorporates the changes made along the way.

You are now ready to begin your final painting. You have a color field sketch and your reference photos. Improve your field sketch and fine-tune troubling areas. Lay tracing paper over your field sketch and move things around until you are satisfied.

Design an entry into and an exit from your painting. For people whose lan-

guages read from left to right, it is more comfortable for the painting to "read" the same way: with the entry on the left and the exit on the right. For people whose languages read the other way, the opposite is true.

Plan each of the four corners to be different, even if it is only subtle. As necessary, add a "stop," a design element that stops the viewer's eye from continuing in one direction and points it in another direction.

The rest of this book will show you how each of these compositional formulas can be used to create successful paintings. Each format is applied to a specific landscape scenario to show how you can face the various challenges of capturing a scene and end up with a great painting.

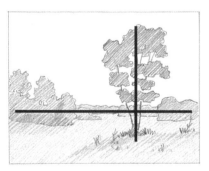

Use the **cross formula** when you have a strong narrow vertical across a strong horizontal landscape.

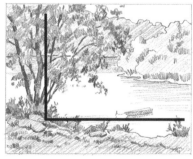

Use the **"L" formula** when you have a tree or building on the left with a shadow area in the foreground.

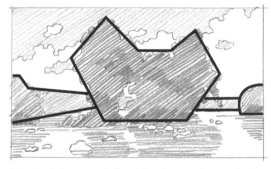

Use the **balance scale formula** when you have a dominant center of interest with similar masses and shapes somewhat equally on both sides.

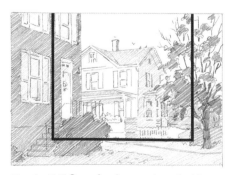

Use the **"U" formula** when you have buildings or trees that frame each side of the painting and connect at the bottom with a strong shadow pattern or other dark area.

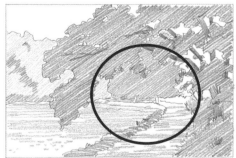

Use the **"O" formula** when you have a center of interest encircled by dark elements, such as overhanging trees.

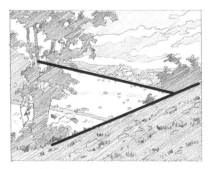

Use the **diagonal formula** when you want to emphasize strong slanting lines, such as a mountain or cliff balanced by an opposing diagonal shape.

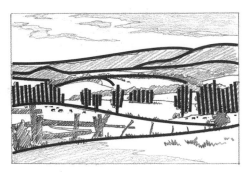

Use the **pattern formula** when you have an expansive vista with no discernible focal point.

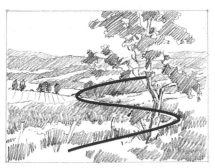

Use the **"S" formula** when you have a road or stream weaving through a scene.

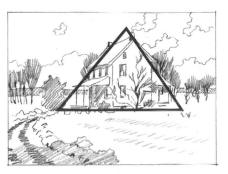

Use the **triangle formula** when you want to arrange elements into a classic, formal composition.

Use the **steelyard formula** when you have a large element and a second similar, smaller element.

Use the **three-spot formula** when you need to organize repeating shapes.

Use the **overlapping shapes formula** to artistically arrange shapes in a short depth of field.

Use the **radiating lines formula** when you have numerous lines radiating from a common vanishing point.

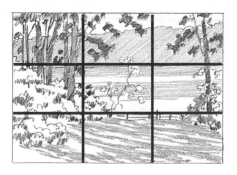

Use the **tic-tac-toe formula** when you need to find the most effective spot for a special center of interest.

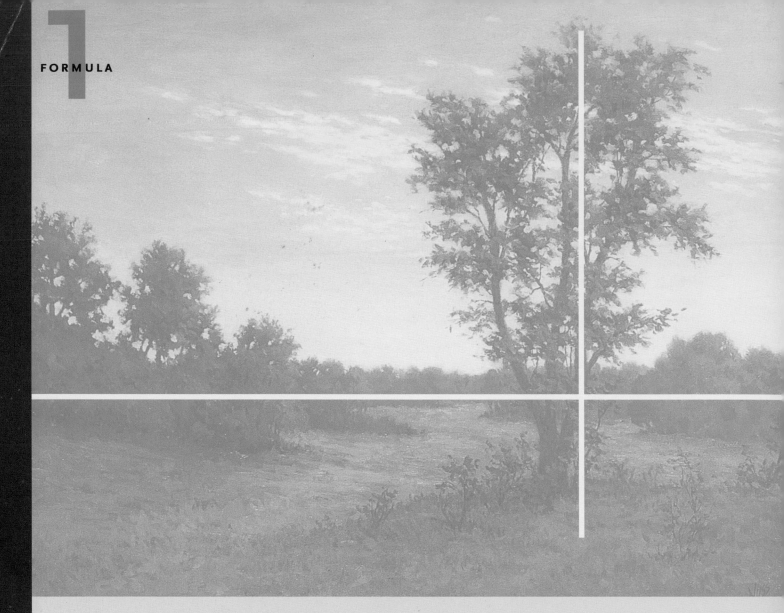

# THE CROSS FORMAT

USE THE CROSS FORMAT TO SOLVE THE PROBLEM OF PORTRAYING A LARGE VERTICAL, SUCH AS A TREE, WITH THE NUMEROUS HORIZONTAL LINES FOUND IN DISTANT PLANES.

While giving a workshop, I made a futile attempt at a sunset field sketch. Earlier in the day, I had located a hardy windblown tree outlined against a backdrop of mountains, and a lake that could provide striking reflections at sunset. The day was partially cloudy, but I eagerly watched as spots of cobalt sky occasionally peeked through the gray to suggest the spectacular sunset to come. Wrong! At sunset, the sky was one gray, dense mass of heavy clouds.

The following day, I watched puffy cumulus clouds strut across the sky and hoped they would still be there at sunset. Wrong again! This time the clouds all disappeared and left one pathetic cloud cautiously limping across the twilight sky.

Back at home I gave it one last try while the leaves were still colorful and before the cold weather arrived. I had scouted around the local area for weeks before finding a solitary tree that could be viewed against the sky and a place where I could situate myself to paint it comfortably. From here I would paint the subtle warm colors of an autumn sunset. Knowing that I had about fifteen minutes to record the scene, I concentrated only on the values and colors. Looking directly into the setting sun, it was nearly impossible to make out the tree's silhouette. Using my reference photos, I would correct the drawing later in the studio.

Capturing the right values and colors on location emphasizes the importance of color field sketches as a prelude to a final studio painting. There's no way I could have photographed this scene accurately. It's a good example of why artists should not copy colors from photos.

# Reference Photos

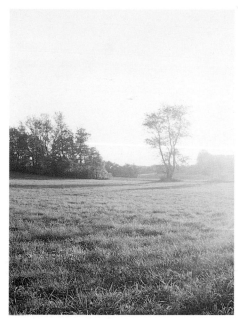

OVERALL REFERENCE
Once the sun has gone below the horizon, shoot again, getting some detail of the other tree shapes.

TREE REFERENCE
Even though you are looking straight into the blinding sun, photograph the tree's silhouette. With your hand, shield the lens to prevent the sun from hitting it directly.

INCLUDE THE CLOUDS
Introduce the clouds that fortunately meandered into your view. You can rearrange the formations as you like.

# First Sketches

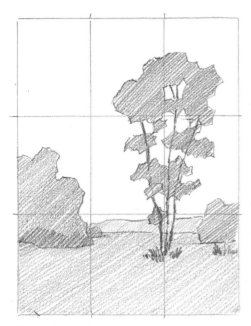

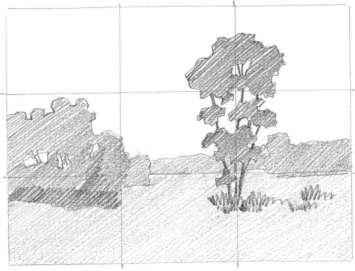

### SECOND VALUE SKETCH

Try a more horizontal shape incorporating other elements since the few clouds won't have a significant effect. Again, place the tree one-third in from the right. The tree row on the left effectively balances the silhouetted shape. Convey a sense of distance with overlapping planes of trees and fields.

### FIRST VALUE SKETCH

Before the sun actually sets, do your value sketches based on the value assumptions described on page 13. You know the tree will be the darkest value and the side planes of the tree rows will be slightly lighter. The flat plane of the fields will be an even lighter middle tone. The lightest area will be the sky.

In the first sketch, accentuate the tree by placing it one-third in from the right in a vertical format. Move the tree rows closer to the tree to improve middle-ground interest. If the sunset is spectacular, this could be a skyscape to show off the dramatic colors. The tree has an elegant shape but seems crowded in this vertical format.

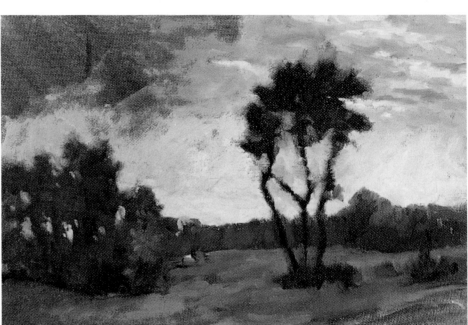

### THE FIELD SKETCH

Capture the colors in the few minutes available. Rapidly draw in the tree trunk and suggest a bit of foliage. Next, paint the farthest trees and gradually warm your colors to paint the progressively closer trees. The rust-colored tree adds a nice touch of autumn.

Once the sun is below the horizon, quickly paint the flat plane of the fields. Add a small bush on the right as a stop to keep the viewer's eye in the painting. With a larger brush, lay in the sky colors, starting with the lightest yellow. Work outward from this light area toward the reds and oranges, then make it more yellow, yellow-green, blue and finally, blue-violet. The sky on the left at the horizon is a pinkish lavender-gray. On top of the sky color, paint the clouds reflecting the gold light from the sun. Your reference photos will help you refine these shapes later.

Since this is a quick sketch, you may need to leave some areas unresolved.

## Problems with the field sketch

Since you planned ahead with an accurate value sketch, the design and division of space are essentially pleasant. A little tweaking will make it even better. Resolve other areas, such as developing the tree rows and flat planes, in the final painting.

# Solve Design Problems and Finalize Your Composition

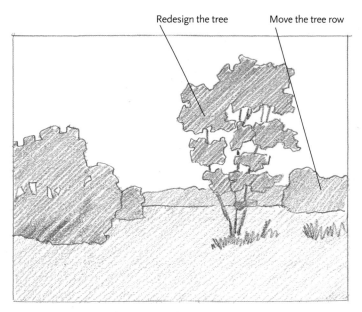

Redesign the tree     Move the tree row

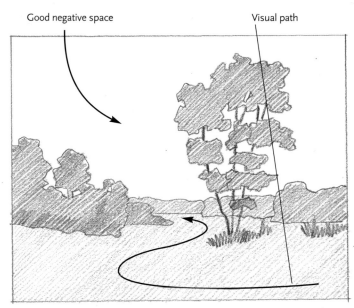

Good negative space     Visual path

## DESIGN SOLUTION: ADJUST THE SIZE

To focus more attention on the silhouetted tree, lop a bit off both sides of the sketch, which is 9" × 12" (23cm × 31cm), so it fits a 16" × 20" (41cm × 51cm) canvas. Referring to the reference photo, redraw the tree into a graceful shape, setting the tone for the serene sunset. Move the tree row to avoid tangent lines and to give the tree air.

## DESIGN SOLUTION: REDESIGN THE TREE ROWS

Reduce the size of the middle-ground and background tree rows, giving the lone tree more importance. Then redesign the overlapping layers of tree rows, allowing the viewer's eye to gently move through the painting.

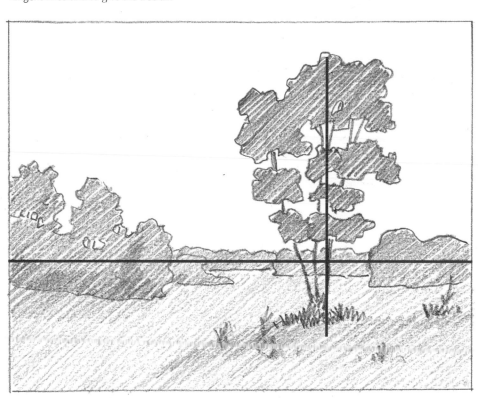

## FINAL PENCIL DRAWING

Bring the tree forward and up on a slight hill to add interest to the foreground. Suggest some weeds. The path into the painting is more apparent with these two minor adjustments.

21

# Painting Pointers

**Sky:** Paint the sky with a large brush, working from bottom to top. First paint the yellow area where the sun has just disappeared behind the trees, then the reds and yellow-greens. Gradually add Ultramarine Blue proceeding toward the zenith, and finally add Quinacridone Red to give the Ultramarine Blue a slight violet tone.

**Clouds:** Using a large brush and lots of white warmed with a bit of Yellow Ochre, paint a scattered formation of clouds. Weave them behind the tree and bleed them off to the right. Refer to your photos for accurate cloud patterns but angle them a bit to suggest movement.

**BEGINNING THE PAINTING**
With soft vine charcoal, enlarge the drawing onto your canvas. With a neutral blue-gray paint, follow the drawing lines, wiping the charcoal away as you go. Then begin blocking in the scene.

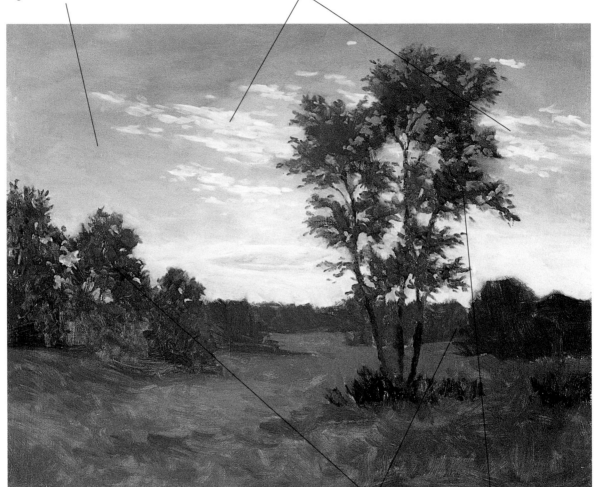

**Other foliage:** Move on to the side planes of the tree rows and use a lighter tone for the flat planes.

**Darkest foliage:** First paint the darkest areas—the main tree trunk with a dark warm gray and the foliage with a dark violet-green.

**Clouds:** Restate the clouds that are tinged with gold using a mixture of white, Quinacridone Red and Cadmium Yellow Light. Paint delicate shadows on top of the clouds (since the sun is below them) with a soft gray made of Cadmium Red Light, Phthalo Blue and white.

**Main tree:** Reshape the tree trunk so it doesn't look like three trees; it is only one tree with three large trunks. Brush more foliage into the sky that has been painted, keeping the edges soft.

## Developing the Painting

Start defining and refining specific areas.

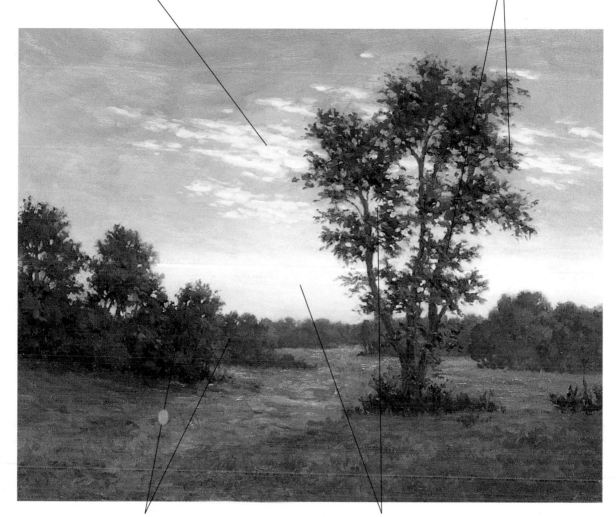

**Tree rows:** Develop the remaining tree rows with varying shades of cool greens, the coolest tree row being the farthest one back. For a touch of autumn, introduce a cool orange to the right tree of the first tree row and to some other trees to spread the color around. Shape the trees with various values of green-violets.

**Sunset:** Following the colors of the field sketch, continue the sunset colors behind the trees. Overlap the sky color onto the tree colors to soften their edges. Paint effective sky holes in various shapes and sizes in the backlit foliage.

Blend the cloud paint into the sky color for effective soft edges. Paint the small distant cloud formation with smaller individual puffs for convincing aerial perspective.

**CAPTURING THE COLORS OF A SUNSET**

The silhouetted tree at a right angle to the horizon forms the timeless cross format. Dividing both the horizontal and vertical spaces into thirds alleviates any static shapes. The slight elevation in the foreground contributes not only to a sense of depth but also allows a path through the painting. The viewer's eye exits the painting on the cloud mass bleeding off the right edge.

The simple, glowing cloud formations repeat the horizontal planes of the tree rows, contributing to a quiet autumn sunset.

**October Evening**
Oil on linen
16" × 20"
(41cm × 51cm)

Paint the flat plane with a bare hint of texture and a variety of greens, interspersing the greens with browns and oranges. Introduce some silhouetted bushes with squiggly branches and bits of leaves.

Paint the rest of the shadowed trees simply since little detail is visible. There is a slight value change at the treetops where they receive reflected light from the descending sun. Softly blend the tree colors over the sky color and vice versa.

# Lessons From the Gallery

## TRY A VERTICAL DESIGN

This painting began as a field sketch demonstration during a workshop. The original field sketch was horizontal, but after revisions, the vertical design that better encompassed the height of the tree without extraneous hills and fields won out. The vertical design, though, is similar to *October Evening* with the silhouetted tree in the right third of the painting. It is a simple, elegant format ideally suited for gentle landscapes.

**Summer Pastures**
Oil on linen
20" × 14" (51cm × 36cm)
Private collection

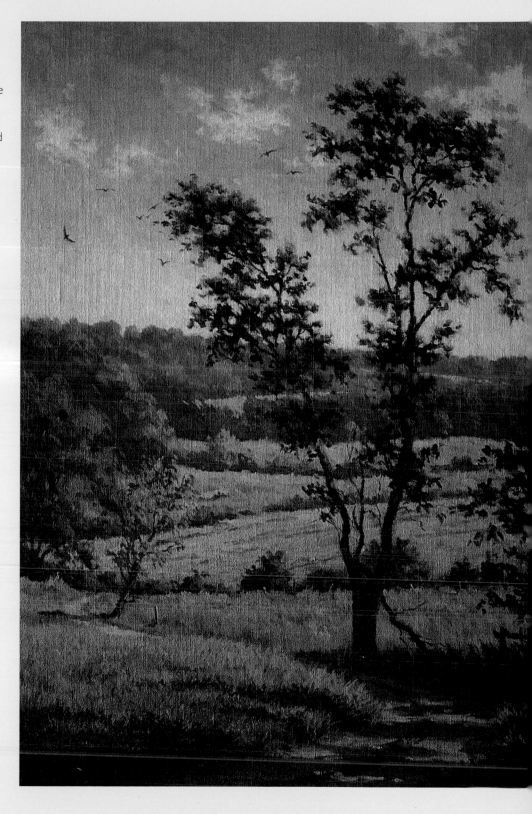

# THE L FORMAT

USE THE "L" FORMAT TO
ORGANIZE A STRONG VERTICAL
DARK MASS ON A SIDE WITH A
SIMILAR DARK MASS OR
SHADOW PATTERN ACROSS THE
BOTTOM OF A PAINTING.

Braving beastly hot and humid weather, I ventured out to my favorite riverside dock. I was interested in finding a good composition that really caught my interest, as well as locating a nice, cool shady spot beneath one of the enormous oak trees. Merging these requirements proved to be quite a challenge.

I liked the quiet water in the lagoon and the maroon rowboats, which I have painted numerous times. I also liked the cool blue-violet colors of the far shoreline, which contrasted well with the sunny gold areas on the land. There was one particular graceful tree that caught my eye.

# Reference Photos

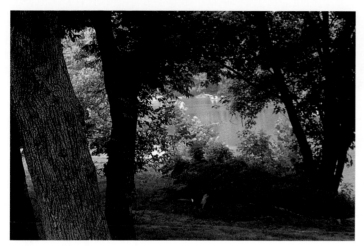 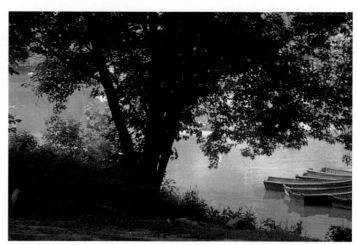

### OVERALL REFERENCE
From your painting spot, photograph the basic scene in overlapping sections.

### INCLUDE NEARBY SCENES
Walk around the area and photograph the distant shore and the rowboats, which will be handy reference material later.

### CAPTURE DETAILS
Photograph another area revealing some particulars of the island as well as a closer view of a rowboat.

# First Sketches

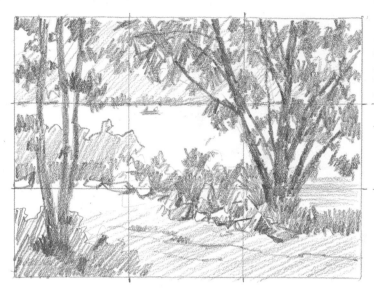

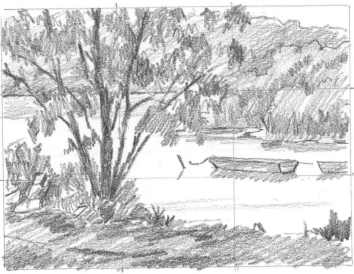

### FIRST VALUE SKETCH

In the first sketch, place the tree on the right and move some other trees in from the sidelines to balance the mass. Contrast these dark areas with a light area of ground, water and a rowboat in the distance. Place the waterline one-third down from the top of the painting. Within the shape created by the trees, place a boat with a fisherman in it. The path into the painting, however, is from right to left and creates an uncomfortable feeling.

### SECOND VALUE SKETCH

As an alternative, place the graceful tree on the left with a strong foreground shadow to fit the "L" format. This arrangement emphasizes the placid water with the subdued far shore and a suggestion of an island on the right. Some sky in the upper right corner adds depth. Back in the studio, fiddle with the arrangement of the rowboats.

### THE FIELD SKETCH

When painting the actual scene, be as accurate as possible in matching colors. The colors in the far shoreline and the island are the most difficult since they are influenced in various degrees by atmospheric perspective.

The ugly muddy color of the water revealed the effect of recent rains and would need improvement later in the studio. Despite the number of rowboats in the water, paint just one and the bow of another. Mainly capture the colors of the boats and their cast shadows, as well as the cast shadow from the tree on the water.

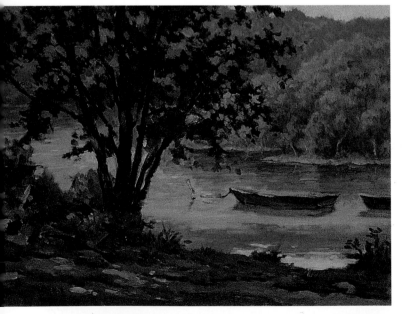

## Problems with the field sketch

- The tree overwhelms the sketch and is more centered than originally intended. The island shoreline, obscured by the tree foliage, needs clarification.

- The rowboats are too large and cry for attention. They should be smaller so that their contribution to the painting is to give it a sense of place rather than making it a boat painting.

- The water needs a better color as well as sky streaks to make it convincing.

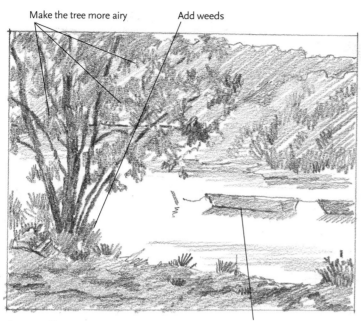

Make the tree more airy
Add weeds
Better spacing

## DESIGN SOLUTION: ADJUST THE SIZE

Remove space from the left of the field sketch for a squarer format, such as a 16" × 20" (41cm × 51cm). Then move the tree to the left but keep the island where it is. Reposition the rowboats so they are not centered in the water area.

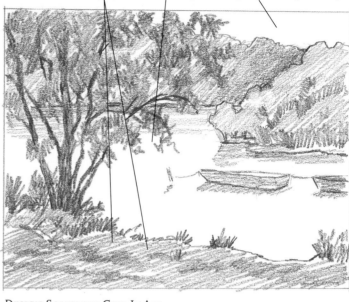

Needs rocks
Redesign the foliage
Better negative shape

## DESIGN SOLUTION: GIVE IT AIR

Elongate the foreground line between the tree and the bush, keeping the bush on the right as a stop. Reduce the size of the far shore and reshape the island with tree trunks on the point so that you can see water going around them. Overlap the far shore with the island to create a more interesting negative sky space as well as more distance.

These revisions give the drawing more air to let it breathe. Now the viewer's eye can get into the painting and around the island, which it couldn't do before.

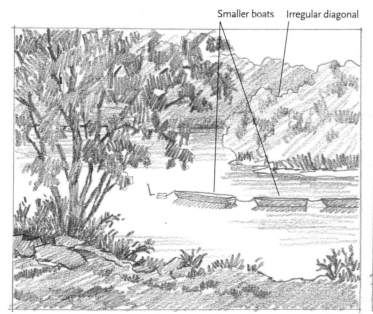

Smaller boats
Irregular diagonal

## DESIGN SOLUTION: ARRANGE THE ROWBOATS

Play with the arrangement of the boats by drawing them on tracing paper and moving them around on top of the sketch. All of these boats, even though smaller, still make the sketch look more like a boat painting. The reference material has exerted an obvious influence.

Determine the final position of the rocks. Keep their shapes different and include a dead branch for contrast.

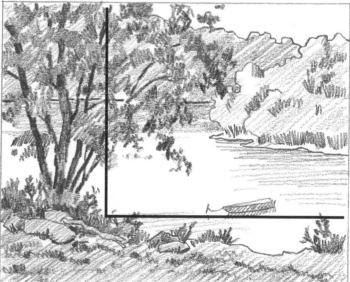

## FINAL PENCIL DRAWING

Select only one boat and position it obliquely to the land areas. Point it toward the foreground shore, remove the float and angle the piling counterpoint to the bow of the boat. This new arrangement not only adds more interesting negative spaces in the water but also improves the mood. By reducing the clutter of distracting boats, the viewer can savor this cool shady spot on a hot day.

# Painting Pointers

**FORMING THE TREE TRUNKS**

Using basic rendering rules for painting cylinders, paint the tree trunks as if they were textured pipes. Begin the trunks by painting them a dark grayish brown. To make them appear round, add a lighter side on the left toward the direction of the light. On the right side, add a slightly orange cast where the trunks and branches receive reflected or bounced light. The darkest parts of the trunks are toward the viewer. Make the trunks sparkle by introducing spots of middle-value reddish orange where the sunlight hits the surface.

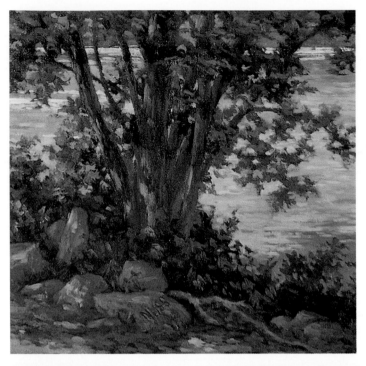

**MAKING THE WATER SPARKLE**

When the painting is dry, load your brush with a light sky color. Hold your mahlstick parallel to the picture plane. Keeping your brush as parallel as possible to the canvas, drag the brush lightly along the mahlstick across the surface of the painting. This allows the loaded brush to barely touch the highest points of the painting surface, creating the sparkle. In watercolor, you can achieve a similar effect by scratching off the paint down to the white surface of the watercolor paper.

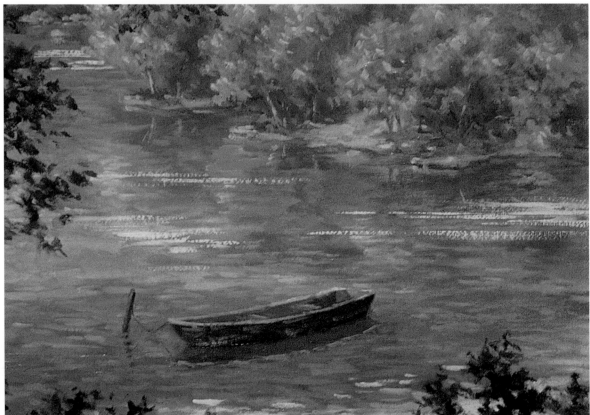

# The Finish

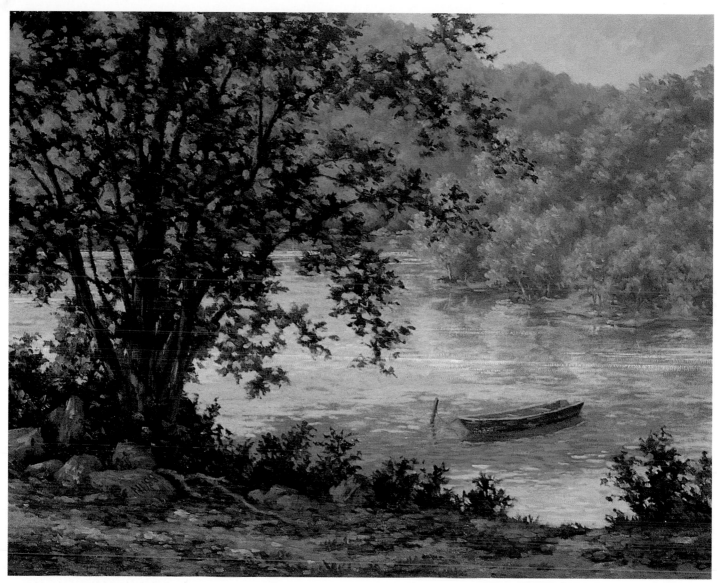

## MAKING A HOT DAY LOOK COOL

The classic "L" format effectively frames this lagoon with the lone rowboat. Include just enough detail in the foreground to make it interesting. The viewer's eye enters the left side of the painting on the dirt path and follows it across to the break in the weeds where the sky is reflected on the water.

    The bush used as a stop directs the viewer's eye toward the rowboat, which is pointing back to the near bushes. Then the viewer's eye travels up the trunks to the branches that graciously point back to the boat tied to the piling, a secondary point of interest. The major focus of this painting is to capture the mood of a hot day in the shade at the water's edge.

**Shady Side**
Oil on linen
16" × 20" (41cm × 51cm)

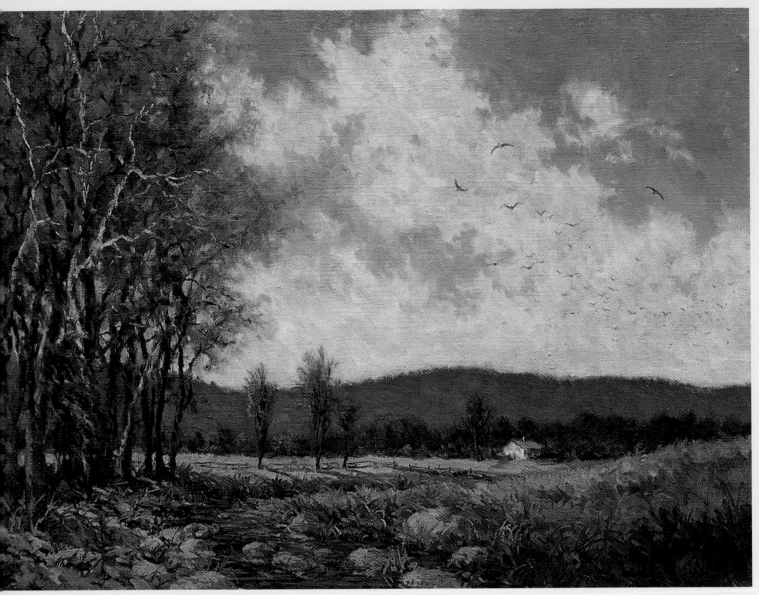

**Transform an Unappealing Road Into an Eye-Catching Creek**
An ugly purple macadam road transformed into a rocky creek forms the horizontal leg of this strong "L" format. Peppered with a flock of birds, billowy clouds add energy to this otherwise wintry day.

**January Fields**
Oil on linen
12" × 16" (31cm × 41cm)

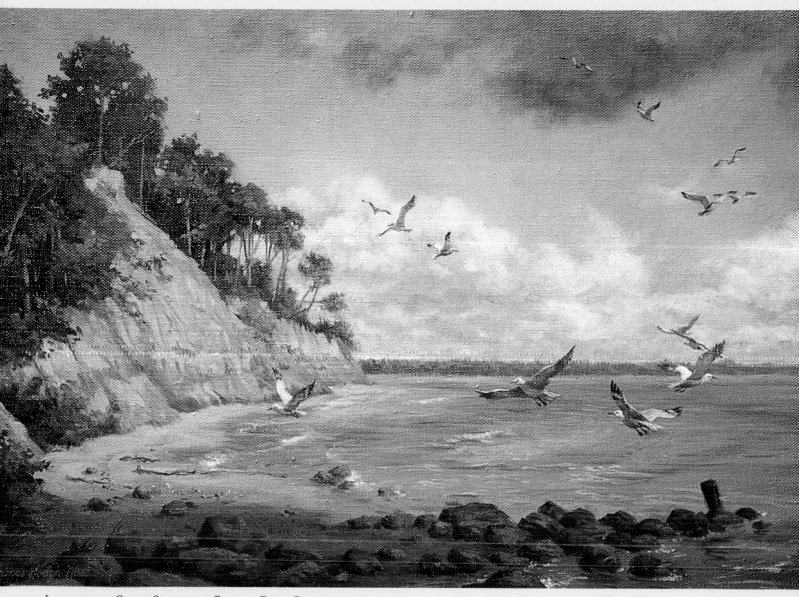

## INTRODUCE A CLOUD SHADOW TO FRAME A FOCAL POINT

Even though this scene was bathed in bright sunshine, I cast the foreground in a cloud shadow to emphasize the rugged shape of the foreground jetty against the water. By connecting the cloud shadow with the strong vertical tree shape into an "L" format, I effectively framed the gulls, cliffs, and shoreline.

**Morning at Calvert Cliffs**
Oil on linen
20" × 28" (51cm × 71cm)
Private collection

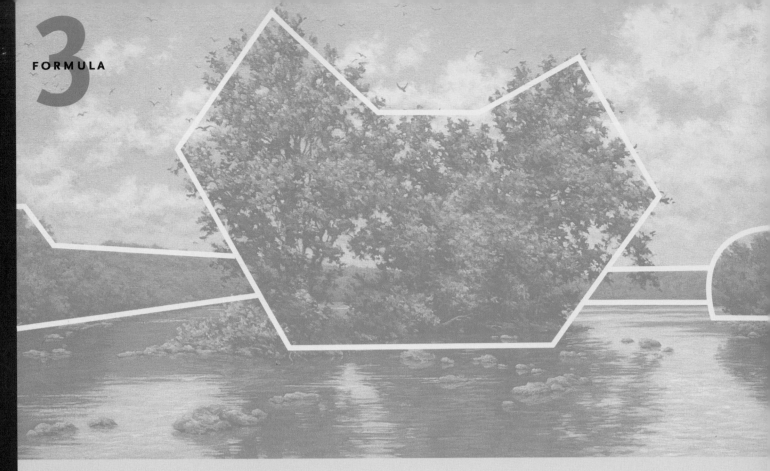

# THE
# BALANCE
# SCALE FORMAT

USE THE BALANCE SCALE FORMAT TO PLACE

SIMILAR MASSES AND SHAPES SOMEWHAT

EQUALLY ON BOTH SIDES OF A DOMINANT

CENTRAL FOCAL POINT.

It was early afternoon on a typical hot, muggy summer day. Lugging our painting gear and cameras, my friends and I had hiked a half-mile (1km) on a narrow overgrown path along the river. When we rounded a bend, we encountered this lush island, just begging to be painted. We had seen other islands but none so grand and imposing as this one. Since the river was low, craggy rocks poked up around the island and the shorelines. These rocks offered a rugged counterpoint to this tranquil scene that the sky had bathed in cobalt. To capture this restful spot, two composition arrangements needed to be explored.

# Reference Photos

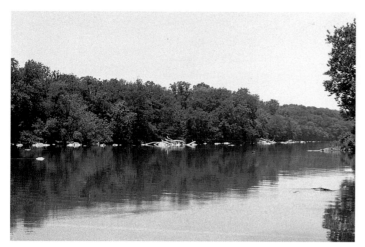

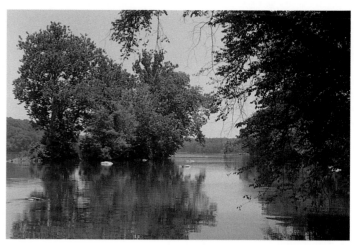

**OVERALL REFERENCE**
Photograph the scene in sections to capture the fundamental details.

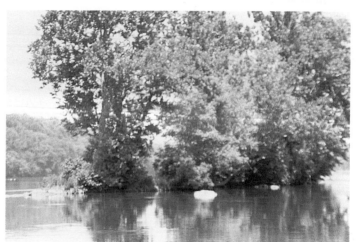

**LOOKING INTO THE SHADOWS**
Overexpose one shot to reveal shadow areas that are not visible at a normal exposure.

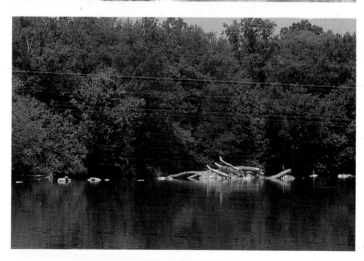

**CAPTURE DETAILS**
Zoom in on an assortment of rocks and rubble for future reference.

# First Sketches

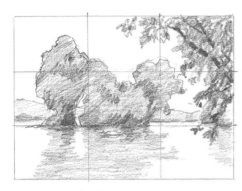

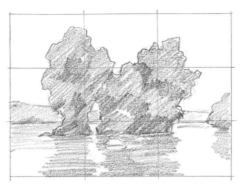

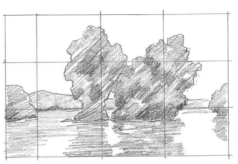

**FIRST VALUE SKETCH**
Place the island off center and frame it with a foreground tree. The dark shape silhouetted against the sky draws attention away from the island, diminishing its grandeur.

**SECOND VALUE SKETCH**
Center the island to dominate the composition. This arrangement achieves a classic symmetry that is balanced and comfortable.

**THIRD VALUE SKETCH**
Elongate the sketch by adding the riverbank on the left to provide the island with a sense of place. This new format adds to the feeling of peace and serenity.

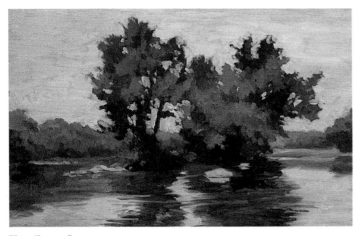

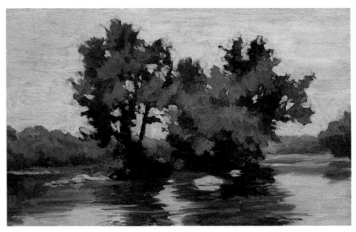

**THE FIELD SKETCH**
Paint the field sketch to capture the colors and atmosphere: the effect of the cobalt sky upon the island, the water, and the values and colors in the distant trees. Make elementary changes that would improve the composition. For instance, since the island is on a plane horizontal to the picture plane, add interest and depth by pushing the right side of the island into the distance a bit. Focus on the rock patterns and cloud formations later in the studio.

**CROPPED FIELD SKETCH**
After analyzing my field sketch, I felt that there was too much foreground. To solve this problem, attach 1-inch (2.5cm) white artist's tape across the bottom of the sketch. This new elongated shape results in a lowered horizon line and a more interesting division of space.

## Problems with the field sketch

- Areas that command unwanted attention include the dark foreground reflections and the bright orange rocks.
- The sky is dull and boring.

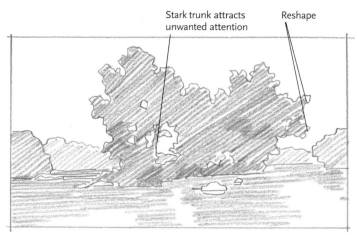

Stark trunk attracts unwanted attention

Reshape

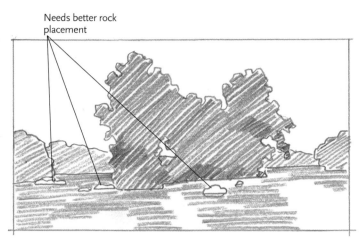

Needs better rock placement

## DESIGN SOLUTION: ADJUST CONTRAST AND FIX UNSIGHTLY TREE SHAPES

The right-hand tree is top-heavy and its shape directs the viewer's eye out of the painting. Introduce a graceful branch hanging over the water to move the viewer's eye back into the painting.

## DESIGN SOLUTION: ARRANGE A GROUPING OF ROCKS

Arrange the craggy rocks to guide the viewer's eye around the painting. Lead in with a large rock and zigzag back to others in various sizes and shapes on different planes. Remember to paint the rocks a cooler, more realistic color in the final painting.

## DESIGN SOLUTION: A DULL SKY NEEDS CLOUD SHAPES

Add a frothy cumulus cloud formation from another plein air sketch to enliven the boring sky. Angle the clouds to counterpoint the diagonal line of the islands. The two corners of the sky are now different, which gives movement to the painting.

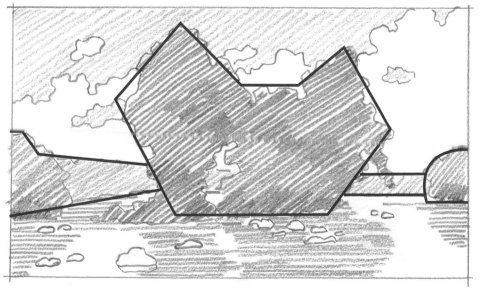

## FINAL PENCIL DRAWING

Make a final pencil drawing to incorporate the design decisions. The new rock formation brings the viewer's eye in from the right, across the dark reflections, back to the left bank and finally to the center of interest. The viewer's eye then travels across the trees, and the added graceful branch brings the eye back into the painting. The cloud formation adds the necessary interest and counterpoint.

# Painting Pointers

THE BLOCK-IN

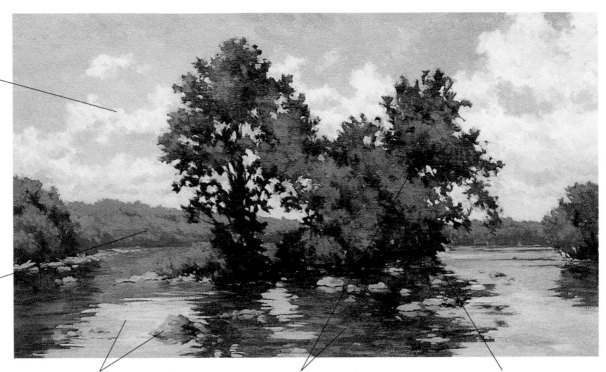

**Clouds and sky:** Rough in the clouds using white tinged with orange on the sunlit side and grays on the shadow side. Working down from the top, paint the sky using Ultramarine Blue and white, then Cobalt Blue and white, and finally Phthalo Blue and white. Near the horizon line, add a tad of Phthalo Green to the white.

**Background shadow areas:** Use a lighter blue-violet tone for the shadow areas on the far shorelines. Use a wipe-out tool to describe the rock formations in these shadow areas.

**Sky reflections and rocks:** Paint the sky reflections slightly darker and grayer than the sky itself. For the rocks, use a gray mixture of Ultramarine Blue, orange and white to harmonize with the other bluish tones in the painting.

**Trees and water reflections:** With a variety of middle-value gray-greens, fill in the trees by working into the wet shadows. Add the middle tones of browns and greens to the water reflections.

**Middle-ground shadow areas:** Dark red-violet tones define the shadows in the island trees and the reflections.

DEVELOPING THE TREES

Rework the trees, beginning with the darker values and working toward the lighter ones. Use a cool green of Ultramarine Blue, Cadmium Yellow Light, a tad of Quinacridone Red and another tad or two of white for the shadow areas. For the medium and light tones, vary the greens by judiciously adding white, yellow, orange and/or blue.

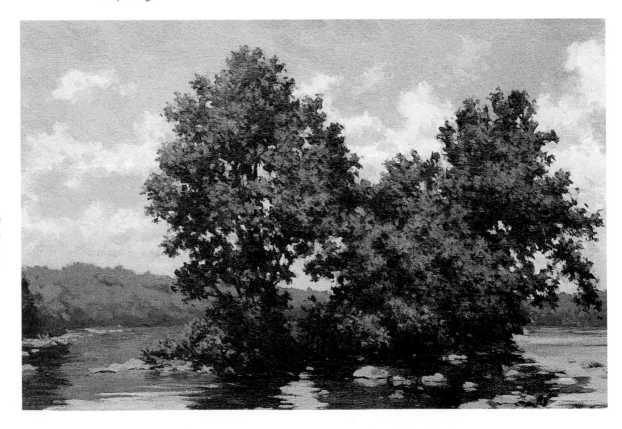

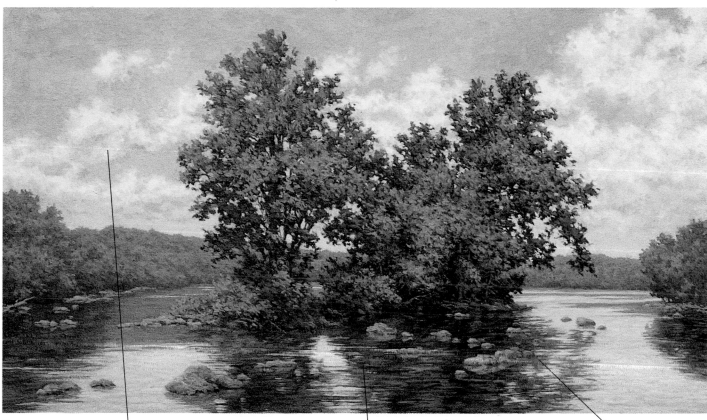

REFINING THE
CLOUDS AND
DEVELOPING THE
REFLECTIONS

Restate the clouds, removing any peculiar shapes like smiley faces, doughnuts or dragons flying through the sky. Keep the edges soft with bits of blue breaking up the cloud masses.

Make convincing reflections by adding a glaze of Burnt Sienna. This reddish tone hints of the riverbed and introduces some contrasting colors evident in the field sketch but not in the reference photos. Lighten the Burnt Sienna in some areas by adding Yellow Ochre and/or Cadmium Orange.

Work green tones into the Burnt Sienna areas with sideways strokes parallel to the picture plane. Add the sky reflections, working into the darker areas.

## Painting reflections

Understanding how reflections work is the key to painting them accurately. They are not perfect mirror images. The water "sees" only underneath planes and upright planes of objects, never their top planes. For instance, a barn reflection reveals the underpart of an eave that the viewer can't see, while showing less of a sloping roof that is on an angle between an upright plane and a top plane.

Keep these facts in mind when painting reflections:

- **Width:** Since the reflections come toward the viewer's eye, the outer limits of the reflection can be no wider than the object itself.

- **Length:** If the water is smooth, the reflection is the same length as the object being reflected. The choppier the water, however, the longer the reflection. Paint a choppy reflection as if it were broken into tiny pieces and splintered by shards of sky.

- **Value and color in the dark areas:** Since the sky casts its tone over the entire water surface, the dark reflections from trees become slightly lighter than the trees themselves.

- **Value and color in the light areas:** The water surface varies greatly depending on the weather conditions. When the water is calm the reflections are just a tad darker than the sky. When the water is rough, it has shadows that darken its value. Therefore, the rougher the water, the darker the water.

### PLACING THE BIRDS

Experiment with different bird arrangements by marking or painting on a piece of clear plastic wrap carefully taped to the painting. Try a variety of sizes and flying positions for interest. After you decide where you want them, paint the birds in various shades of dark gray: the smaller the bird, the more distant it is and the lighter it is.

### ROCKS IN THE WATER

Paint the rocks that lead back to the island and emphasize a variety of sizes and shapes. Accentuate their cragginess by using angular strokes. Also paint them cooler and grayer as they recede into the distance, displaying the influence of the atmosphere (atmospheric perspective).

### HIGHLIGHTS IN THE WATER

Break up solid areas of tree reflections with occasional streaks of light, indicating a slight wind current. Extend one horizontal streak off the edge of the canvas to add interest.

# The Finish

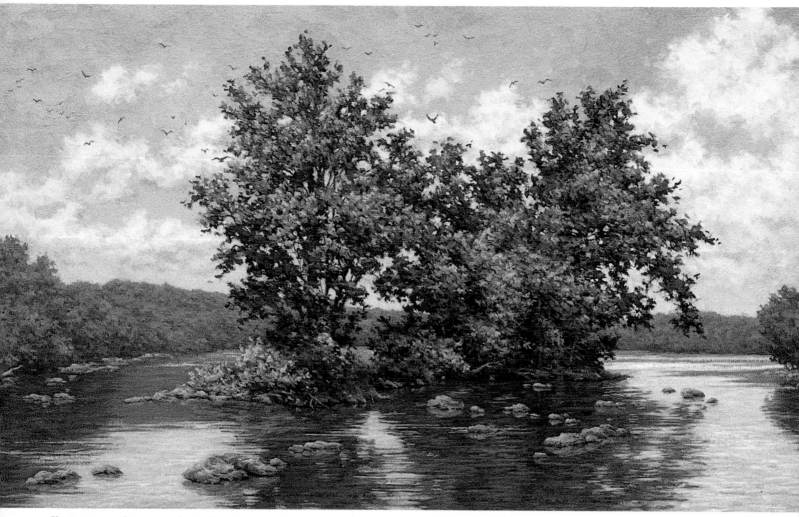

### KEEPING THE SYMMETRY LIVELY

Even though you use this balance scale format for a dominant center of interest, you also need to design the secondary areas of interest as well. Review the painting for structure and composition. Examine how the viewer's eye travels in and around the painting. With this painting, the viewer's eye first focuses on the large rock, zigzags back to the island rocks and journeys left toward the bank where a broken tree points to rocks along the distant bank. Then the eye travels to the large left-hand tree and up its branches, checks out the birds and moves to the right tree and down its side to the hanging branch, which brings the viewer's eye back into the painting.

**Island Refuge**
Oil on linen
18" × 30" (46cm × 77cm)

FORMULA

4

# THE
# U FORMAT

USE THE "U" FORMAT TO

FRAME THE CENTER OF

INTEREST WITH DOMINANT

VERTICAL SHAPES SUCH AS

TREES OR BUILDINGS THAT

ARE CONNECTED BY A

STRONG HORIZONTAL AREA.

On this November day, some painting friends and I ventured out to a nearby historic town to paint the remnants of another time and place. The day was windy and depressingly gray with threatening clouds. To stay out of the wind and occasional sprinkles, I chose a side street where I could park my car, open the rear hatch and paint under it for protection. From there, I could get a good view of this typical street corner and be out of the way of traffic. I prefer painting field sketches in oil, but often make the final painting in watercolor as I did here.

# Reference Photos

**GETTING THE VERTICALS**
Include the top of the left house and forget about the partially bare tree on the right. This shot will include more of the foreground.

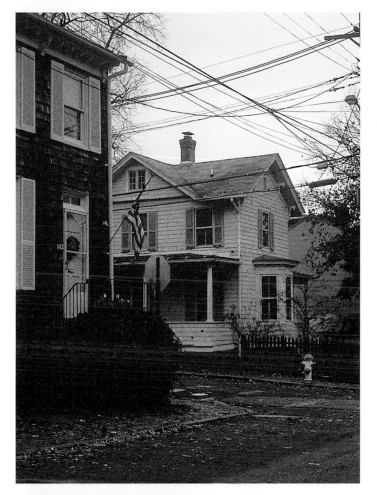

**SHOOT SIDEWAYS**
Turn your camera horizontally to encompass the partially bare tree. In this shot, ignore the top of the cedar shake house.

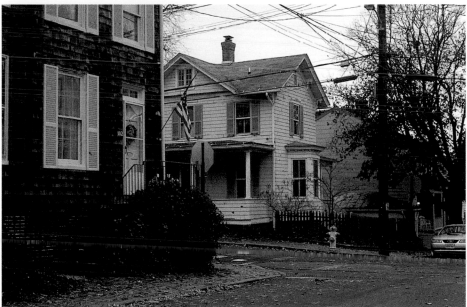

### FIRST VALUE SKETCH

A vertical format is an effective way to present a nontraditional landscape or cityscape, as in this case. Show the top of the cedar shake house to include the second-story window and roofline and include the flag. Retain the bare branches behind it to soften the jutting roof angle. Show just a few branches from the tree on the right.

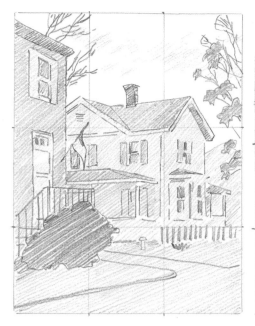

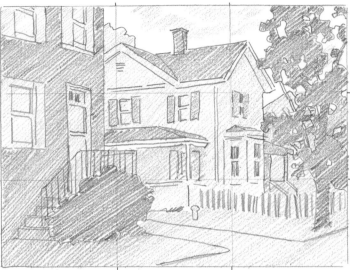

### SECOND VALUE SKETCH

Draw the second sketch in a horizontal format that will include more elements. Move the partially bare tree on the right to replace the stark telephone pole shown in the reference photo. Eliminate the wires, stop sign and distracting flag that obscures part of the white house façade. Elements such as flags, commercial outdoor signs, animals and human figures are obvious attention-getters and require careful consideration as to their purpose and placement in a painting. In this sketch, the flag only adds confusion. Substitute a leafy tree behind the cedar shake house for the twiggy one.

### THE FIELD SKETCH

Capture the gray mood of the day. Change the yellow fire hydrant to red for a bright color accent. The steps and railing leading into the horizontal format are more effective than in the vertical format where they are cropped off.

## Problems with the field sketch

Gloomy, gray and uninspiring are the main problems with this field sketch. The tree and house need more space and the entire gray, overcrowded sketch needs light and air.

# Create simple cast shadows

Effective shadow patterns can pull a painting together and link unrelated objects. Sometimes you may want to create new shadows or change existing ones into a more dramatic presentation. Learning this simple method of casting parallel shadows gives you the freedom to put them in your drawing or painting with confidence in their accuracy.

To get the shadows right, you must get the perspective right. Establish your drawing with its vanishing points on the eye-level line. The cast shadows will use these same vanishing points. If you are having trouble determining your eye-level line, try holding a straightedge against your nose so the top of it horizontally bisects your eye. Looking straight out in front of you, the top of this straightedge is the eye-level line where horizontal perspective lines converge at vanishing points.

Consult other sources for procedures for casting shadows coming toward you or going away from you, which are more involved than what you see here.

### STEP 1
Draw two boxes, revealing the hidden edges with dashed lines as shown. From the three bottom relevant points of each box, extend lines **A** parallel to the picture plane in the direction you want the shadows to fall.

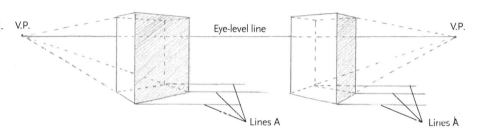

### STEP 2
Form three 45° triangles for the left box by extending lines **B** from the three relevant top points through lines **A** drawn in step 1. Do the same with the right box, only form three 60° triangles instead.

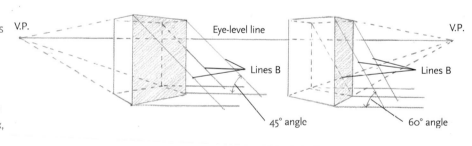

### STEP 3
Connect the intersections of lines **A** and lines **B** with new lines **C**. These lines will define the outside dimensions of the new cast shadows. Shade these new areas to complete the process.

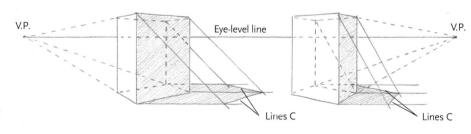

### DESIGN SOLUTION: INTRODUCE SUNSHINE

Elongate the sketch to give the white house and tree more space. Following the reference photos, refine your drawing and perspective.

Change the day to sunny by beaming rays of bright light onto the white house. Cast a strong shadow from the cedar shake house across the foreground to set up an effective "U" format with the partially bare tree on the right. The shadow edge crosses the street, goes up the curb, across the sidewalk, up the fence, and angles back to suggest the cast shadow from the rooftop. The white house now sparkles between the shaded areas, getting its deserved attention.

Enhance the lower right corner with a garden surrounded by a white picket fence. The cast shadow on the fence forms an arrow that points toward the garden and house. Continue the fence down the sidewalk on the right. Add a garage behind the fence and barely suggest other houses along the side street. Eliminate the fire hydrant, which is no longer necessary for a color accent.

Arrow shape

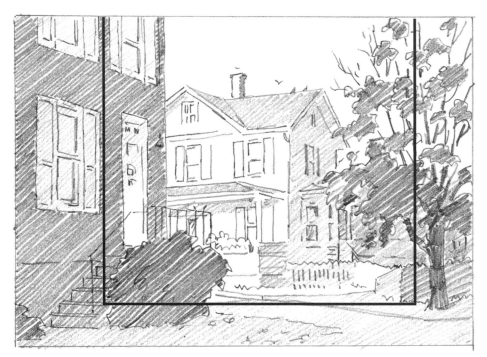

### FINAL PENCIL DRAWING

With the major changes made, work out the minor adjustments to clarify unresolved areas. Redesign the masses of foliage on the tree to overlap the house and add depth. Include more bare branches. Place a small bush in the lower left corner to help distribute the greens. Refine the picket fence, add a window box to the white house and include some birds flitting around the rooftop.

# Painting Pointers

### LAY THE BRICK AND SIGN YOUR NAME

Using your original pencil drawing as a guide, lay in perspective lines for the cedar shakes and bricks. To paint the bricks, shape your brush to form a chisel edge. Following the perspective lines, use one short stroke for each brick.

In this historic area, many homes have plaques designating them as such. To inconspicuously incorporate your signature into the painting, hang a brass plaque on the brick and carefully print your name on it. Adding shadows to the side away from the light and to the bottom of each letter will make the letters appear raised. You could also include the date.

### MIND THE DETAILS

Add small bare trees and fallen leaves to the garden area. Scatter more fallen leaves on the street and sidewalk as a reminder that it is a brisk November day. Increase interest with other details like a porch light and cheery, yellow autumn flowers in the white window box.

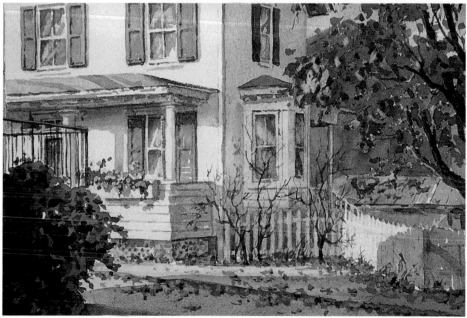

**TURNING GRAY INTO SUNSHINE**

The "U" shape effectively frames the sunlit area on this autumn day. The streak of sunlight brings the viewer's eye into the painting, and the shadow shape on the sunlit fence forms an arrow thrusting the eye back toward the house where the flower box adds a bright color accent. Scattered fallen leaves contribute to the feeling of the day. The wet-in-wet sky illustrates the typical changing weather patterns. The birds add a vital spark of life to the painting.

**Corner of Charles and Cathedral**
Watercolor
12½" × 17½" (32cm × 45cm)

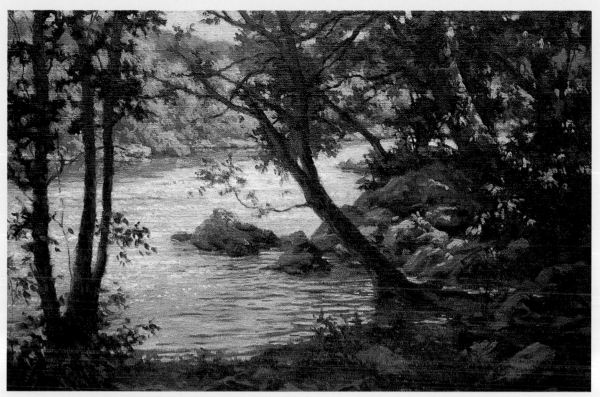

### Organize Assorted Trees Into the "U" Format

The mass of the dark trees on both sides of the painting and the dark shore at the bottom are more typical of the "U" format. Here, as in *Corner of Charles and Cathedral*, the dark area frames a sunlit one. In this painting, the rugged rocks lead the viewer's eye back toward the sunlit shoreline to give a peaceful scenic view.

**River View**
Oil on linen
12" × 16" (31cm × 41cm)

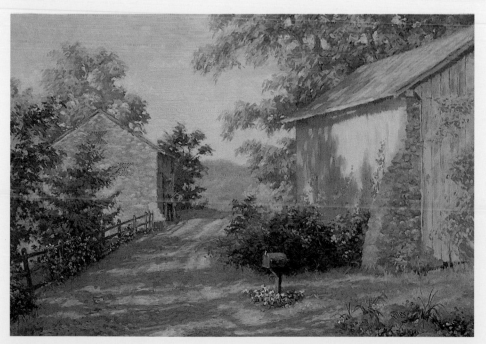

### Frame the Major Area of Interest

The green mailbox first attracts the viewer's eye, which then travels back along the lane toward the figure, the center of interest. Accurate atmospheric perspective gives convincing depth.

**The Green Mailbox**
Oil on linen
14" × 20" (36cm × 51cm)
Private collection

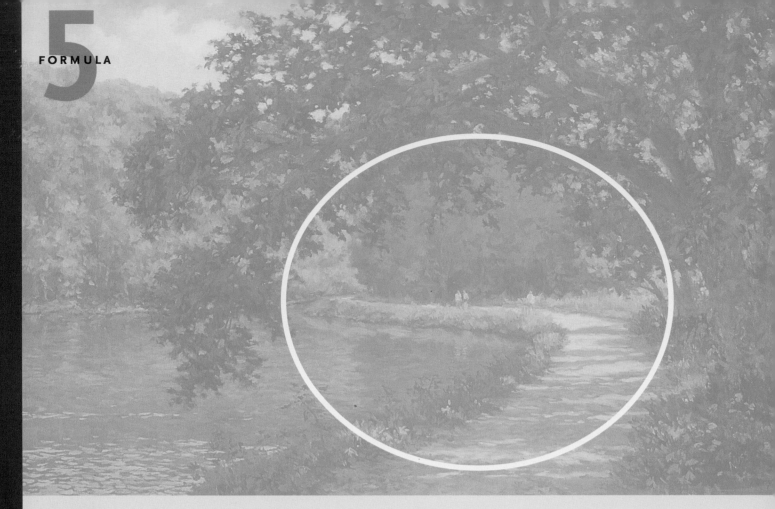

# FORMULA 5

# THE
# O FORMAT

USE THE "O" FORMAT TO
CIRCLE AN AREA OF INTEREST
AND BRING THE VIEWER INTO
AN INTIMATE SETTING, IDEAL
WITH SOME TREE FORMATIONS.

The Chesapeake & Ohio Canal National Historical Park that meanders 183 miles (295km) from Georgetown in Washington, D.C. to Cumberland, Maryland is my all-time favorite park for painting. Though the canal, begun in 1828, was considered obsolete by the industrial age's new railroad line that paralleled its route, the canal limped along in operation until 1924 when, after another frequent flood, it finally closed for good.

In 1954, Associate Supreme Court Justice William O. Douglas had the intelligence and vision to persuade the public to convert this overgrown relic of transportation into a diverse national park instead of paving it over for another regional parkway. The residents of the D.C. metropolitan area, and particularly those in the Maryland suburbs, have been forever grateful.

The park is a haven for hikers, runners, campers, dog-walkers, bird-watchers, fishermen, picnickers, bicyclists, canoeists, kayakers, trysting lovers and, of course, artists. Beside the towpath paralleling the canal, there are numerous overgrown paths branching off of it that lead to other scenic areas and to the Potomac River for expansive riverscapes.

After exploring several of these secluded paths with my painting companions without being considerably inspired, we trekked back to the towpath where we discovered this graceful old tree bowing to the canal. The tree's silhouette framing a bright sunlit area would provide the foundation of an effective composition without much editing. A rare occurrence!

Two views interested me: one closer in and one in the distance.

# Reference Photos

**THE WHOLE SCENE**
The straight overhanging branch and towpath will be redesigned in the field sketch for a smoother composition.

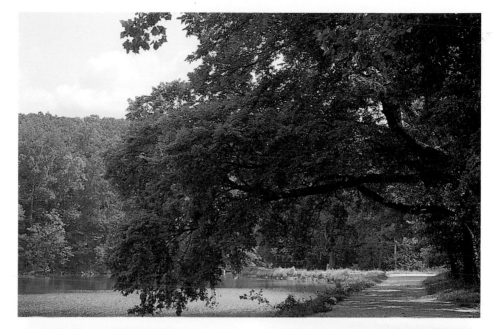

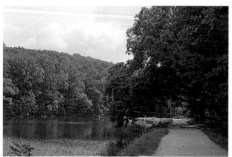

**STEP BACK FARTHER**
Take a photo that focuses on the bank of trees and rippling water.

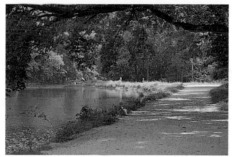

**MOVE IN FOR A CLOSER LOOK**
Include the detail of the towpath shadow patterns and the two tiny figures out for an afternoon walk, giving scale and interest to the scene.

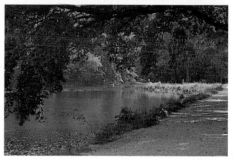

**PAN TO THE LEFT FOR THE DETAIL OF THE BRANCHES**
Photograph different water sparkles and the two figures in the background, which enliven the scene.

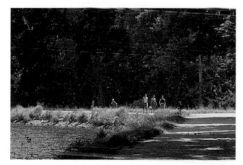

**ZOOM IN ON THE FIGURES**
Include distant figures walking along the towpath, which can animate the final painting.

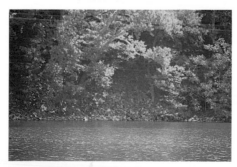

**DETAIL OF THE FAR SHORE**
Include a close-up of the shore of rocks and woods.

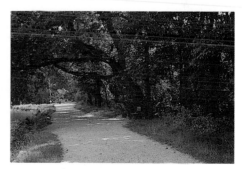

**VIEW INTO THE WOODS**
Examine the underbrush bordering the towpath for details of the tree trunk and surrounding area. As a bonus, the photo includes two more distant figures.

51

# First Sketches

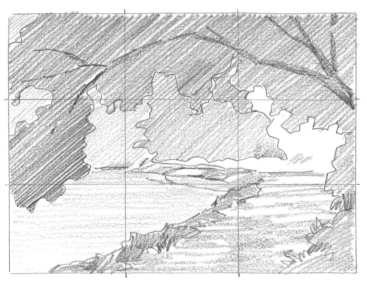

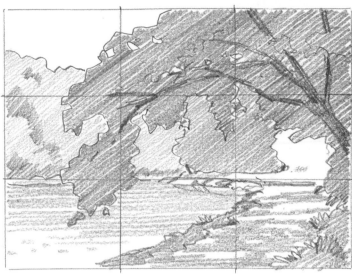

### FIRST VALUE SKETCH
Zoom in on the brightly lit middle-ground trees for the center of interest. Transform the heavy branch into a graceful curving shape to effectively frame this lively area of color.

### SECOND VALUE SKETCH
Back up about fifteen yards (13.5m) for a view to include the overhanging branch kissing the water and the sparkling water reflections. The warm sun-lit areas in the middle ground are an ideal spot for casual canal walkers.

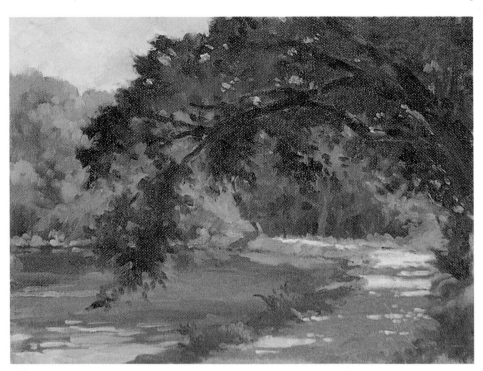

### THE FIELD SKETCH
Use a 9" × 12" (23cm × 31cm) canvas panel for the field sketch—the same proportion as the viewfinder. Curve the towpath to optically connect it to the overhanging branch. Silhouette the tree against the background with dark green-violet tones. Capture the cool shadow and sunlit colors as close as possible. Enliven the shadow patterns on the towpath with sparkles of sunlight.

## Problems with the field sketch

This basic "O" format effectively presents this scene, but small modifications would improve it.

- Including the underbrush and tree trunks would contribute interesting texture.

- Adding distant figures would add focal points along with the bright sunlit areas.

- Add richer shadow tones to the background trees.

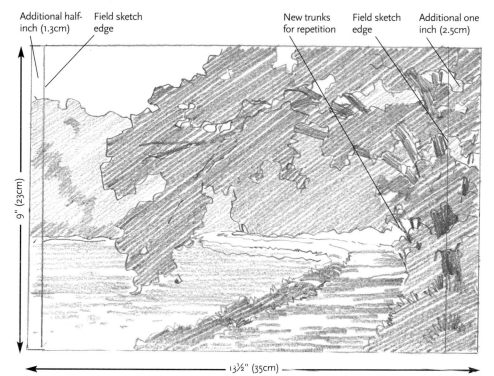

Additional half-inch (1.3cm)  Field sketch edge  New trunks for repetition  Field sketch edge  Additional one inch (2.5cm)

9" (23cm)

13½" (35cm)

## DESIGN SOLUTION: MAKE ROOM FOR THE UNDERBRUSH AND TREE TRUNK

My original field sketch was 9" × 12" (23cm × 31cm), but I chose a 16" × 24" (41cm × 61cm) canvas for the final painting. I determined with my proportion wheel that the new sketch needed to be 9" × 13½" (23cm × 35cm). I added a half-inch (1.3cm) to the left side and one inch (2.5cm) to the right side, allowing enough space for the trunk and underbrush.

## FINAL PENCIL DRAWING

Using the reference photos as a guide to relative size, arrange three figures in the distance for a focal point in the "O" formed by the branch and curving towpath. Show two figures together and a third walking toward them. In addition to adding a typical slice of towpath activity, the figures give the landscape a sense of scale.

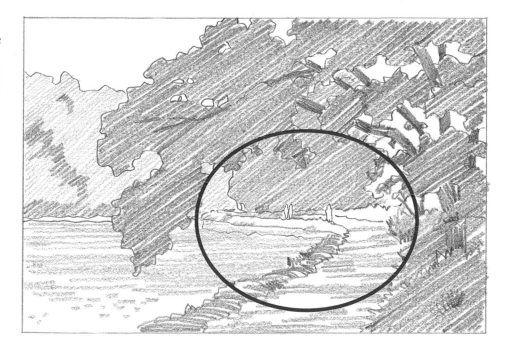

# Energizing Shadows With Rich Color

*This step-by-step demonstration of the "O" format illustrates how to enliven the shadow colors to make them vibrant and interesting. This is primarily a painting of shadows with a few spots of sparkling light, especially focusing attention on the figures.*

## MATERIALS

| | |
|---|---|
| SURFACE | Stretched linen canvas, 18" × 24" (46cm × 61cm) |
| BRUSHES | Robert Simmons filberts: nos. 8, 6, 4 and 2 ■ Winsor & Newton Monarch filbert no. 2 ■ Winsor & Newton Monarch round no. 0 |
| OILS | Cadmium Orange ■ Cadmium Red Light ■ Cadmium Yellow Light ■ Phthalo Blue ■ Phthalo Green ■ Quinacridone Red ■ Ultramarine Blue ■ White ■ Yellow Ochre |
| OTHER | Soft vine charcoal ■ Mahlstick ■ Cotton rags ■ Odorless turpentine ■ Liquin |

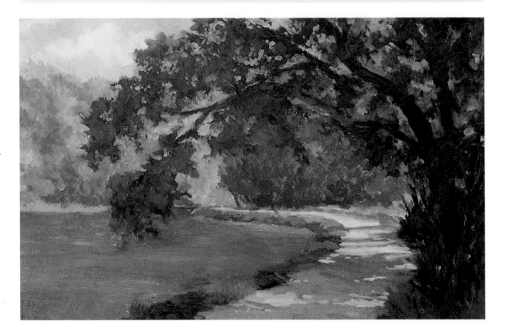

## 1 LAY THE COLOR FOUNDATION

Transfer your drawing to the canvas with soft charcoal. Ignore the figures for now. Solve the last problem of the field sketch by using rich violet and blue in the shadows on the distant banks, mixed with Ultramarine Blue, Quinacridone Red, a little Cadmium Yellow Light and white. Vary the color proportions for depth and variety.

On the silhouetted tree, use cool dark-green mixtures: Phthalo Green with Quinacridone Red; Phthalo Green with Cadmium Red Light; and Ultramarine Blue, Cadmium Yellow Light, Quinacridone Red and white. Describe the tree trunks and branches with a violet-brown (Phthalo Blue and Cadmium Red Light). Connect all the branches and limbs by lightly drawing through the foliage.

Paint the cloud shapes with a mixture of white and a tad of Yellow Ochre. With white and a tad of Phthalo Blue, paint the areas of sky around the clouds. Softly overlap the sky color into the tips of the trees in the far bank.

Using a no. 4 filbert and horizontal strokes, design shadow patterns on the towpath with a warm violet (Phthalo Blue, Cadmium Red Light and white). Make some shadow areas fairly solid interspersed with other areas with lots of spots of light. Fill in these remaining spaces where the sunlight is hitting the towpath with a light value of white tinged with Cadmium Orange.

Paint the large area of water a blurry and slightly darker version of the banks that it reflects using similar colors. Do not include the sky highlights at this point.

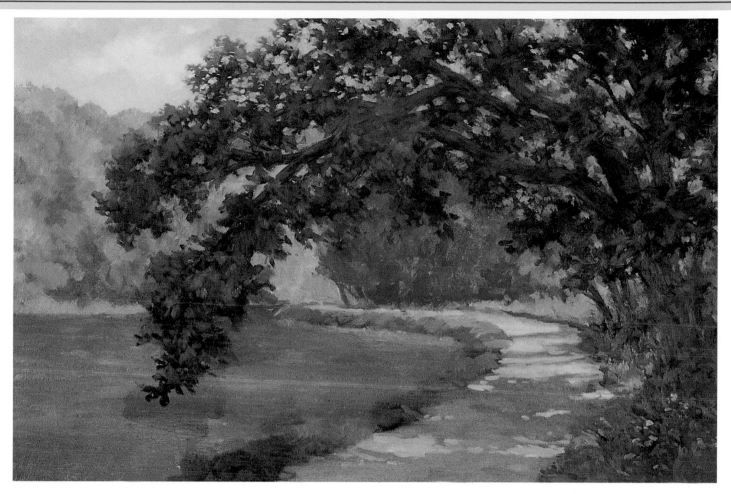

## 2 DEVELOP THE TREE AND FOREGROUND FOLIAGE

Working from dark to light, paint the tree—the darkest element—as completely as you can. Restate the trunks and the branches with the same violet-brown made with Phthalo Blue and Cadmium Red Light. Paint the medium dark values in the foliage with the same combinations used in step one, but save some of the deepest darks from step one for accents.

The lighter surfaces of foliage and branches receive reflected light from the sky, the water and the towpath. Cool the tops of the branches where they receive light from the blue sky by adding a whisper of white to the green mixtures. With a hint of Cadmium Orange, warm the underneath sides of the branches where they receive reflected light off the towpath.

Camouflage confusing intersections or distracting patterns of branches and trunks with strategically placed foliage. Beware of distracting X's where the branches naturally cross each other. Before the foliage dries, restate the clouds with soft edges and eliminate the striped sky shape separating the two clouds. Then paint the remainder of the sky and the sky holes, blending the sky color into the edges of the tree. The smaller the sky hole, the darker it should be. Paint bright spots of sunlit foliage peeking through the tree and scattered spots on the grasses along the towpath. Begin to develop the foreground underbrush and suggest a few colorful wildflowers.

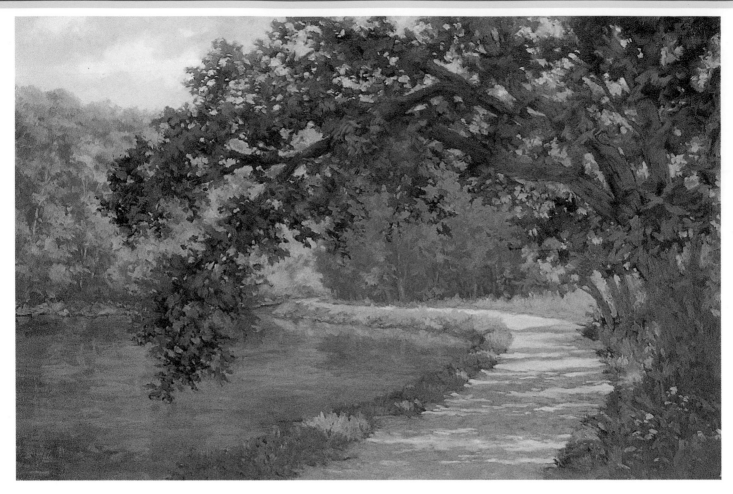

### 3 DEVELOP THE REST OF THE PAINTING

Adjust and refine the colors in the left bank using cool greens in combinations of Phthalo Green, Phthalo Blue, Quinacridone Red, yellow and white to define tree shapes. In the shadow areas, use rich violets of Phthalo Blue and Quinacridone Red and/or Ultramarine Blue and Quinacridone Red varied with yellow and white. Suggest a few tree trunks amid the foliage. Work a few rock shapes into the shadows along the water's edge by adding white and a tad of orange to the shadow colors.

For the middle-ground trees on the right, use primarily violets made with Ultramarine Blue and Quinacridone Red, warmed with tads of yellow and white to define tree shapes. Using the same colors you used for the background and middle-ground trees, restate the water with broken strokes of color, following the shadow and light areas of the trees as a pattern for the reflections. Use no. 2 filberts with little horizontal strokes to indicate slightly rippled water. Reflect a few rocks and tree trunks into the water.

Continue developing the foreground area of underbrush up and around the main tree trunk, adding blades of grass and assorted weeds. Develop the towpath with cooler spots of color in the shadow areas using combinations of Phthalo Blue, Cadmium Red Light and white. Allow a few of the previously-painted warmer spots to show through for variety.

Have fun with the scattered spots of light on the towpath, and add some lighter areas with orange and white. Indicate a few dry leaves for a touch of naturalism and wildflowers to sprinkle color into the underbrush.

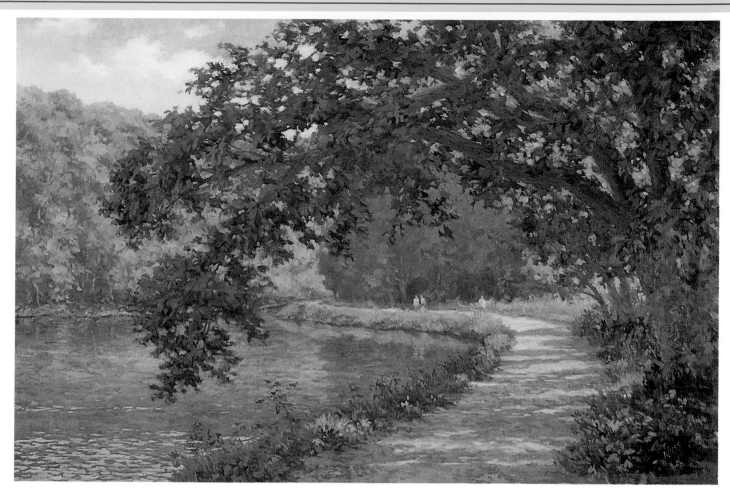

## THE FINISH

4 Once the paint is dry, brush a light coat of Liquin on the water area to prepare it for the sky reflections. With a color that is just a tad darker than the sky, use small horizontal strokes, using one of the photos as a guide. Complete this foreground area with grass and weeds along the textured towpath. Lightly paint three small figures on the towpath. Check your reference material for their relative size. No detail is required—just a few accurate color strokes will say it all.

Refine the color of the sky just above the trees making it grayer with a Phthalo Blue, Cadmium Red Light, and white mixture. Brighten the blue above the clouds with spots of a mixture of Ultramarine Blue and white. For better value contrast, lighten some of the reflections behind the large branch.

The towpath serves as a strong entrance into this painting. The viewer's eye wanders in from the left and follows it to the arching tree trunks. They, in turn, point the eye in a circular direction along the large arching branch toward the foliage kissing the water. A small branch grabs the eye and returns it to the towpath, where it ultimately rests on the figures in the background. The "O" format allows movement and rhythm while effectively framing the entire center of interest.

The variegated shadows on the towpath, the various textures in the underbrush and the sparkly reflections on the water entertain the viewer on the journey. Warm, sunny highlights and cool shadows convince the viewer of a hot summer afternoon along the canal.

**Afternoon on the Towpath**
Oil on linen
16" × 24" (41cm × 61cm)

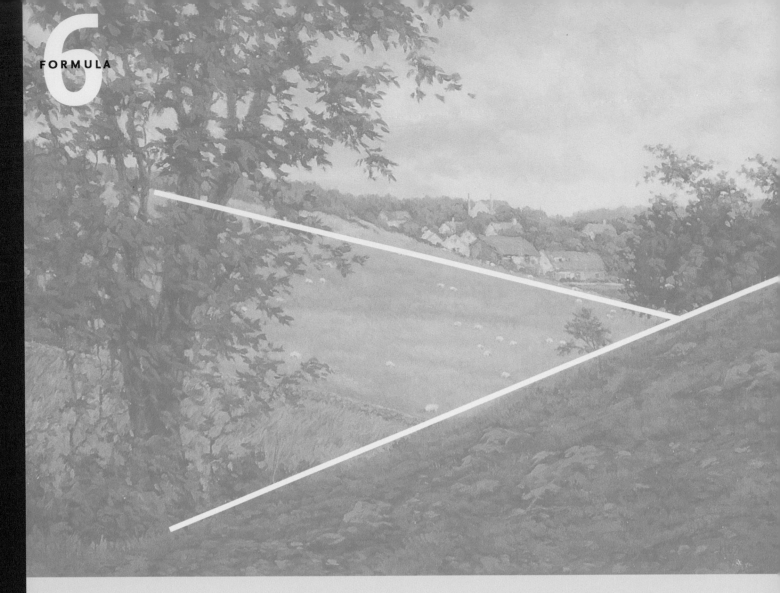

# THE
# DIAGONAL
## FORMAT

USE THE DIAGONAL FORMAT FOR A SCENE IN
WHICH A STRONG SLANTED SHAPE, SUCH AS A
MOUNTAIN, CLIFF OR ROCK FORMATION, IS
BALANCED BY AN OPPOSING SLANTED SHAPE.

While visiting England, my husband and I braved the rugged
Mountain Goat tour along a narrow, precarious trail into the scenic
Lake District. I had no idea what views to expect in this landscape
full of craggy hills and expansive lakes.

Even though this day was typically overcast, I held the camera in
my hands, telephoto lens and all, ready to shoot at an instant's
notice. Occasionally the driver pulled to the side of this one-lane
path to allow another vehicle to pass. At one of these moments, I
caught this dramatic scene: a little village tucked into the sharp
rocky hillsides teeming with sheep. Click! One shot and it was out of
my sight forever.

The diagonal hillsides and the village form the basis for this
strong composition. During my stay in England, I photographed
other villages used here as supplemental reference material. These
and other photos gave me valuable information. The foreground
would require editing and redesigning, however, to make the paint-
ing successful.

# Reference Photos

**MAIN REFERENCE**
Catch the basic scene in the instant of the camera's quick shutter.

**SKY INSPIRATION**
Borrow rainy-day clouds from a previous field sketch.

**LANDSCAPING INSPIRATION**
Use a bush from another English tree.

**ADDITIONAL REFERENCES**
Photograph other English villages for details and inspiration.

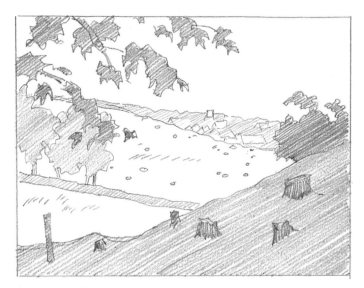

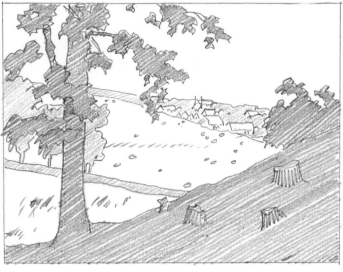

## FIRST VALUE SKETCH

In the first sketch, open up the area around the village. Eliminate the road sign, telephone pole, fence and large foreground tree. Spread out the village into this new space by adding some more houses in a random pattern, snuggling them into the trees. Substitute the elegantly spired church from a reference photo for the one in the original photo.

Include graceful branches from an unseen tree to frame the village. Add a few tree stumps, which are barely discernable in the photo, to the sharp, shaded hillside. Reshape the bushes on the right into a stop that points the viewer's eye back into the painting.

## SECOND VALUE SKETCH

Reintroduce the large tree trunk. Add some branches and foliage to soften its shape. Add one long, overhanging branch as in the reference photo. The big problem with this sketch is that the tree trunk resembles a telephone pole. It is the area of greatest contrast and thereby attracts undue attention.

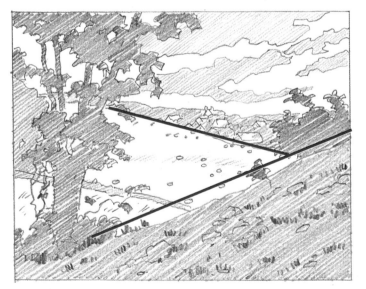

## DESIGN SOLUTIONS AND FINAL PENCIL DRAWING

Adjust the final size to fit a 14" x 18" (36cm x 46cm) canvas. Simplify the background tree shapes, unifying them into one gray-green mass. Add a distant hill for balance.

From the previous value sketch, replace the angular tree stumps with softer-shaped rocks to help move the gray color around the painting. Increase the amount of foliage around the tree trunk and put some bushes in front of it to soften the shape.

Include a rainy-day sky to add interest to the otherwise boring, overcast day.

## Problems with the second value sketch

In this case, no field sketch was done on location, so evaluate the second pencil sketch.
- The silhouetted tree is still too stark against the fields of grazing sheep.

- The foreground would benefit from some softer shapes and more grass and weeds. The tree stumps are too angular.

For interest in your paintings, you may want to introduce repetitive elements. This may include sheep (as in this painting), cows, birds, puffy clouds, flowers, fence posts, trees, rocks, people and so on. As a guide to an artistic presentation, use odd numbers, like three, five or seven. When the elements are not easily counted at a glance, the number becomes irrelevant.

Randomly group the elements with natural variety in mind. For convincing perspective, make some larger in the foreground and some smaller in the middle ground and background. Clump several together and then let one or two stand on their own. Consider the negative spaces and keep them interesting.

**This**

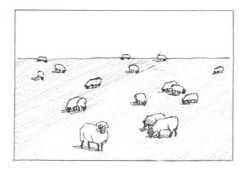

**Not This**

### SCATTER SHEEP IN THE PASTURE

Face grazing animals in different directions, including an occasional frontal pose. With birds, include some gliding around in different phases of the flight pattern and some that have already landed. With geese or ducks, it's fun to have one diving in the water for food with its tail feathers sticking straight up in the air.

**This**

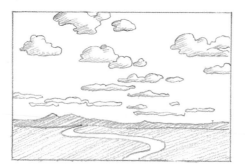

**Not This**

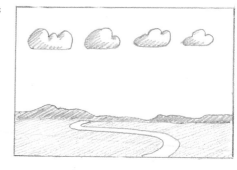

### ARRANGE PUFFY CLOUDS

Repetition appears in nature from time to time. Depending on weather conditions, similarly shaped clouds sometimes line up across the horizon like marching cotton balls. Rather than paint a static arrangement, vary the cloud shapes and sizes and let at least one bleed off the top and another off a side.

**This**

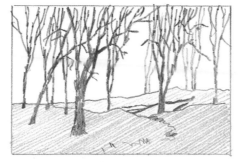

**Not This**

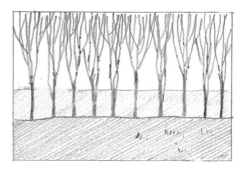

### ORGANIZE A NUMBER OF TREES

You may see cultivated trees lined up like soldiers standing at attention along a ridge. Reorganize them into interesting clusters and vary their sizes. Have one dominant tree, add broken branches to others and place a fallen one on the ground.

# Painting Pointers

## USE SUBTLE GREENS TO PORTRAY CONVINCING DISTANCE

Differentiate the foreground, middle ground and background that are all under a gray sky with various shades of subdued greens. There is an abundance of moisture in the air that affects the values and colors more on an overcast day than on a sunny, crisp day.

This is a logical place to use your value 5 and value 7 pre-tubed grays. Combine Ultramarine Blue, Cadmium Yellow Light and white for your basic green color. To this, add pre-tubed gray to achieve the desired subtle effects.

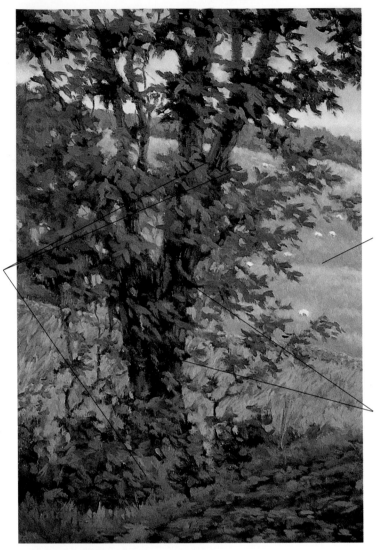

Add grasses and leaves in lighter, cooler greens.

Gray the greens more as they recede into the distance. The more moisture in the air between you and the background elements, the grayer these elements will appear. The moisture lightens the darks and darkens the lights. Save the strongest darks for the foreground.

In the foreground, contrast the background gray-greens with darker values on the trunk and surrounding foliage. For the darkest darks, use a combination of Phthalo Green with Quinacridone Red, Burnt Sienna or Cadmium Red Light.

## FOCUS ON THE BACKGROUND INTEREST

The moisture in the air not only grays distant elements but softens their edges as well. With blended areas and lost edges, paint the village houses and church. To distribute the grays, add some other houses and surround them with trees to suggest the hilly terrain. Paint the white houses light gray and paint the black windows dark gray.

Keeping the effect of the moist atmosphere in mind, paint the sheep on the hillside with little detail. Scatter them in a natural random pattern and reduce them in size as they recede into the distance. Use the reference photo for guidance.

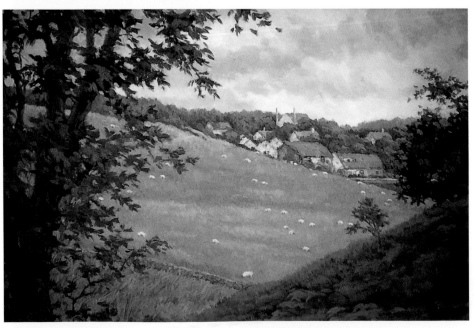

# The Finish

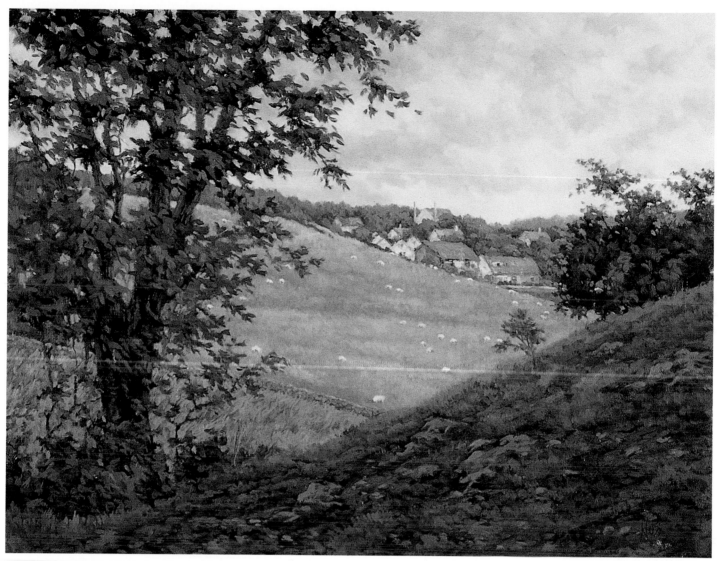

## ADDING THE ATMOSPHERE OF A RAINY DAY

The dynamic diagonals of this typical English hillside effectively portray a rainy-day mood and a quiet sense of place. The viewer's eye enters from the left, initially attracted by the softened value contrast between the tree and the reddish-brown grasses behind it. The viewer's eye then follows the contour of the steep hill up toward the large bushes which stop the eye and direct it back toward the village and the grazing sheep. It then travels down the tree and begins the process again.

In this painting as well as in the following two examples of the diagonal format, the diagonal lines form an arrow pointing to the right. In all three paintings, there is a stop or other design element on the right to prevent the arrow from leading the viewer's eye out of the painting.

**Along the Mountain Goat Trail**
Oil on linen
14"×18" (36cm×46cm)

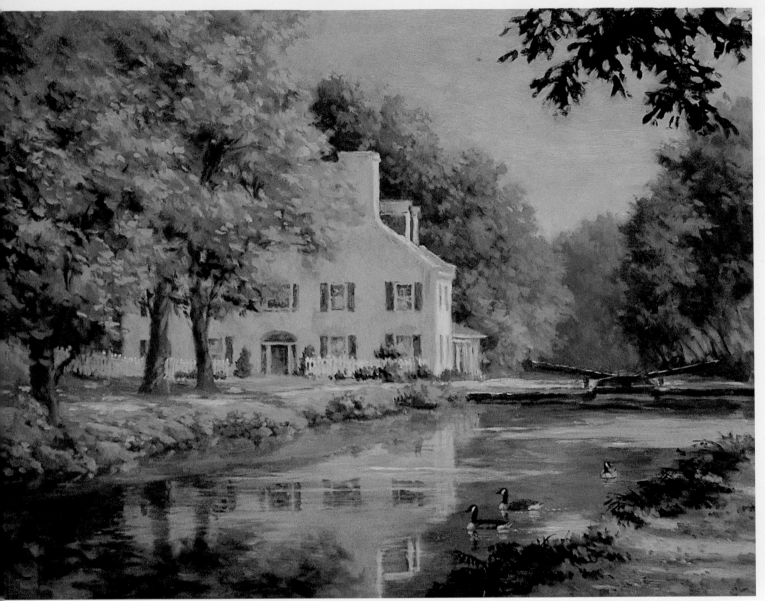

**USE THE ANGLE CREATED BY A DIAGONAL TO DIRECT THE VIEWER**

This painting along the canal began as a field sketch and was finished in the studio. The strong angled direction of the canal counterpoints with the angle formed by the tavern and adjacent trees. These diagonals form an arrow that points to the closed lock in front of the tavern. The lock's left swing arm then directs the viewer's eye back toward the tavern. The familiar resident geese swimming in the canal contribute to the character and atmosphere of this historic tavern.

**Tavern in June**
Oil on panel
11" × 14" (28cm × 36cm)

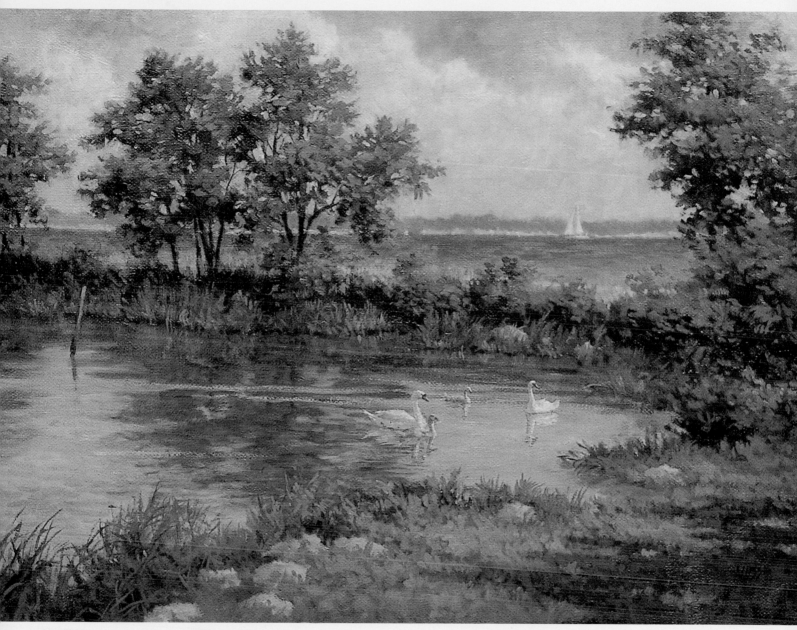

## USE DIAGONALS TO FRAME THE CENTER OF INTEREST

On this bay inlet where the swan family enjoys their afternoon swim routine, the oblique shorelines of the inlet form the basis of the composition. The distant shoreline and sailboat suggest an aquatic atmosphere without distracting from the strong diagonal format.

**Family Outing**
Oil on linen
12" × 16" (31cm × 41cm)
Private collection

# THE
# PATTERN
## FORMAT

USE THE PATTERN FORMAT WHEN

THERE IS NO DISCERNIBLE FOCAL

POINT IN A PANORAMIC SCENE.

On painting trips away from home, I am challenged by a variety of weather conditions, many of which are less than ideal. Despite the gloomy, windy weather that was present on this day, the low hills and distant mountains gave me the opportunity to capture the subtle color variations in the hills as they receded into the distance. With no definite center of interest, using the pattern format with interlocking shapes would effectively emphasize the numerous colors and textures in the landscape.

The ever-changing sky and clouds were indicative of the prevailing winds. The challenge was to paint a moody painting, not a depressing one, without being blown away.

High winds are probably the most adverse weather condition a landscape painter can endure. Some painters weigh down their easels with sandbags and secure everything else with large clamps or bungee cords. Others just give up. On this particular day, though, I was fortunate to be able to view the scene from under my car's open hatch door, giving me some protection from the wind and occasional raindrops.

## MAIN REFERENCES

Photograph the basic scene to capture the essence of the rolling countryside with its various patterns in the hills and mountains.

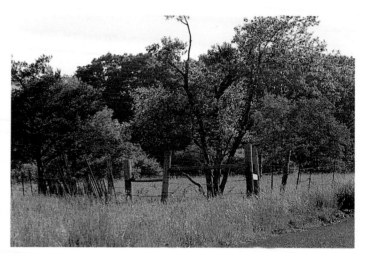

## LOCATE SUITABLE FENCES

Photograph some rustic wooden fences to consider for the final painting. The fence must not only contribute to the overall mood of the painting, but also be a compositional tool to control the viewer's eye.

# First Sketches

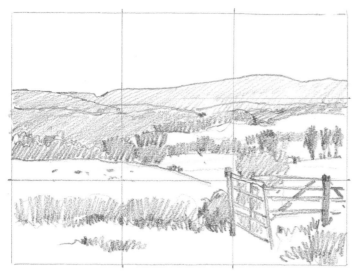

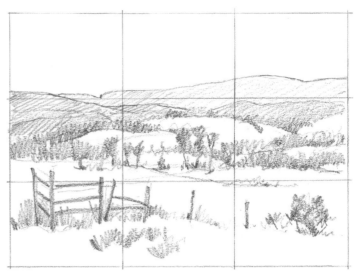

### FIRST VALUE SKETCH

Sketch the scene including the rusty cattle fence in the lower right corner. This old fence adds depth to the scene and interest to the foreground area. Its straight lines contrast with the roundness of the hills. With its industrial appearance, however, this fence detracts from the character of the rural scene and needs to be replaced.

The straight line of the foreground underbrush running parallel to the picture plane impedes easy access to the painting.

### SECOND VALUE SKETCH

Imagine a weathered fence as a replacement. Try it in the lower left corner as a lead into the painting. Use the shrub on the right as a stop to prevent the viewer's eye from leaving the painting. These changes correct the problems with the first value sketch, making it a better design. Transfer the gridded sketch onto the painting panel for the field sketch.

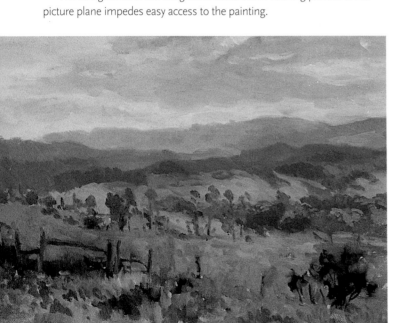

### THE FIELD SKETCH

Since the pattern format has no obvious center of interest, the objective is to capture the effects of atmosphere upon the landscape and the subtle differences of light upon the receding grass, trees and hills. Color accuracy is critical since the reference photos won't capture these slight variations. Carefully compare color swatches for accuracy in hue and value.

Use various combinations of Phthalo Green, Quinacridone Red and white to paint the back mountains and hills. Extend the revised weather-beaten fence off the left side of the painting. The fence provides direction for the viewer's eye as well as a foreground element. Since the sky and clouds are changing minute by minute, capture a composite of windy cloud formations.

## Problems with the field sketch

- The green fields are monotonous and should have more variety in texture and color. They need to interlock and counterpoint one another to indicate a clear sense of foreground, middle ground and background.

- The cloud shape is unappealing and needs to be designed to work well with the other shapes.

- The challenge is to delight the viewer's eye by changing the mood from gloomy to restful and appealing.

# Solve Design Problems and Finalize Your Composition

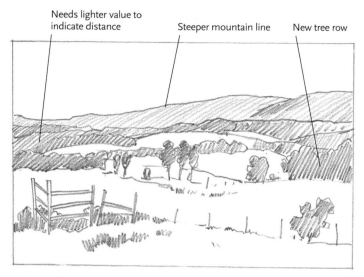

Needs lighter value to indicate distance

Steeper mountain line

New tree row

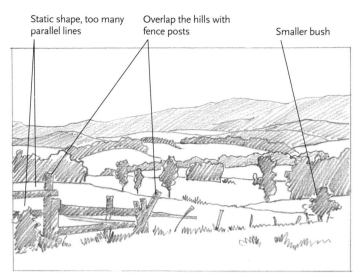

Static shape, too many parallel lines

Overlap the hills with fence posts

Smaller bush

## DESIGN SOLUTION: EXPAND THE HORIZONTAL

Elongate the field sketch to emphasize a tranquil feeling. Either reduce the area allocated for the sky or add onto each side of the sketch. For the latter option, the reference photos provide adequate information. This solution retains the pleasant division of space of one-third sky and two-thirds land. Move the bush, used as a stop, farther to the right and add a tree row above it that will organize the scattered trees and add variety.

## DESIGN SOLUTION: ORGANIZE THE JUMBLE

Revise the mountain lines and rearrange the hills for better interlocking shapes. Clump more trees together and eliminate others to allow better paths through the painting. Try using a fence reversed from the reference material. March the fence posts back toward the small bush silhouetted against the light field for depth and a clear path for the viewer's eye.

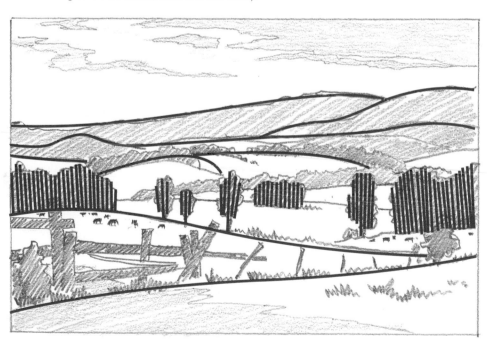

## FINAL PENCIL DRAWING

Add a cloud shape running counterpoint to the mountains. Develop a darker area of tall grass in the foreground to add drama and direct the viewer's eye to the middle ground.

To suggest the character of the countryside, add some cattle grazing on the fields. These little details surprise and delight viewers and contribute to a sense of place.

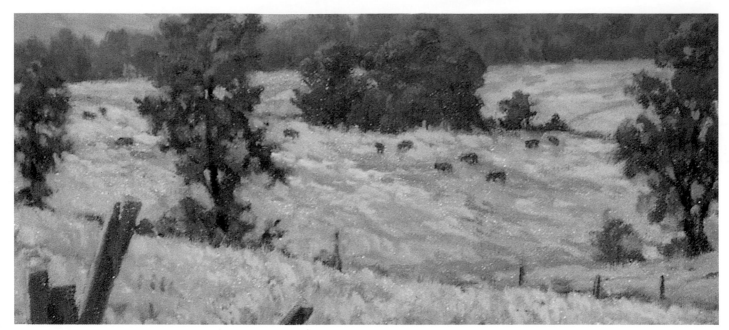

### PLACING THE COWS

In the final pencil drawing, there were cows on two separate side fields. Try out different positions by painting them on clear plastic wrap and laying the wrap over the dry painting. From a variety of arrangements, see what looks best. A simple placement of just a few cows on the center field is sufficient to suggest human presence without being distracting.

### ADD COLOR ACCENTS

Suggest an array of wildflowers in the foreground in a variety of color clusters. The flowers should be painted indistinctly, not accurately enough for botanical identification. The idea is for the viewer to remark, "Oh, wildflowers," not "Look at the buttercups, daisies and Queen Anne's lace!"

# The Finish

## EXPLORING THE MOOD OF AN OVERCAST DAY

Though the sky casts a silvery light over the entire landscape, warm colors are essential to contrast with the cool blues and grays of the mountains and distant hills. Paint several fields a reddish color, considering the effects of the atmosphere. The warm colors of the flowers and the reddish hills add the necessary punch to the painting.

Through careful planning of the painting elements and making the trees, hills and mountains the right value and color, the viewer's eye easily flows through this painting. The rugged old fence points the way to the moody patchwork panorama that was transformed from an uninspiring field sketch.

**Mountain View**
Oil on linen/panel
16" × 24" (41cm × 61cm)

EDIT A LANDSCAPE TO ELIMINATE UNINTERESTING AREAS AND TO
INCLUDE MORE PATTERNS

After exploring high elevations to view some distant mountains, I discovered this apparently deserted farm, which was owned by a man named Richard. With his permission, I was able to see the mountains in many directions from his land. *Richard's Farm* is a composite of three vistas with large chunks of boring forest deleted. The result is an interesting array of receding fields with some houses, barns and a distant town suggested in the foothills.

**Richard's Farm**
Oil on linen
20" × 36" (51cm × 92cm)
Private collection

## A Foreground Cloud Shadow Accentuates Numerous Patterns in Early Sunlight

This scene, which is less than two miles from my home, exemplifies the rolling hills of this rural area. By putting grazing sheep in shadow in the foreground, the highlighted middle ground becomes the primary area of focus. There the viewer's eye explores the various textures of the corn fields and irrigation pond that are home year-round to hundreds of Canadian geese. The distant buildings add further areas of interest to charm the viewer.

**July Fields**
Oil on linen
16" × 28" (41cm × 72cm)
Private collection

# THE
# S FORMAT

USE THE "S" OR "Z" FORMAT

TO WEAVE A ROAD, STREAM OR

TRAIL THROUGH A SCENE,

BECOMING THE PATH

THAT THE VIEWER'S EYE

FOLLOWS INTO A PAINTING.

I love summer, and this beautiful day in the mountains displayed the vast palette of colors and values that tickle my creative nature. The bright yellow flowers added the strategic color accents. With so much available subject matter, the challenge was what to include as well as what to leave out.

I wanted to paint the mountains, hills and nearby fields as well as the bright yellow flowers. I wanted a clear view of the panorama without heavy foliage obscuring it. Because the arrangement of the trees would require so much editing, I took that problem back to the drawing board.

# Reference Photos

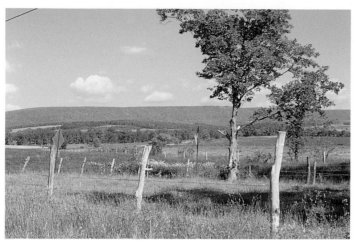

**OVERALL SCENE**
Overlap photos for a wide-angle view with trees, shadows and the basic panorama.

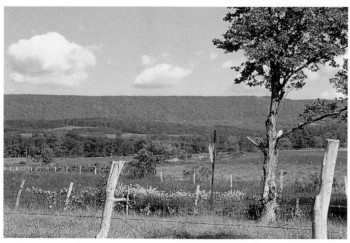

**CHECK OUT DIFFERENT DIRECTIONS**
Photograph a different view of the mountain and some passing clouds.

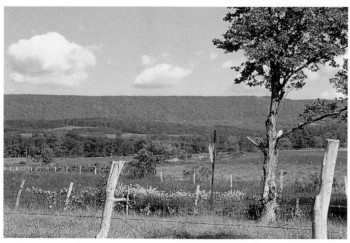

**ZOOM IN FOR DETAILS**
Take a photo focusing on the tree trunk, fence posts and flowers.

# First Sketches

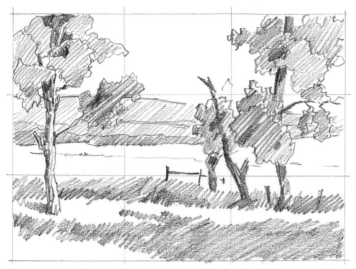

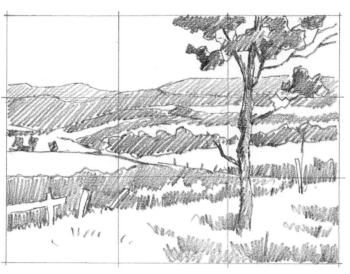

**FIRST VALUE SKETCH**
Sketch the trees to frame the panorama and include the jagged shadow pattern in the foreground. This arrangement is effective, but not for an extensive view of the hills and mountains. They are mostly obscured by heavy foliage, which defeats the purpose of the painting.

**SECOND VALUE SKETCH**
Use just one tree—the left one in the first value sketch. Interlock some distant mountains at different angles to eliminate the static, horizontal mountain shape in the first sketch. Enlarge the nearer hill to introduce a middle layer of interest.

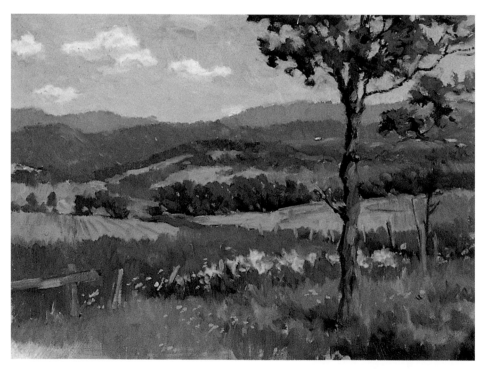

**THE FIELD SKETCH**
First, lay in the darks of the tree trunk and foliage and establish the location of the yellow flowers. Then paint the sky, mountains, distant hills and middle ground around these shapes without diluting their colors and values. Intersperse the green fields with orange ones to break up the monotony and add complementary color notes. The challenge is to paint all the layers of the scene in convincing atmospheric perspective, differentiating between the myriad of greens in the countryside as they recede into the distance.

## Problems with the field sketch

- The fence looks contrived and the tree resembles a telephone pole.

- The yellow flowers are too centered. For a more natural look, extend them to one side and scatter them into the grass.

Good value contrast    Effective shadow pattern    New fence posts    Panorama is more visible

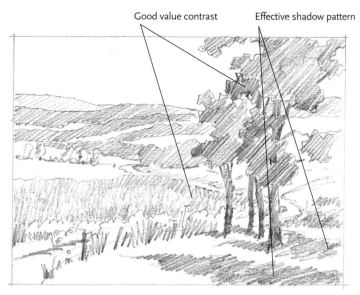 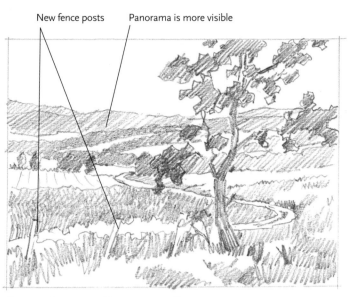

**DESIGN SOLUTION: EDGE THE SCENE WITH TREES**
Try using the trees from the first value sketch but eliminate the lone tree on the left. These dark trees offer a striking comparison to the broad expanse of countryside, but the trunks are too vertical and the foliage is too dense.

**DESIGN SOLUTION: REPLACE THE TREES**
Design an old weathered tree with sparse foliage. In the lower right corner, keep the jagged shadow pattern cast from the unseen trees out of the picture. Weave a road alongside the flowers to emphasize the "S" format, which gives a strong thread to the painting.

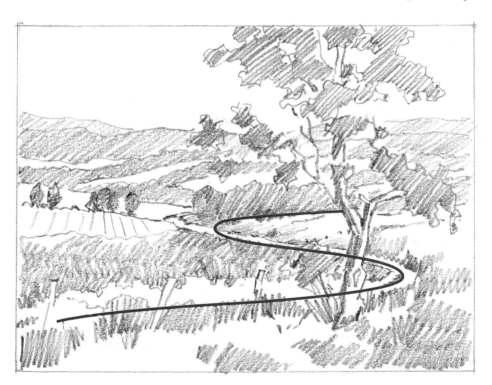

**FINAL PENCIL DRAWING**
Place a piece of tracing paper on top of the previous sketch. Trace just the tree, flip the paper over and then trace the rest of the sketch. This reversed tree, now facing into the painting, effectively frames the scene and keeps the viewer's eye involved in the landscape. Extend the road to the left and redraw new fence posts next to it.

# Painting the Greens of Summer

*This step-by-step demonstration of the "S" format will focus on painting numerous greens and other summer colors in a landscape. Green can be an overwhelming color, and it is important to treat the greens in a variety of temperatures, intensities and values. Make color charts similar to the ones on the next page.*

## MATERIALS

| | |
|---|---|
| **SURFACE** | Stretched linen canvas, 18" × 24" (46cm × 61cm) |
| **BRUSHES** | Robert Simmons filberts: nos. 8, 6, 4 and 2 ▪ Winsor & Newton Monarch filberts: no. 2 ▪ Winsor & Newton Monarch round no. 0 |
| **OILS** | Cadmium Orange ▪ Cadmium Red Light ▪ Cadmium Yellow Light ▪ Phthalo Blue ▪ Phthalo Green ▪ Quinacridone Red ▪ Ultramarine Blue ▪ White ▪ Yellow Ochre |
| **OTHER** | Soft vine charcoal ▪ Mahlstick ▪ Cotton rags ▪ Odorless turpentine ▪ Liquin |

### 1 BLOCK IN THE DRAWING

With charcoal, transfer the new drawing onto the canvas. First, paint the darks with a purplish brown mixed with Phthalo Blue and Cadmium Red Light while wiping away the charcoal drawing. Draw the lighter areas using the same mixture with a light touch or use a blue-gray middle tone.

### 2 LAY IN THE COLOR FOUNDATION

Following the colors of the field sketch and working from dark to light, mass in the various areas with no. 4 filberts. Paint all the colors slightly darker than the intended final color. Leave the dark-brown tree trunk as is.

Keep the greens unobtrusive or they will overwhelm the entire painting. Paint the background mountain a cool blue-gray mixed with Phthalo Green, Quinacridone Red and white. Gradually add Cadmium Yellow Light to the mountains and hills coming toward you. The warmest greens will be in the foreground. Refer to the color charts on the opposite page for various mixing combinations, and add white to create various tints. Add a cloud disappearing out of the upper left corner for variety.

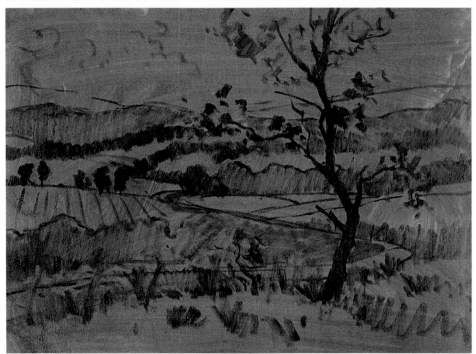

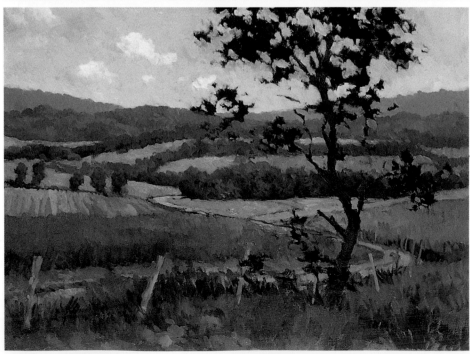

Using a limited palette, you can mix any green and brown in the landscape. To the base colors of Ultramarine Blue, Phthalo Blue and Phthalo Green, add different quantities of all the other colors on your palette—plus white to create various tints—for an infinite range of rich hues. Make color charts for reference, trying other combinations.

Here are a few specific tips for working with each base color:

- **Ultramarine Blue** is the most versatile color for landscape greens. It's the base of a wide variety of cool and warm greens that can be used in cool shadow areas and warm light areas.

- **Phthalo Blue** is a convenient blue that can be used to create rich greens and browns. Add white to it for a true blue sky. For shadow areas on cumulus clouds, use a gray of Phthalo Blue, Cadmium Red Light and white.

- **Phthalo Green** is the most difficult to use because of its intensity. Handle it like vanilla: Even though it has a delicious flavor, a little bit goes a long way and a lot is a disaster. The secret to successfully using Phthalo Green is to start with whatever other color you're going to use and then add Phthalo Green to it. For instance, add a whisper of it to white for the sky color just above the horizon. Add it to Quinacridone Red for deep, rich blacks.

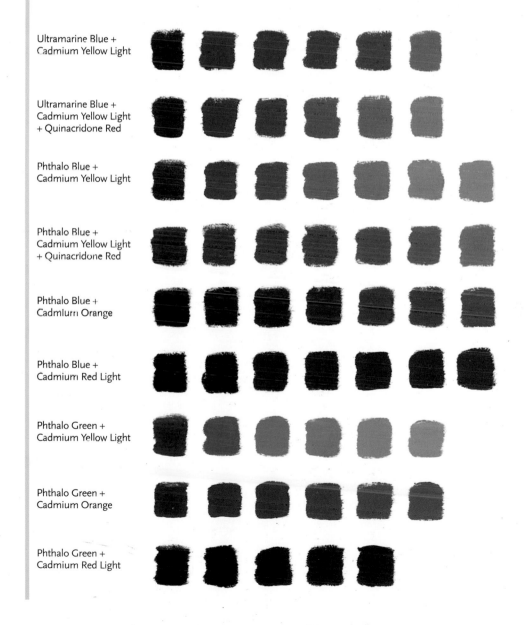

Ultramarine Blue +
Cadmium Yellow Light

Ultramarine Blue +
Cadmium Yellow Light
+ Quinacridone Red

Phthalo Blue +
Cadmium Yellow Light

Phthalo Blue +
Cadmium Yellow Light
+ Quinacridone Red

Phthalo Blue +
Cadmium Orange

Phthalo Blue +
Cadmium Red Light

Phthalo Green +
Cadmium Yellow Light

Phthalo Green +
Cadmium Orange

Phthalo Green +
Cadmium Red Light

### 3 DEVELOP THE TREE

Since the tree is the darkest area in the painting, develop it first and then add the lighter landscape colors around it. Lay in the shadow areas of the foliage with a cool green-violet from the Ultramarine Blue chart. Retain some of the initial lay-in colors to add variety. Considering the location of the light source, paint the middle and light green values, blending them into the darker ones. Widen and strengthen the tree limbs and trunks with browns from the Phthalo Blue chart.

Connect the foliage to the trunk with some twigs and limbs. Most of the bark on the upper limbs is in a shadow cast from the foliage. Have a few scattered spots of sunlight filtering through the leaves. The main trunk, in full sun, should flaunt its rough texture around the gnarled knot.

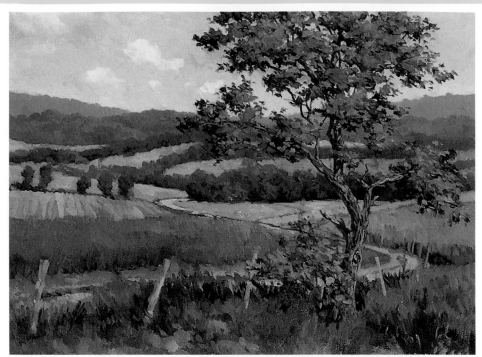

### 4 REFINE THE SKY, CLOUDS AND MOUNTAIN

Shape the shadow areas of the clouds with a light gray. With another brush, shape the light areas of the clouds using white tinted with Yellow Ochre. Using a third brush loaded with sky color, paint around the clouds, softening the edges as you go. Make all the cloud shapes different. Add a cloud behind the foliage for a natural look. Keep the edges soft.

Add other colors to the sky to give it atmosphere. Just above the mountain, paint with a mixture of Phthalo Green and Yellow Ochre, keeping the value lighter on the right toward the light source. With a value 5 gray of Phthalo Green, Quinacridone Red and white, paint the top edge of the mountain. Blend it into the sky while the paint is still wet. Using small vertical strokes, gradually pull sky color into the mountain color and vice versa.

With color to match the sky, paint around the masses of foliage to shape the outer edges, suggesting leafy areas. Then paint irregularly shaped sky holes within the foliage to give it a natural, lacy look. Keep the edges soft with a drybrush effect. Since the density of the leaves and the atmosphere cause a blurry effect on sky holes, paint them progressively darker as they get smaller. They will jump out at the viewer if painted too light.

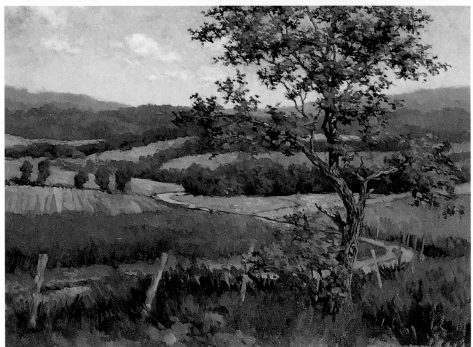

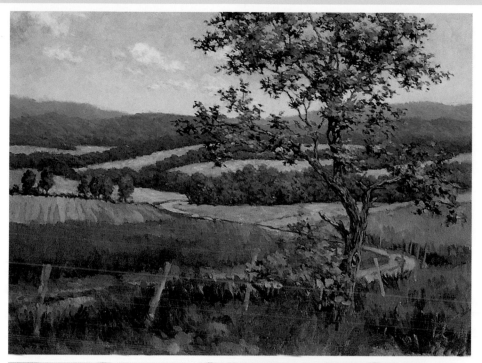

## 5 WORK ON THE MOUNTAINS AND DISTANT HILLS

Continue painting the far mountain with the gray of Phthalo Green, Quinacridone Red and white. Use other combinations for variety but keep them cool blue and gray. Exaggerate the coolness if necessary to make the foreground tree stand out. Add a tad of yellow to the landscape colors as you proceed toward the foreground to ensure accurate atmospheric perspective. Keep the edges soft.

## 6 PAINT THE MIDDLE GROUND

Progressing toward the foreground, the colors become more intense and more yellow, and have a wider range of values. Introduce other colors to add variety to the greens. Refer to the color charts for shadow combinations; add oranges, ochres and pinks to the greens in the lighter areas.

Keep the actual green colors to a minimum and on the bluish side. The flat planes receive a lot of reflected blue light from the sky and therefore retain a bluish cast. Avoid bright greens by painting them bluer or more orange.

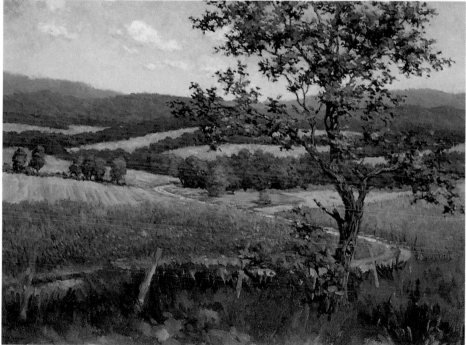

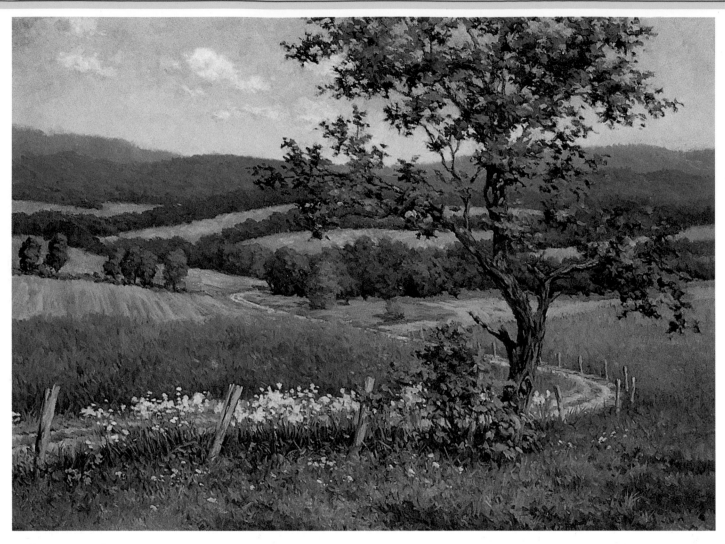

## 7 DEVELOP THE FOREGROUND

With Cadmium Yellow Light straight from the tube, mass in the yellow flowers first and work the rest of the foreground around them. Paint bits of road peeking through the flowers and stems. Add more weeds and flowers at the far left side of the road as stops so the viewer's eye doesn't move out of the painting. Use a no. 2 Monarch filbert for the fine grass blades.

Intersperse the foreground with orange strokes to suggest dead grasses. Scatter yellow flowers among the foreground grasses for color accents. Paint the fence posts with a cool color on the shadow sides mixed with Ultramarine Blue, Cadmium Orange and a tad of white. Using the same colors but more orange and white, paint the sunlit sides.

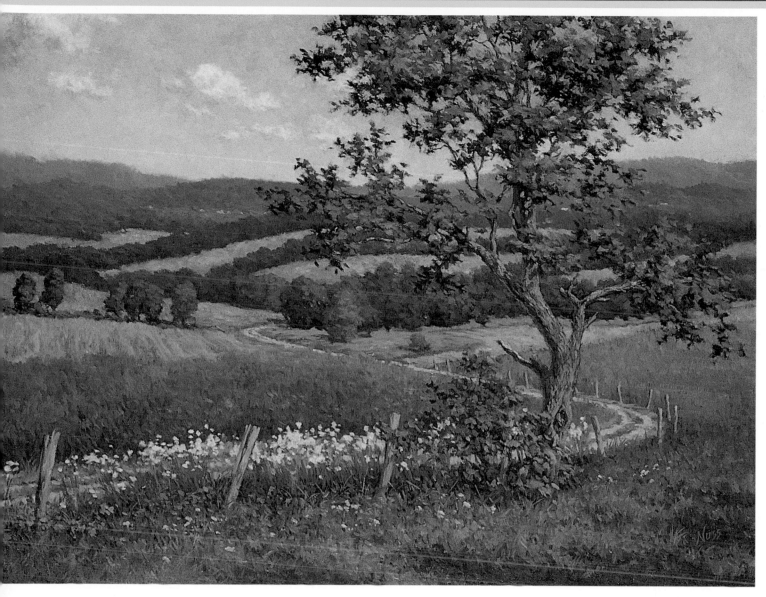

## 8 THE FINISH

Accentuate the trunk's texture and add final lights and accents to the painting. Use a wide range of values to portray the ragged bark. To make the trunk look round, add reflected light to the dark side of the trunk with an orange glaze (a thin mixture of Liquin and Cadmium Orange). Sparingly add lighter leaves and lighten the flower stems. With a value 5 gray, suggest a few rooftops on the mountainside.

The feeling of this scene is a pleasant summer day with soft green fields and gently plowed land. The viewer can sense the cool mountain air that winds its way through the valley, keeping the summer heat at bay. The bright yellow flowers immediately get the viewer's attention. The viewer's eye starts there at the bottom curve of the "S," then travels along the road through the painting to appreciate the farmland and distant mountains. The panorama is clearly visible since the foliage of the weathered tree is mostly on the top.

**Skip Back Hollow**
Oil on linen
18" × 24" (46cm × 61cm)

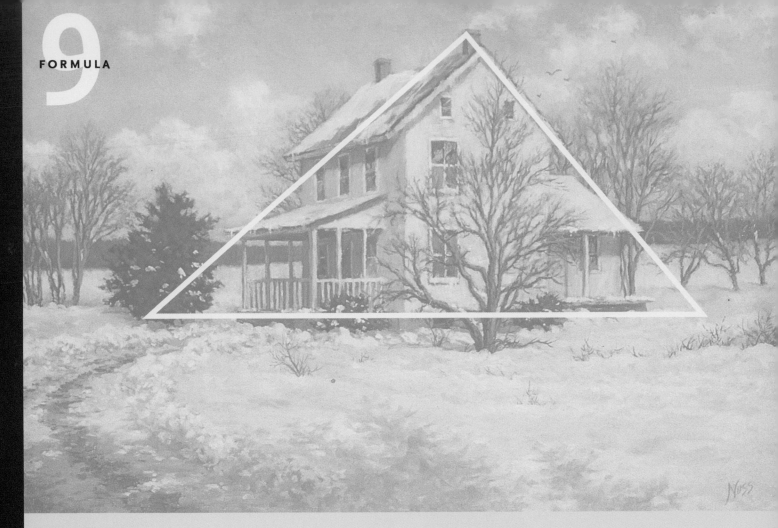

# THE
# TRIANGLE
## FORMAT

USE THE TRIANGLE OR PYRAMID

FORMAT TO POSITION ELEMENTS

IN A CLASSIC FORMAL

ARRANGEMENT, SHOWING

STRENGTH AND SOLIDARITY.

I was inspired by the freshly fallen snow to explore the local countryside for a scene revealing the many subtleties of the new white blanket. Promising scenes abounded with colorful shadows on the snow, but they didn't have the required accessibility. On such a cold day, I needed a safe place to park since I would paint from the driver's seat with my pochade box propped against the steering wheel.

Then this charming, old roadside farmhouse, with the brilliant sunlight hitting the yellow siding, caught my eye. A cleared area across the road afforded me the protection I sought. Although it was in the shade, I was able to back into it for a good view and still be shielded from cars and trucks speeding along the freshly salted road. There were enough elements in the scene to form the basis of a painting to be composed later in the studio.

# Reference Photos

## OVERALL SCENE
Photograph the scene to the left and right of the farmhouse along with the outbuildings.

## ANOTHER SNOW SCENE
Locate previously photographed references to develop snowy areas in the final painting.

## INCLUDE THE NEIGHBORHOOD
Include a shot of the farmhouse across the road, which is useful as a reference for evergreens and plowed snow.

# First Sketches

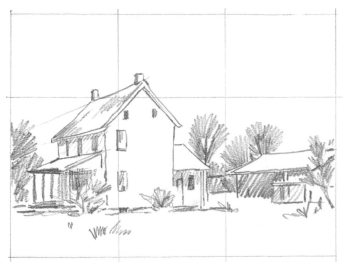

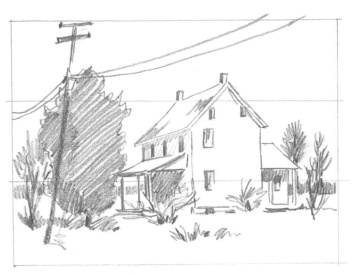

### FIRST VALUE SKETCH

First, include only the farmhouse, the equipment shed and the chicken coop. Eliminate the distracting elements: the red barn, small silo and vehicles.

This arrangement does not easily direct the viewer's eye into the painting. With the farmhouse facing outward, the viewer is confused about what direction to take. Additionally, there is only a middle ground with no background or foreground.

### SECOND VALUE SKETCH

Eliminate the outbuildings and place the farmhouse to the right of center opposite the large evergreen flecked with snow. Suggest background hills to replace the deleted outbuildings. Include the telephone pole as foreground interest to break up the tree and add a sense of scale.

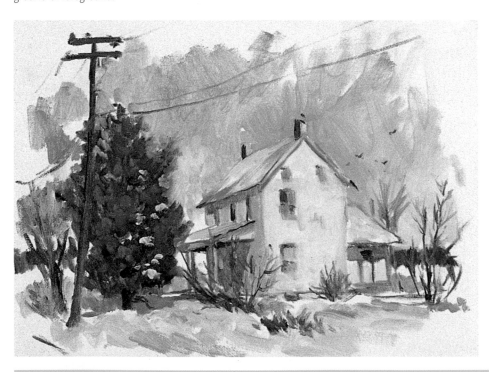

### THE FIELD SKETCH

Contrast the pale sunshine yellow of the farmhouse and the dark green foliage with the aquamarine winter sky. Accentuate the few shadows on the snow, painting the subtle blues and lavenders with accuracy. Capture the sky blue reflections on the snowy flat planes.

## Problems with the field sketch

The fundamental problem with the field sketch is that the evergreen tree and the farmhouse are both vying for attention since they are so similar in size. Preferably the farmhouse should dominate since it was the initial attraction to the scene. By reducing the size of the evergreen and centering the farmhouse, the triangle format solves the problem of how to arrange the remaining elements in the painting.

A pattern of shadows on the snow is needed for value contrast and drama.

# Solve Design Problems and Finalize Your Composition

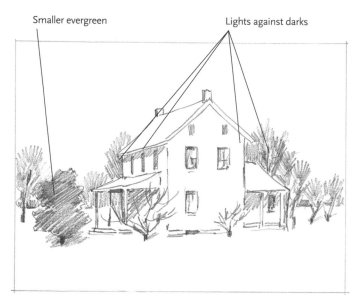

Smaller evergreen     Lights against darks

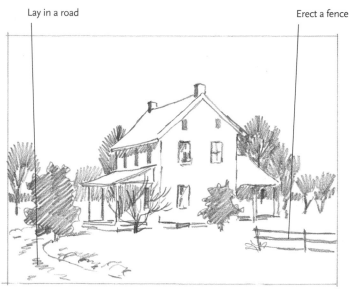

Lay in a road     Erect a fence

### DESIGN SOLUTION: CONSTRUCT THE TRIANGLE

Silhouette the major elements into a triangle against the sky with the farm house basically centered and its surroundings as secondary elements.

Resize the tree as a bush to complement the farmhouse. Eliminate the overwhelming telephone pole that no longer serves its purpose. Sneak some trees behind the back part of the house to set off the light yellow color. Add another window to the side of the house for additional interest.

### DESIGN SOLUTION: INTRODUCE ELEMENTS FROM REFERENCES

To allow the viewer's eye to enter the painting easily, lay in a snowy road leading to the farmhouse. Add a split-rail fence on the right for foreground interest and change the little scraggly bush on the side of the house into an evergreen. Consider a 16" × 20" (41cm × 51cm) canvas, a similar proportion to the field sketch.

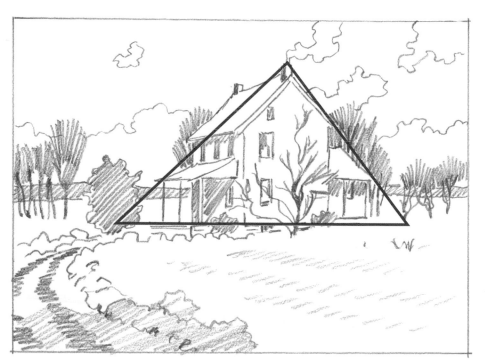

### FINAL PENCIL DRAWING

To relieve crowding and prevent the painting from looking like a house portrait, reduce the major elements within the borders. Add more trees to each side of the house, add foreground space and readjust the final proportion to a 14" × 20" (36cm × 51cm).

The newly enlarged foreground area affords new possibilities, but the fence is distracting. Replace it with remnants of a harvested field for subtle foreground texture. Imply trees casting shadows across the snowy road. Transform the scraggly bush that is hiding part of the front porch into a scraggly tree at the side of the house.

Place two evergreen bushes from a reference photo: one in the space vacated by the scraggly tree and another toward the back of the house. This new landscaping design reveals a front porch in need of well-defined columns and railings. For the final touches, add the cloud bank, chimney smoke and birds that were in the field sketch. Correct the drawing and perspective from the reference material.

# Depicting the Nature of Snow

*This step-by-step demonstration of the tri-angle format will concentrate on painting the nuances of snow, particularly the blues and violets in the shadows, which are readily apparent on sunny days.*

## MATERIALS

| | |
|---|---|
| SURFACE | Stretched linen canvas, 18" × 24" (46cm × 61cm) |
| BRUSHES | Robert Simmons filberts: nos. 8, 6, 4 and 2 ▪ Winsor & Newton Monarch filbert no. 2 ▪ Winsor & Newton Monarch round no. 0 |
| OILS | Cadmium Orange ▪ Cadmium Red Light ▪ Cadmium Yellow Light ▪ Phthalo Blue ▪ Phthalo Green ▪ Quinacridone Red ▪ Ultramarine Blue ▪ Yellow Ochre ▪ White |
| OTHER | Soft vine charcoal ▪ Mahlstick ▪ Cotton rags ▪ Odorless turpentine ▪ Liquin |

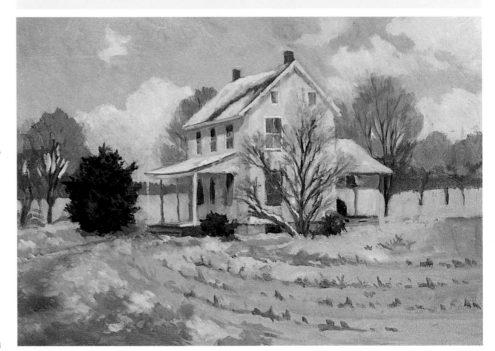

## 1 LAY IN THE COLOR FOUNDATION

Transfer the drawing to the canvas. Near the horizon, paint the sky with white and a whisper of Phthalo Green. As the sky progresses toward its zenith, use Phthalo Blue and white, and finally Ultramarine Blue and white. Block in the farmhouse with Yellow Ochre and white. Add violet to the farmhouse mixture for shadow areas under the eaves, porches and window trim.

Paint the flat planes of the snow a slightly bluish cast using tints of white with Phthalo Blue and white with Ultramarine Blue. With grayish browns made with Phthalo Blue and Cadmium Red Light and white, rough in the bare trees, cornfield remnants and road.

Describe the evergreens by painting the shadow areas first with shades of Phthalo Green and Quinacridone Red, followed with a slightly lighter tone of Phthalo Green and Cadmium Red Light on the branches.

## *Painting snow*

When painting snow on a bright sunny day, it is easy to identify the obvious blues and violets in the cast shadows, verifying the existence of these colors in all shadow areas. Keep the following guidelines in mind to accurately paint snow:

- **Value and color in the light areas:** Even though white is white, paint the flat plane about a value 3 white tinted with blue. This plane reflects blue light from the sky, giving it a cool tint, and leaves room for visible white highlights.

- **Value and color in the shadow areas:** Since shadow areas are generally two values darker than light ones, use about a value 5 to paint the blue and violet shadows on the flat plane. Go one value darker for the upright planes.

- **Highlights:** Where the sunlight directly hits the snow, use a mixture of white and Yellow Ochre in values 1-2.

- **On cloudy days,** snow loses the blues and violets in the shadow areas, which become variations of grays.

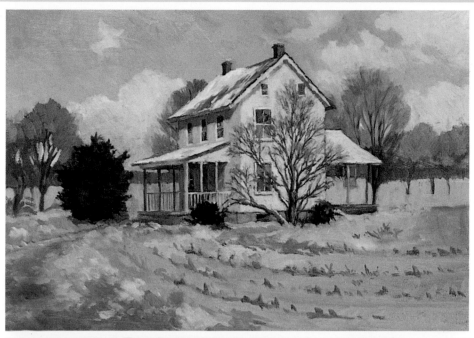

## 2 REFINE THE HOUSE, PORCH AND LANDSCAPING

Check the drawing and perspective on the house before developing it further. Redraw the house with Cadmium Red Light. Restate the bare tree on the side of the house with value 7 browns made with Cadmium Red Light, Phthalo Blue and white. Mass the twigs with one brushstroke and a lighter shade of brown.

Paint the light side of the house with a mixture of white and Yellow Ochre, working toward the branches and trunk with the house color. Then with the twig color on one brush and the house color on another, work back and forth to blend the edges of the twigs. Paint the larger areas of the house showing through the tree as if you were painting sky holes, except these are house holes.

Rebuild the front porch with columns and a railing on each side. Line up the new windows and front door with the three windows on the second floor. Paint the dark side of the chimneys with Cadmium Red Light cooled and darkened with Phthalo Blue, and the light side with Cadmium Red Light warmed and lightened with white and Yellow Ochre. For the roof, add a cool gray of Phthalo Blue, Cadmium Red Light and white and then paint the remaining snow.

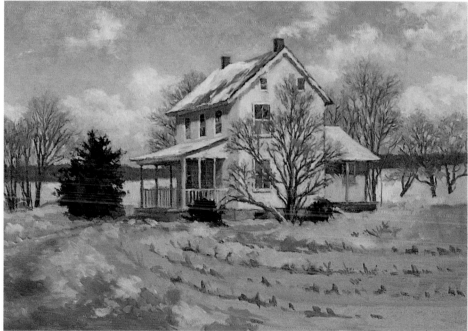

## 3 DEVELOP THE SCENERY

Define the sunlit planes of the clouds and the chimney smoke with white and Yellow Ochre. Paint the shadow areas of the clouds with a gray mixture (Phthalo Blue, Cadmium Red Light and white). Brush the sky and cloud color lightly over the tree branches. Work the branch color back into those colors for a soft transition between the two areas.

Overlap the roof edge and chimneys with sky color to make the edges soft. Shape the evergreen bush with the cloud color. Paint the trees with a no. 2 Monarch filbert and use a darker and redder value of Phthalo Blue, Cadmium Red Light and white for the trunks. Work upward to the thin branches, lightening them as they get thinner. Then paint the background tree row in a value 6 using the same colors but varying them slightly so that the row is not just a flat color.

## 4 PAINT THE SNOWY FIELD

Paint the field, laying in the lightest values first and then work the shadow values into them. With the lighter value, work behind the orchard trees to define them and eliminate the hard edges.

Add a lighter area to the middle-ground trees where the sunlight hits them. Then add clumps of snow to appropriate areas—on the evergreens and on the boughs of the large tree branches that are big enough to hold snow. Paint the shoveled snow along the lane, suggesting shadows from unseen trees.

## 5 MAKE REFINEMENTS

Eliminate the cornfield, which is too distracting. Paint over it but leave some wavy variations on the field. This leaves room for a stronger shadow pattern on the snow from those unseen evergreen trees.

Restate the low clouds behind the trees, clarifying some cloud holes and thinning the branches. Brush a thin coat of cloud paint over the tips of the trees to make them softer. Lighten the lights on the clouds, especially next to the sky blue, for better contrast.

Lighten the side of the house like the field sketch and redraw more graceful branches. With a fine brush, add a few branches and extend them up past the roofline. For more convincing atmospheric perspective, cool the temperature of the light side of the chimneys by adding a few dabs Cadmium Red Light diluted with white and Phthalo Blue.

Add a few dark gray birds circling around the house, making sure their profiles and sizes are varied. Use a no. 2 Monarch filbert and grays made with Phthalo Blue, Cadmium Red Light and white.

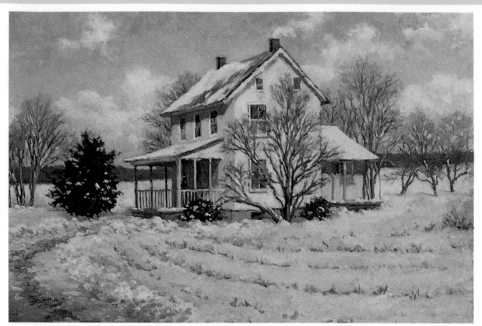

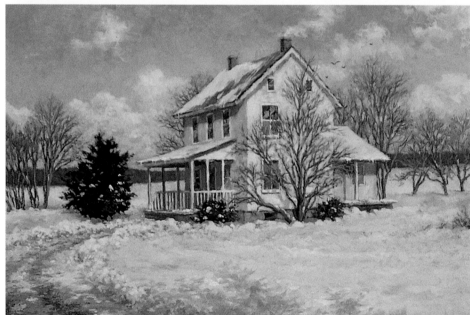

## A format for all ages

The classic triangle format has been used since the early sixteenth century when Leonardo da Vinci organized figures in pyramidal groups and influenced Raphael, who painted the Madonna and Child in various triangular arrangements.

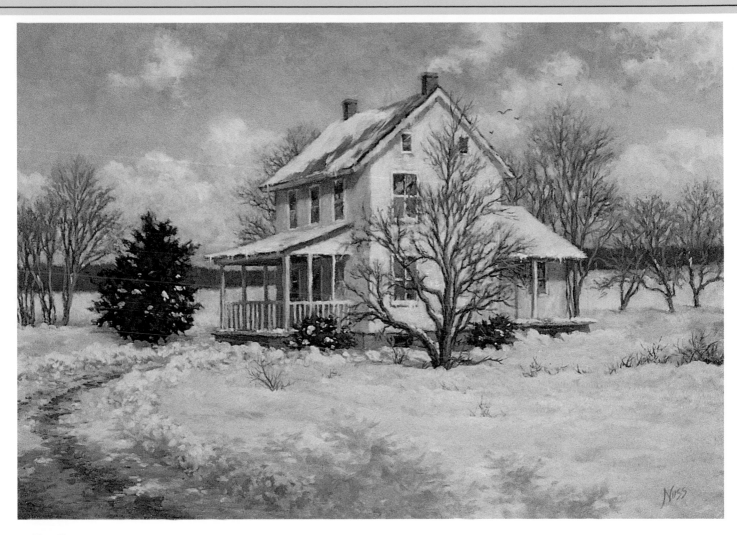

### 6 THE FINISH

As a final change, move the tree toward you by lengthening the trunk, effectively putting space between it and the house while breaking up the foreground snow. Pile up snow around the trunk, making sure to add appropriate shadows. Add some other scraggly bushes and weeds near the house and in the field.

The farmhouse—the foundation of the painting—holds together areas of secondary interest. The viewer's eye enters the painting via the plowed lane and continues on to the front porch. From there the other areas come into play: the snow on the evergreens, the patches of snow on the roof with icicles, chimney smoke suggesting a human presence and a few circling blackbirds. The viewer's eye then travels down the tree and exits the painting via the back porch and the three orchard trees.

**Shadows in the Snow**
Oil on linen
14" × 20" (36cm × 51cm)

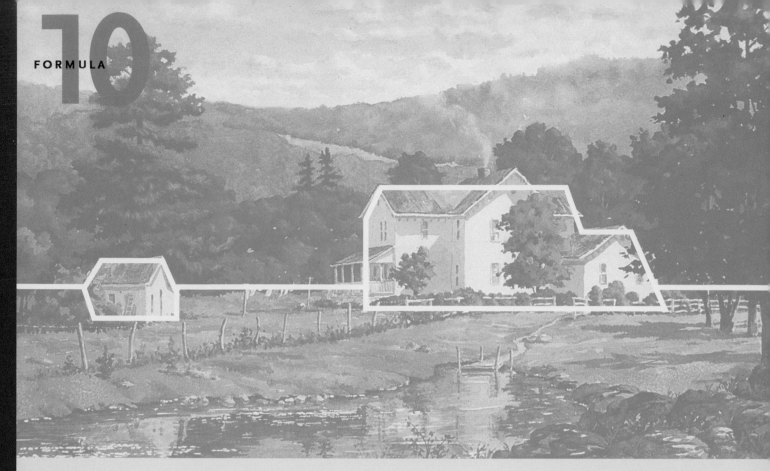

# THE
# STEELYARD
## FORMAT

THIS FORMAT, ALSO CALLED THE SEESAW, BALANCES MASSES ON AN IMAGINARY FULCRUM. IT PLACES A LARGE MASS NEAR THE CENTER OF A PAINTING BALANCED BY A SMALLER SIMILAR MASS CLOSER TO THE EDGE. USE IT WHEN YOU HAVE SIMILAR ELEMENTS, ONE LARGE AND THE OTHER SMALL.

On a week-long trip with friends to paint Amish farms nestled in this picturesque mountain area, I was inspired most by the white structures on this farm. My eyes easily settled on this rustic example that radiated a simpler way of life not often seen in today's hectic pace.

Structures painted white are most appealing because they contrast strongly with the cool greens in a landscape. They are clean and crisp with colorful shadows that are fun to paint. Gray and red structures that don't contrast well with landscape colors are difficult to paint effectively. They do look sharp, however, against snow or sky.

The big problem was how best to focus on the farmhouse, amid the cows and clutter, so I could paint it. I even considered a cow painting. Since we did not have permission to go on the property to get a closer view, several of us set up our French easels along the lightly traveled road to paint the country setting.

# Reference Photos

**THE BASIC SCENE**
Isolate the house in its mountain environment, showing the cast shadows from unseen trees.

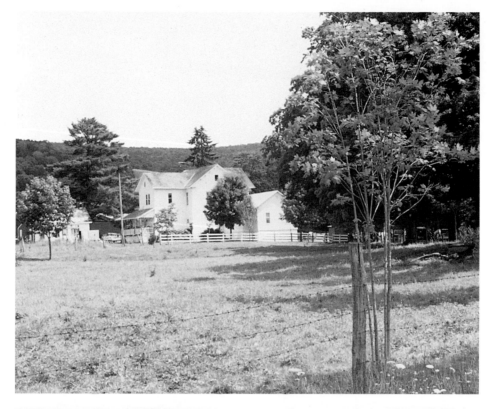

**PORCH AND HOUSE DETAILS**
Zoom in on the back porch for the details of the railing, lattice and back windows. Ignore the cows that add to the clutter.

**THE SHED AND LAUNDRY LINE**
Zero in on the shed and laundry behind the tree. Disregard the red barns and cows.

# First Sketches

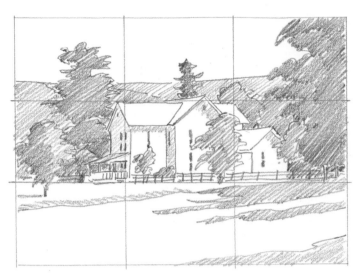

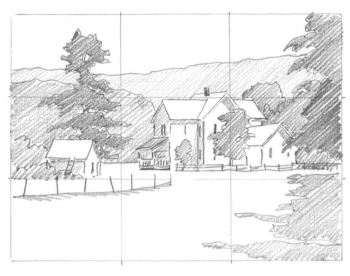

## FIRST VALUE SKETCH

First center the white farmhouse, since it's the major attraction and fairly uncluttered. Plunking the farmhouse in the center, however, creates a static arrangement even though all four corners of the painting are different. The finger-shaped cast shadows from unseen trees add only minimal visual interest to the foreground. It will require more than just these shadows to make this area interesting.

## SECOND VALUE SKETCH

Enlarge your field of vision to include more elements, but eliminate the red barns and other confusing elements contained in the reference photos. Focus on the steelyard balance of the white structures by including the left-hand shed and rotating it to face into the painting to receive the sunlight. Add a chimney to the house for a spot of color. In the background, angle the mountain and eliminate the lone tree behind the house. Add fence posts along the gully and reshape the tree shadows in a less menacing design.

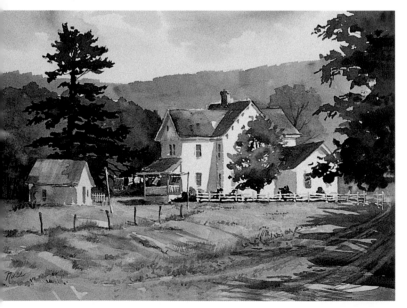

## THE FIELD SKETCH

Introduce other elements like the laundry hanging on the line to visually tie the buildings together. Establish a visual rhythm with the white fences and the white porch pickets. Eliminate the little tree in front of the house. Make sure to accurately draw the house; it presents tricky perspective in the opposing rooflines. Apply masking with a toothpick to the fences, laundry and clothesline poles.

Using light washes, work top to bottom. Paint the sky, the mountains and then the trees. Keep the house and shed clear of color. Paint the dark pine tree starting at the top as if to float a wash. Keep it all wet by adding different colors and working quickly from top to bottom. Work back into it with darker color for the trunk. Paint the other trees in a similar manner. Use cool blue-violet shadows to define the shapes of the house, shed and split-rail fence. For final accents, paint the drying laundry with some bright reds to pick up the red in the chimney.

## Problems with the field sketch

- The basic problem with the field sketch is the boring foreground. After removing so much clutter, this area is now essentially empty. Consider other options besides the partly trampled road.

- In the background, the mountains and hillsides could be redesigned into contrasting shapes.

- Consider a change of season. The white structures will still sparkle against the golds and rusts of autumn.

Deeper shadows    Less foreground

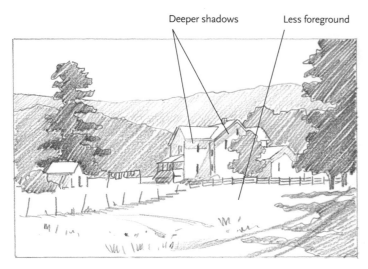

Add pines    Replace tree to break up white shape    Open a gate

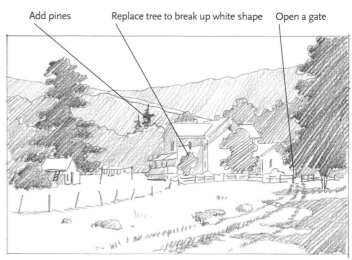

### DESIGN SOLUTION: SPREAD OUT THE ELEMENTS

Elongate the scene by adding space between the buildings, giving the scene a cleaner country look. Retain the dynamic of the steelyard format by keeping the house—the larger element—near the center while snuggling the shed near the edge to balance it. This arrangement isolates the laundry thereby bringing more attention to it.

### DESIGN SOLUTION: REDESIGN THE MOUNTAINS AND TRY OUT A ROAD

Introduce taller mountains with more effective diagonals to suggest greater distance. Change the trampled grass path into a rocky dirt road that leads the viewer's eye toward an open gate by the house.

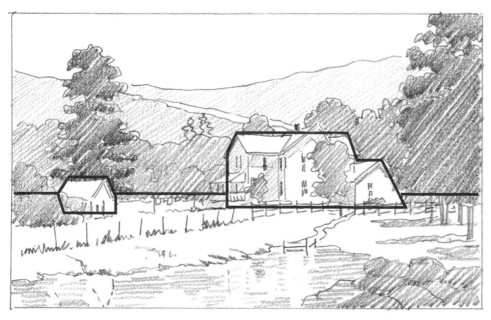

### FINAL PENCIL DRAWING

Overhaul the foreground by replacing the road with a pond edged with rocks and weeds. Soft reflections contribute to the scene's serenity. A rickety dock connects to a jagged path that leads the viewer's eye to a different open gate by the house. Shift the laundry closer to the right so it is off center between the house and the shed. Add some tree trunks on the right.

# Converting the Season From Spring to Autumn

*The focus of this step-by-step demonstration is to contrast the white farmhouse and shed against the new revised warm colors of the autumn foliage. You will also practice painting realistic reflections in the water without reference photos.*

| MATERIALS | |
|---|---|
| SURFACE | Arches 140-lb. (300gsm) cold-press watercolor paper, stretched, 12" × 19" (31cm × 49cm) |
| BRUSHES | Winsor & Newton Series 7 rounds: nos. 3, 5, 7 and 9 ▪ Mop brush |
| WATERCOLORS | Burnt Sienna ▪ Cadmium Orange ▪ Cadmium Red Light ▪ Cadmium Yellow Medium ▪ Cerulean Blue ▪ Chromium Oxide Green ▪ Cobalt Blue ▪ Payne's Gray ▪ Phthalo Blue ▪ Phthalo Green ▪ Quinacridone Red ▪ Raw Sienna ▪ Sap Green ▪ Ultramarine Blue ▪ Winsor Violet ▪ Yellow Ochre |
| OTHER | Pencil ▪ Plastic eraser ▪ Craft knife ▪ Incredible Nib ▪ Masking fluid ▪ Rubber cement pickup ▪ Salt |

**1 MAKE THE DRAWING AND APPLY MASKING**
Enlarge your drawing to fit a half-sheet of watercolor paper. Place this drawing over your paper with a graphite tracing sheet between them. With a ballpoint pen, trace the drawing onto the watercolor paper. As you are penciling in the reflections on the water, refer to page 39 for tips. With a soapy brush, apply masking fluid around the edges of the house, chimney and shed. Also carefully apply it to the split-rail fence, fence posts, clothesline posts, basket of laundry and clothes drying on the line.

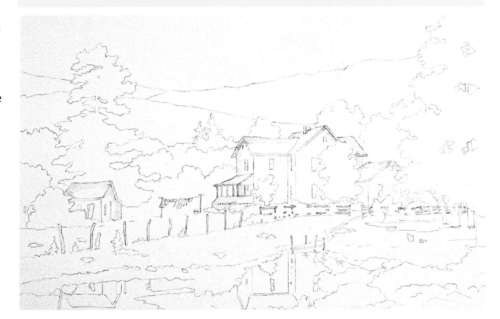

## *Make a graphite tracing sheet*

With a 4B or 6B pencil or graphite stick, scribble a dense layer of graphite onto a piece of tracing paper in a convenient size such as 8¼" × 11" (22cm × 28cm) or 11" × 14" (28cm × 36cm). To "fix" the graphite and keep it from smearing, squirt some rubber cement thinner onto it. Before it dries, rub lightly with a paper towel to achieve a smooth, equal covering. Fold it in half with the graphite sides inside, and use it for years.

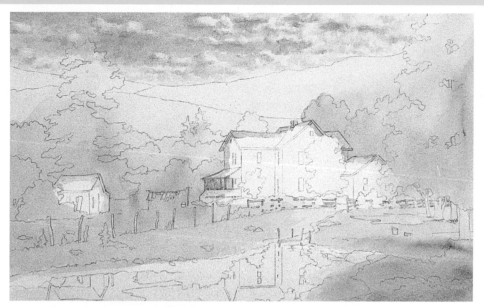

## 2 LAY IN A GOLDEN GLOW AND PAINT A SKY WITH PUFFY CLOUDS

Using a mop brush, wash a tinge of Cadmium Orange over the sky to make sunlit, puffy clouds. As you float the color downward, add some watery Quinacridone Red and Burnt Sienna in the tree areas as a base for the autumn colors. At the bottom of the painting, add watery orange into the reflections where the house basks in sunshine. This combination will give the painting a golden glow.

Lightly draw in a design of puffy clouds. On barely damp paper and working around these cloud shapes, lay in the sky at the apex with Ultramarine Blue and blend in Phthalo Blue and Cerulean Blue toward the mountaintops. Blot up any unwanted paint in the cloud area with a paper towel.

Delicately describe the cloud shadows using a warm gray made with Cobalt Blue and Cadmium Red Light. To softly blend the shadow color into the cloud and sky, use two brushes—one with clean water to lightly wet the shadow area. Use the other to apply the color, allowing it to bleed into the cloud and sky. Use Incredible Nib to soften hard edges.

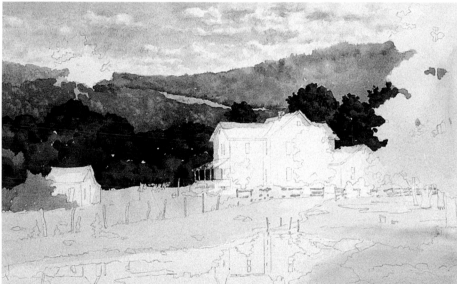

## 3 PAINT THE VARIOUS MOUNTAINS

First paint a light golden field near the mountaintop with Raw Sienna. Dampen the back mountain line with a clean, wet brush. Working into this wet area, paint the back mountain, keeping it cool on the shadow side and warm on the sunlit side. Add subtle combinations of Raw Sienna, Winsor Violet, Cobalt Blue, Yellow Ochre and Quinacridone Red.

For the next closer mountain, use a gold combination of Cadmium Yellow and Quinacridone Red and bleed it into the top mountains. Lift off some color with the chisel end of the Incredible Nib to simulate highlights on some trees.

### 4 SHAPE THE BACKGROUND TREES

With Burnt Sienna and Winsor Violet, paint the trees behind the house, shed and large pine. Add more Winsor Violet for the shadow areas. When it is dry, lift off some color with the chisel end of the Incredible Nib to highlight some of these trees. Drop in a transparent gold of Quinacridone Red and Cadmium Yellow on the sunlit side.

With the pointed end of the Incredible Nib, lift off shapes for tree trunks and branches. Accent these trunks and branches by painting shadow areas on either side of them.

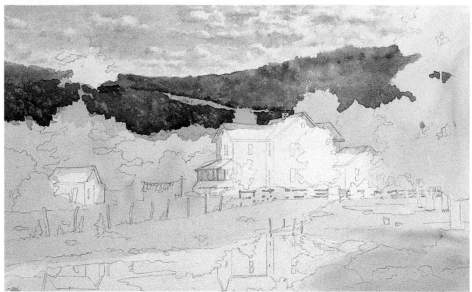

### 5 FORM THE LARGE PINE TREE

Start at the top and work down using Chromium Oxide Green and Yellow Ochre or Chromium Oxide Green and Cadmium Orange for the light areas, and Sap Green and Burnt Sienna for the middle greens. Use Phthalo Green, Burnt Sienna and Ultramarine Blue for the dark accents. For soft edges, brush or spritz on clean water to keep the area damp. Lift out the tree's highlights with the Incredible Nib.

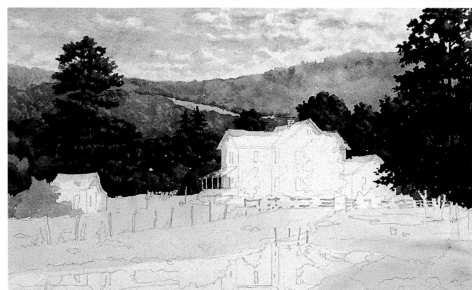

#### DETAIL OF DARK TREES

Paint the other shadowed trees the same as the large pine, using the same colors and techniques to keep the area workable. Many of the darkest darks are in these trees. Warm up some areas with Burnt Sienna.

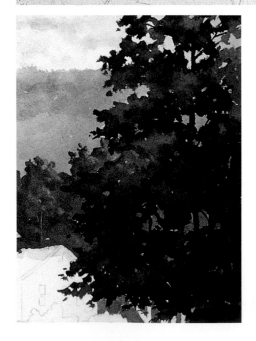

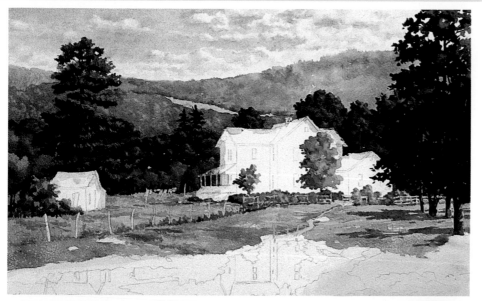

### 6 PAINT THE GROUND

Apply a wash of Yellow Ochre over all of the ground, sunlit trees and bushes, varying the areas with a bit of Sap Green. Add more concentrated areas to contour the ground and create interest. Add Ultramarine Blue for the shadow areas. On some areas of dry ground, wash in some Cadmium Red Light and quickly sprinkle salt on it for a textured effect.

Tie the foliage on the right to the ground with tree trunks painted first with a gold wash of Cadmium Yellow and Quinacridone Red. Then add the shadows with a cool tone of Winsor Violet and Cadmium Red Light. Use this same color combination to add shadows to the bushes by the shed.

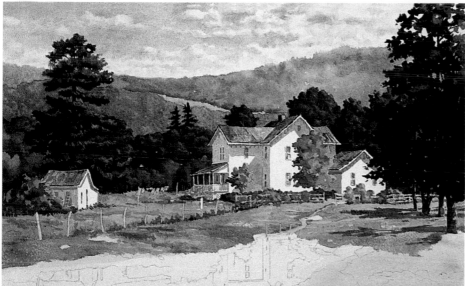

### 7 DESCRIBE THE HOUSE AND SHED

Remove the masking and carefully paint the shadow areas with a blue-violet color of Cerulean Blue and Winsor Violet. For the roofs, use Cerulean Blue and Burnt Sienna. Accent the details with darker values or Burnt Sienna and Ultramarine Blue.

Lift off some Burnt Sienna from the trees behind the farmhouse roof. To contrast these trees with the redness of the roof, apply a wash of Cerulean Blue.

## 8 PAINT THE REFLECTIONS

Lightly draw some horizontal lines parallel to the picture plane in the water's darker areas. With your fingers, shape an old brush into a chisel shape. With the brush, apply masking to produce thin horizontal water sparkles along these guidelines. With a pointed brush, apply little dots around the edge of the pond where water bubbles appear against the shore.

To suggest soft, rippling water, paint these reflections with little horizontal lines to visually blend the images. (See page 39 for tips on painting reflections.) Paint the reflections in similar but slightly darker values than the objects being reflected, except for the darker colors which will reflect slightly lighter.

## 9 INSERT ROCKS AND WEEDS

With mixtures of Burnt Sienna, Cerulean Blue and Ultramarine Blue, paint the middle tone and shadow tones of the rocks, leaving specks of the underpainting for sunlit spots. Add weeds between the rocks with a cool green of Chromium Oxide Green and Ultramarine Blue.

Rub the masking off the remaining rocks and paint them with tones of Burnt Sienna, Cerulean Blue and Ultramarine Blue. For the rock reflections, lift areas from the water with the Incredible Nib and paint a shadow line under the rock. Add some stumps for variety in this green area.

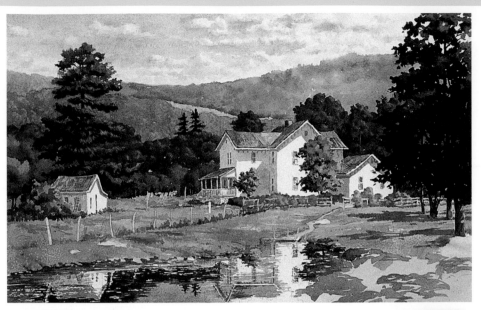

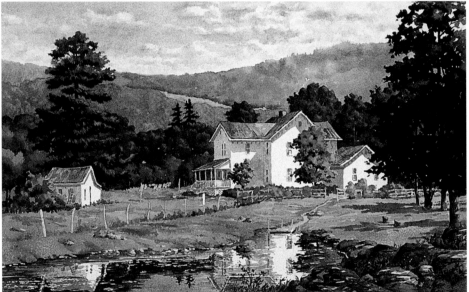

## Why is it called "Steelyard"?

A steelyard is a seventeenth-century weighing device. The object to be weighed was hung from a short arm of a lever balanced by a sliding weight on a counterpoised long arm, similar to the balance scales found in doctors' offices today. The steelyard format also resembles the mechanics of a seesaw: a light person sitting far out on a seesaw plank can balance a heavy person sitting on the other end of the plank nearer to the fulcrum.

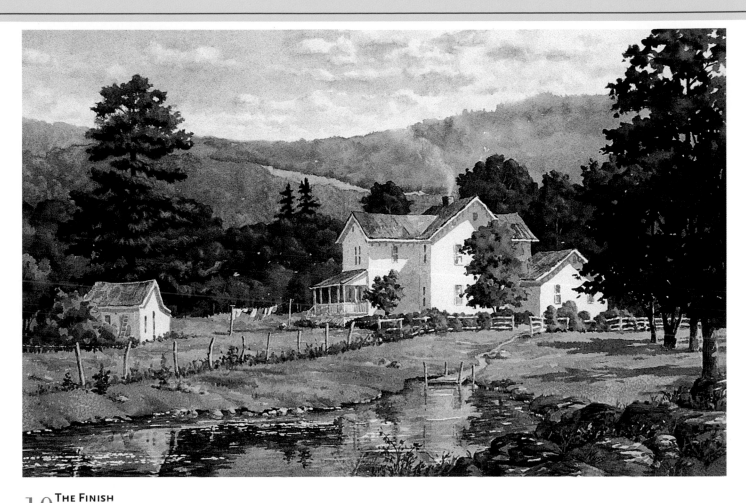

## 10 THE FINISH

Carefully wash Burnt Sienna over the green trees for a warm autumn glow. Remove the annoying tree stumps, which were attracting undue attention because of the high value contrast. Wash a thin layer of Payne's Gray over the water to tone down the reflections. Lighten some of the dark areas as well.

Apply a mixture of Cerulean Blue and Winsor Violet to the shadow sides of the white fence. Leave the white paper for the light side. With various greens, define the bushes and underbrush along the fences. Add sparkly accents to the drying clothes with bright reds and blues. With a craft knife, scratch out the clothesline and barbed wire between the fence posts. With the Incredible Nib, lift off paint from the hills and mountains suggesting a gentle plume of smoke rising from the chimney.

The steelyard format comfortably balances the white farmhouse and small shed in this rural setting. The complexities of the pond reflections immediately attract the viewer's attention. The dirt path leads the eye from the rickety dock to the house where it follows the fence to the left along the drying laundry and on to the shed pointing up to the large pine. The golden field on the mountain redirects the eye back toward the house and then up the curling smoke and along the mountain ridge. The warm autumn colors contrast with the crisp, cool shadows on the white farm buildings to exude a warm, nostalgic appeal. The curling smoke and drying laundry announce that someone is home.

**October Morn**
Watercolor
12" × 19" (31cm × 49cm)

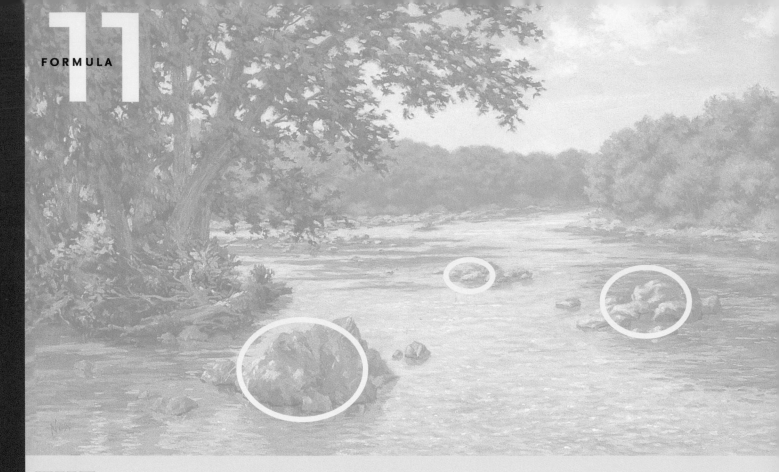

# THE
# THREE-SPOT
## FORMAT

USE THE THREE-SPOT FORMAT TO ESTABLISH

ORDER AMONG SIMILAR REPEATING SHAPES

IN DISSIMILAR SIZES, SUCH AS ROCKS, TREES

OR BUILDINGS.

Local outdoor painters retreat to this quiet, lush area along the river for inspiration and creative endeavors. Since a thick canopy of branches offers vast amounts of shade along with a gentle river breeze, this secluded spot lends itself to comfortable painting all through the hot, humid summer. Though the ground is usually soft and sometimes muddy, artists can safely spread out their gear on the few seasoned picnic tables.

On this particular summer day, I was with watercolorists as well as oil painters. With many appealing views available, the water-colorists took over the picnic tables, set up their gear and easily settled in for a morning of painting.

Considering the variety of possible scenes, I was most attracted to this jut of land thick with old weathered trees framing the river. Little sparkles of filtered light danced along the grasses and twigs, enlivening the foreground.

Repetition and continuity form the core of the three-spot format. In this painting, major rock formations of diminishing sizes are repeated to direct the flow of the viewer's eye through the painting. Smaller rock formations complete the repetition.

# Reference Photos

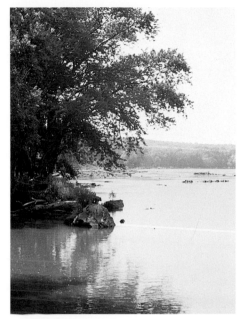

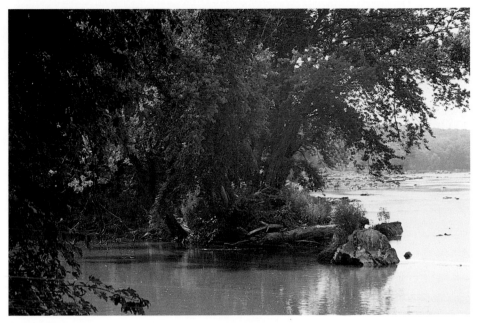

**GETTING THE VERTICAL PROFILE**
The cluster of weathered trees plus their shadows on the water give a sense of place.

**SHOOT SIDEWAYS**
With your camera turned horizontally, show the tree trunks, fallen limbs and massive foreground rock.

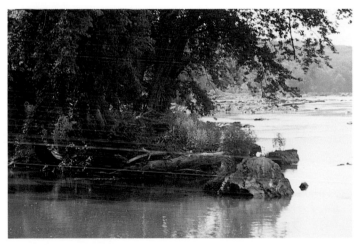

**FOREGROUND DETAILS**
Zoom in for a closer look at the fallen limbs, twigs and cluttered underbrush.

**OPPOSITE SHORE DETAIL**
Focus on the reflections, rock formations and temperature variations in the colors of the distant trees.

**MORE DETAIL**
Zoom in for an even closer look at the rocks and reflections.

# First Sketches

**FIRST VALUE SKETCH**
Sketch this wooded jut of land to dominate a vertical format. This approach displays the graceful old trees and the various surrounding textures that contrast to the irregular rocks and peaceful river. This "tree portrait" is a possible future painting with a rearrangement of rocks to balance the heavy dark area.

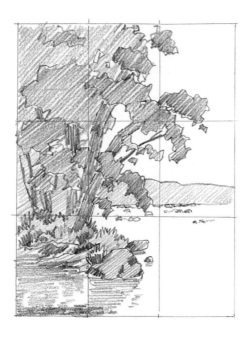

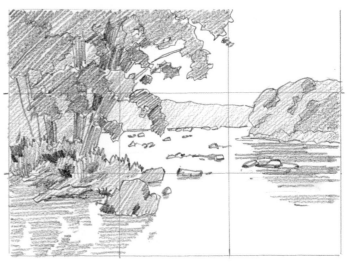

**SECOND VALUE SKETCH**
Try a traditional horizontal format to reinforce the feeling of calm and serenity of this quiet river scene. Introduce depth and atmosphere by including the riverbanks and scattered array of rocks. Weave various rock formations into the river expanse and water reflections, taking advantage of the numerous opportunities for repetition.

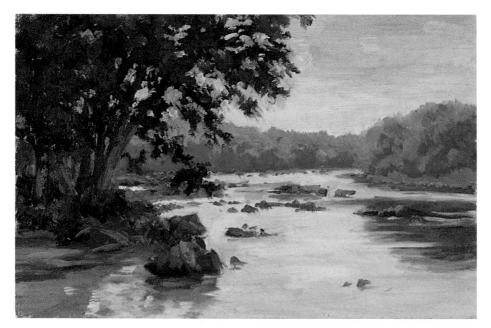

**THE FIELD SKETCH**
Carefully record the tricky colors of the distant banks. In the mild summer haze and muggy atmosphere, the far shadows assume cool violet tones. The trees on the distant shore exhibit little difference between the shadow values and the sunlit values. Achieve the difference with a color change: warm in the sunlit areas and cool in the shadow areas.

Capture the complex color of the foreground muddy water and the cast shadows from the unseen trees that fall onto it. The photos will not likely represent the colors accurately. Paint the random rock formations in the river as they appear, even though they are awkward, ineffective and add too much weight to the left side of the sketch. Plan to redesign these rock arrangements later for a more effective visual path through the painting.

## Problems with the field sketch

The sketch lacks balance because of the weak distribution of rock formations, resulting in a large area of boring blue water without visual interest. Solve this problem by using the three-spot format to arrange rock formations that effectively lead the viewer's eye through the painting. Several design possibilities exist.

# Solve Design Problems and Finalize Your Composition

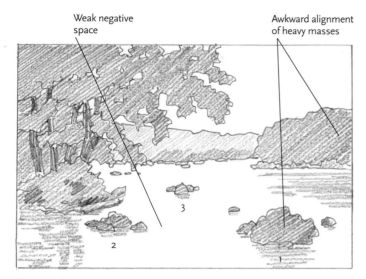

Weak negative space

Awkward alignment of heavy masses

## DESIGN SOLUTION: ARRANGE THE ROCKS

Try out the no. 1 spot in the lower right quadrant to balance the left side of the field sketch, which is heavy with trees and rocks. Stagger the no. 2 and no. 3 spots back into the painting. Interject small rocks as a bridge from formation to formation and add distant rocks hugging the far shore.

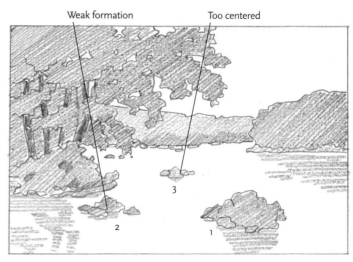

Weak formation

Too centered

## DESIGN SOLUTION: REARRANGE THE ROCKS

Improve the design balance by moving the no. 1 spot to the left so it no longer lines up with the large mass of trees. The negative space improves but the no. 2 spot lacks impact with its relative position in the design. The composition is still jumpy and lacks rhythm since the viewer's eye naturally enters from the left and sees the no. 2 spot before the no. 1 spot.

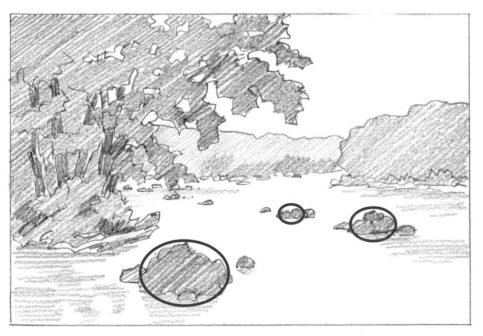

## FINAL PENCIL DRAWING

Place the largest formation of rocks—the no. 1 spot—back on the left side, creating a more natural entry into the painting. Separate it from the tree reflections to make it an effective formation in the three-spot format. The viewer's eye now easily enters the painting from the left, focusing on the large mass of trees and the largest arrangement of rocks.

Place the sunlit no. 2 spot in an area of dark tree reflections from the right bank. Some incidental smaller rocks guide the eye to the no. 3 spot, located more toward the center of the painting. Other random rocks complete the path to the background. This final arrangement of rocks creates harmony, and the viewer's eye moves easily through the composition.

# Getting the Right Angle on Rocks

*This step-by-step demonstration of a muggy day on the river will show the various hues and values in correct atmospheric perspective in addition to the painting of natural-looking, craggy rocks.*

## MATERIALS

| | |
|---|---|
| SURFACE | Stretched linen canvas, 16" × 24" (41cm × 61cm) |
| BRUSHES | Robert Simmons filberts: nos. 8, 6, 4 and 2 ■ Winsor & Newton Monarch filberts: no. 2 ■ Winsor & Newton Monarch round no. 0 |
| OILS | Cadmium Orange ■ Cadmium Red Light ■ Cadmium Yellow Light ■ Phthalo Blue ■ Phthalo Green ■ Quinacridone Red ■ Ultramarine Blue ■ Yellow Ochre ■ White |
| OTHER | Soft vine charcoal ■ Mahlstick ■ Cotton rags ■ Odorless turpentine ■ Liquin |

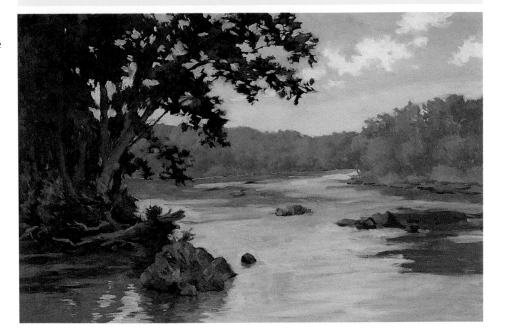

### 1 LAY THE COLOR FOUNDATION

Using a grid and soft charcoal, enlarge the final pencil sketch to fit on your canvas. Wipe out the charcoal and, without losing your drawing, lay in a color foundation.

Use a mixture of Cadmium Red Light and Phthalo Blue to lay in the trunks, branches and other shadow areas. Mass in the foliage with greens made with various combinations of Phthalo Green with Quinacridone Red, Phthalo Green and Cadmium Red Light and other greens from the chart on p. 79. Then paint the rocks with grays made with combinations of Phthalo Blue, Cadmium Orange and white. Rough in a clump of weeds behind the large rock on the left, rock formation no. 1, to distribute the green.

For the shadow areas of the background foliage, use violet greens made with Ultramarine Blue and tads of Quinacridone Red, Cadmium Yellow Light and white. In the lighter areas, use the same colors, but with more yellow and white.

Paint the sky and water, beginning by painting an interesting cloud shape with white and surrounding it with blues. For the blues, use Ultramarine Blue and white at the apex and gradually warming the color toward the horizon with Phthalo Blue and white and finally with Phthalo Green, Yellow Ochre and white. Paint the colors in the water similar to the objects being reflected, and because of the influence of the sky, the lights should be slightly darker and the darks should be slightly lighter.

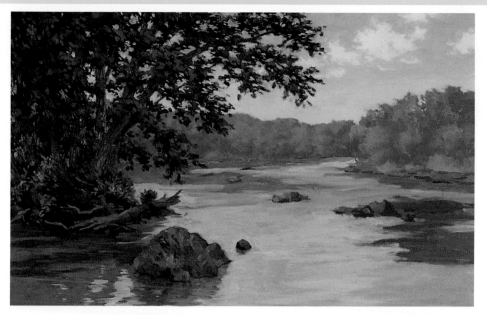

## 2 DEVELOP THE TREE LIMBS AND FOLIAGE

For the darkest areas of foliage, use a combination of Quinacridone Red and Phthalo Green. Mix other dark greens with Ultramarine Blue and Quinacridone Red with bits of white and Cadmium Yellow Light. Make these cool greens with just enough yellow so they aren't gray.

Add cooler tones of Phthalo Blue, Cadmium Red Light and white to the trunks to calm the reddish areas, but leave some of those spicy bits peeking through. Add Cadmium Orange to the colors at the bases of the trunks to indicate reflected light. Refine the sky holes with appropriate light blues, depending on which color was used in the color foundation. Use a light touch and keep the edges soft by working into the wet paint of the leaves and branches. Eliminate the clump of weeds behind rock formation no. 1 to separate it from the land mass and give it more importance.

## Shaping Dynamic rocks

Deliberately design rocks in asymmetrical shapes, making each and every rock different with appropriate sharp angles and irregular planes.

**This**

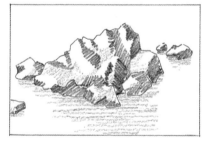

**Not This**

### BEWARE OF ROCKS THAT LOOK LIKE POTATOES, ANIMALS OR OTHER IDENTIFIABLE OBJECTS

Even smooth pebbles and cobblestones have slightly different shapes and colors. If you have too many rocks in similar shapes, join two or three together to make better shapes. Stagger them for effective eye movement and atmospheric perspective, making them smaller, cooler and grayer with slightly lighter shadow values as they recede into the distance.

**This**

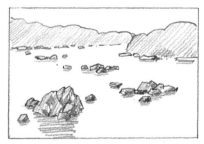

**Not This**

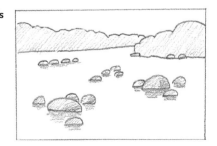

### PAINT CONVINCING WATER REFLECTIONS

The rougher the water, the less noticeable the reflections.

107

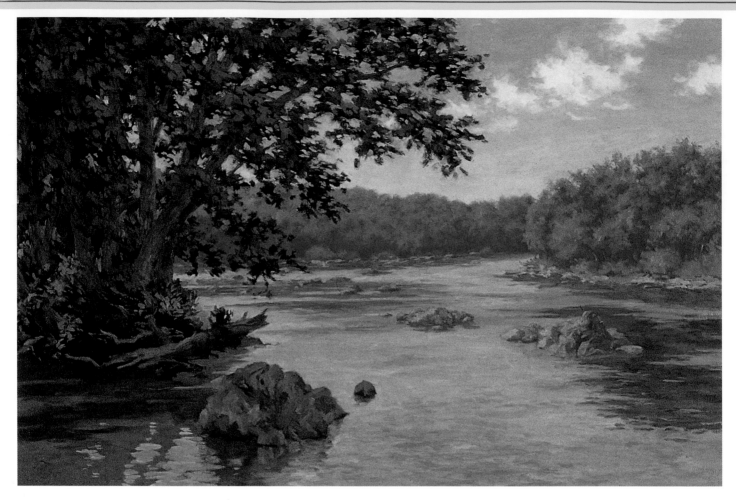

### 3 REFINE THE SKY, BACKGROUND TREES, ROCKS AND WATER

Use Ultramarine Blue and white in the zenith of the sky. Clarify the cloud masses with a gray shadow color of Phthalo Blue, Cadmium Red Light and white. Use a white warmed with Yellow Ochre to paint the sunlit areas of the clouds. Using three brushes—one each for the sky, clouds and cloud shadows—gently blend the different areas together.

Develop the sunlit areas of background trees with a cool blue-green color of Ultramarine Blue, Cadmium Yellow Light and white. Warm it slightly for the sunlit middle-ground trees. Add enough color variation to suggest a few individual clumps of trees. Blend the top edges of the foliage into the sky, which is a warm light color like eggshell white, characteristic of summer haze.

With grays made with Phthalo Blue, Cadmium Red Light and white, define the rock shapes. Add a little Yellow Ochre for the sunlit areas. Short, confident strokes will help the rocks look craggy. Add the water around the rocks, making it lighter in the background and gradually darkening it as it comes toward you. Use the same colors you used in the areas being reflected, including the calm spots of water.

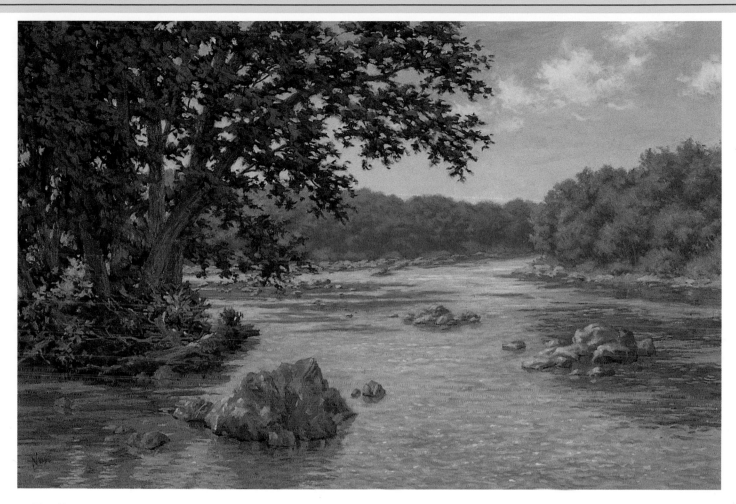

## 4 THE FINISH

Paint the final version of rock formation no. 1 with a variety of warm and cool planes in various directions, suggesting a rugged testament to time. Sprinkle spots of sunlight on the rocks. A hint of orange added to the reflections describes the muddy water. Surround the rest of the rock with sky reflections to isolate it from the nearby bank, ensuring its placement as the no. 1 spot. The small rock on its right points to the no. 2 spot.

Reduce the size and direction of the large, dead tree trunk for a smoother transition between rock formations no. 1 and no. 2. Resolve the repetition of the annoying parallel branches by placing the smaller one in shadow with scraggly dead branches attached to it. Paint shadows on the water with a cool mixture of Ultramarine Blue, Cadmium Orange and white. Then add a few rocks and their reflections to the water. Put sparkles of sunlight on a few of the weeds. With a no. 2 Monarch filbert, add sparkles to the water with white and a hint of Ultramarine Blue.

The large rock formation in the lower left becomes the initial focal point that leads the viewer's eye into this painting. By using small rocks to bridge the gaps, the eye easily crosses the river to the second largest rock formation and on back to the smallest formation and background. Each formation is different not only in size and shape but also in relative value: the largest and smallest ones are dark against light while the middle one is light against dark. These subtle differences avoid monotony in the repetition.

**Swain's Point**
Oil on linen
16" × 24" (41cm × 61cm)

109

# 12

# THE
# OVERLAPPING
# SHAPES FORMAT

### USE THIS FORMAT TO ARTISTICALLY

### ARRANGE SHAPES WHEN YOU HAVE A SHORT

### DEPTH OF FIELD.

Some friends asked me to join them for a morning painting excursion to this gracious historic home overlooking a nearby river. In addition to the brick manor house with numerous chimneys, French doors and patios, all displaying expert craftsmanship, there were extensive formal gardens, gazebos, lily ponds, rustic outbuildings, fields and horses all tempting the artists' appetites. So much to paint and so little time!

I prefer the more casual look as opposed to manicured gardens and parks where every leaf and blade is in its proper place. And I'm a real sucker for window boxes with cascading vines and flowers. So this garden, with its random profusion of greenery, flowering plants and boxwood edging the driveway, activated my creative juices. The challenge was to overlap these diverse shapes into a pleasing arrangement moving the viewer's eye around to savor the various colors and textures.

# Reference Photos

## THE BASIC SCENE
Photograph the garden and shed showing the basic elements even though the sun is not cooperating. When the sun shines, make a mental picture of the light and shadow pattern.

### CLOSE-UP OF THE GARDEN
Shoot the scene in more detail.

### A DIFFERENT VIEW
Walk around the garden to get another angle. This one includes the steps and railings as well as displays more potted plants.

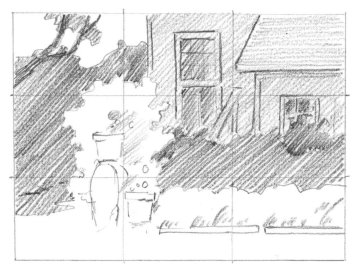

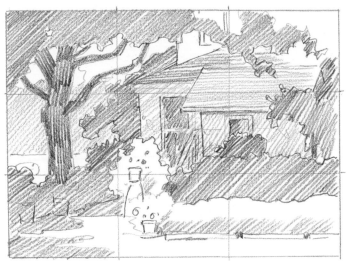

**FIRST VALUE SKETCH**

Sketch a close-up of the planter and the flowering shrubs, utilizing the shed and side door as a backdrop. Then zoom in on the flowers to give them top billing. This sketch doesn't really capture the character of the setting; there are other artistic elements that can contribute to the sense of place.

**SECOND VALUE SKETCH**

In the second sketch, move back from the scene to include the warm brick wall with its angular roofline, which adds an historic touch. Silhouette the large tree against the expansive front lawn and include more flowerpots along the sun-drenched driveway.

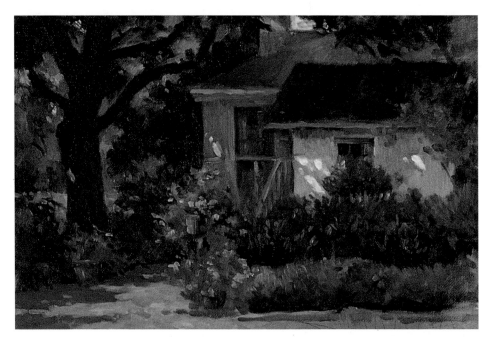

**THE FIELD SKETCH**

This scene is all about color—the reds, pinks and lavenders of the flowers in the pots, window box and shrubbery—and how these colors contrast with their complementary green in all its nuances. The house and shed are cast in shadow, keeping them in the background. Their subtle colors and textures add restful areas to contrast with the multitude of garden colors.

## Problems with the field sketch

The entire sketch looks crowded with many confusing elements and has an unresolved upper right corner. These are the major problems:

- The center planter lines up with the edge of the porch, and the area around the door and railings is confusing. It's not clear why the porch door is elevated, since no steps are visible.

- The boxwood hedge, parallel to the picture plane, forms three long, adjacent rectangular shapes: the driveway, the hedge and the flowering shrubs. These shapes, besides being static and boring, prevent the viewer's eye from moving in any direction.

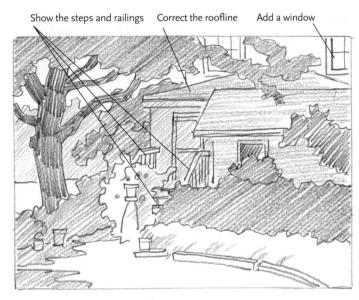

Show the steps and railings · Correct the roofline · Add a window

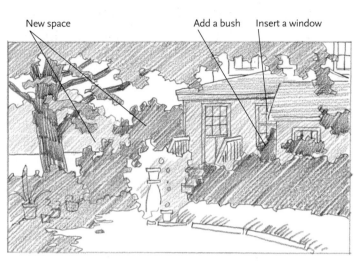

New space · Add a bush · Insert a window

## DESIGN SOLUTION: CURVE THE DRIVEWAY AND MOVE THE PLANTER

Move the planter to the left, which opens up space to clarify a confusing area around the railings and porch steps. Sneak a glimpse of the steps between the planter and the flowering bushes.

Gracefully curve the driveway, making the hedge an interesting shape bordering the flowering bushes. With this one alteration, the three rectangles have been resolved. But the shed is still too long and crowds the area with the planters and pots.

## DESIGN SOLUTION: SPREAD OUT THE OVERLAPPING SHAPES

Elongate the dimensions to allow more space between the tree and the buildings. Emphasize the porch area by moving the shed to the right, bleeding it off the edge. Place a bush behind the shed to separate it from the porch. Also, add more pots to the left side of the driveway for rhythm and repetition.

Reshape the tree and branches with masses of foliage traversing the large branches to break up the strong, dark vertical areas.

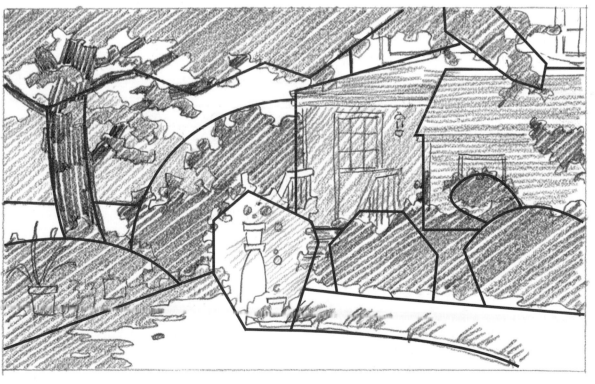

## FINAL PENCIL DRAWING

Replace the distracting new window with a suitable porch light, adding a touch of charm. Move the shed once more to the left, along with the overhanging tree branches. This cozies up the window box with the rest of the flowering shrubs.

**ADD INTEREST WITH VARIOUS TEXTURES**
The straight lines and right angles of the manor house and shed, accentuated by the textures of the brick and siding, set off the soft, fragile forms of the flowers and foliage. In addition, there is variety in the shapes and colors of the flowers, shrubbery and leaves, all adding to the interest in the painting.

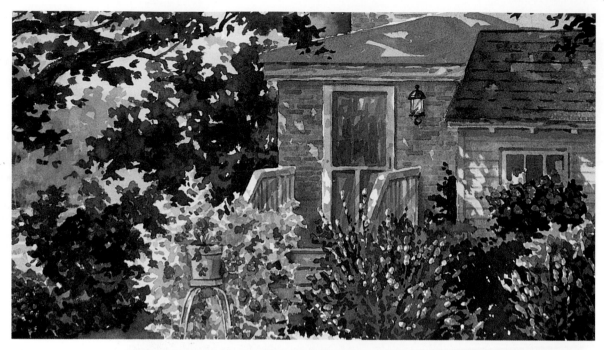

**VARY THE GREENS**
For a wide range of greens, paint some a cool green and others a warmer green. Paint the background trees a bluish tone of Cobalt Blue and Cadmium Yellow Light to contrast and complement the warmer greens in the foreground. Paint other cool greens with varying amounts of Ultramarine Blue or Phthalo Blue with Cadmium Orange or Yellow Ochre. Be cautious when mixing yellow with these two blues or they may become too bright and unrealistic. Mix the extremely light greens with yellow and a tinge of blue.

For the rich, warm greens, use Phthalo Green with Burnt Sienna or Cadmium Red Light. For the darkest, blackest greens, use Phthalo Green and Quinacridone Red. Use Phthalo Green with orange for mid-value warm greens.

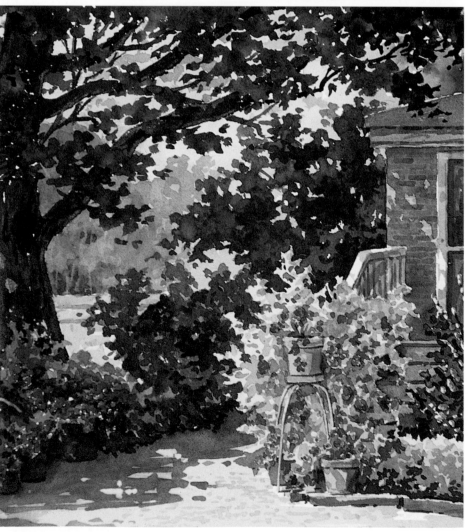

# The Finish

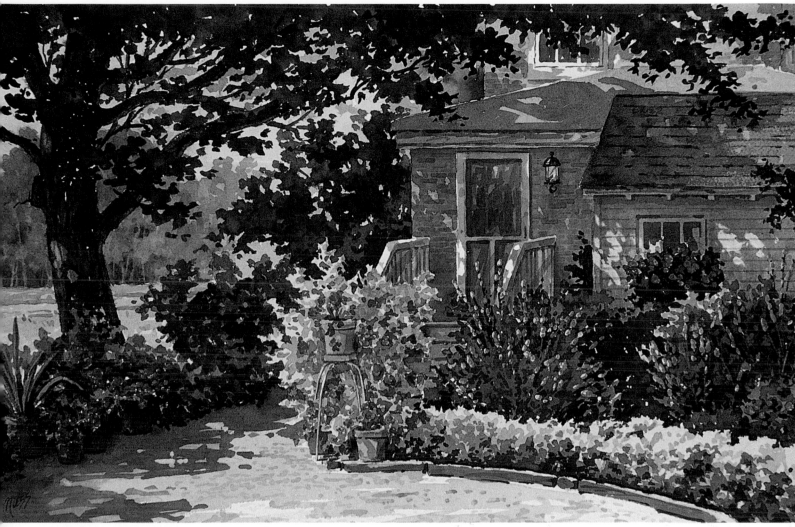

### Cultivating a Lush Garden of Colors and Textures

When you do a painting of a specific house that is not intended as a house portrait, your artistic license gives you the power to take necessary liberties to make a strong and attractive painting. Only by chance would the homeowners ever see this painting. In this instance, the radical changes included moving the shed into a different position and replacing the white siding on the porch with brick. This ties the porch into the house and adds more red to the painting to complement the abundant greens.

In this close-up garden scene, the overlapping shapes indicate depth and interest. The lightest lights and darkest darks are in the foreground, denoting the central focal points. The pots and flowers in the foreground overlap the shed, which overlaps the house, which overlaps the lawn and trees on the left. The little spots of light hitting the railing, house, roof, shed and walkway all help to move the viewer's eye around the painting and make it sparkle.

**Summer Garden**
Watercolor
12" × 19" (31cm × 49cm)

This historic town annually offers home and garden tours. While on one of these special outings, I was able to photograph some of the secluded backyard gardens that are hidden from the general public. Here, the fragrance of the wisteria lured me down the garden path to the dynamic light pattern on the garden shed, which highlighted the other flowers and foliage.

**Wisteria Garden**
Oil on linen
20" × 16" (51cm × 41cm)
Private collection

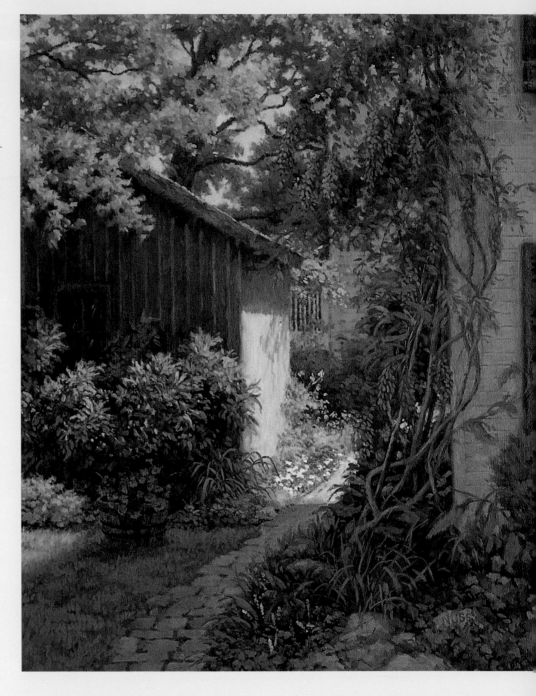

## Overlap Textured Shapes as a Backdrop for the Center of Interest

A weathered shed, which in reality boasted a restaurant's advertisement, complements this profusion of peonies intertwining a split-rail fence. Also, in the actual scene, the fence ran parallel to a road with trucks and cars parked along it. After much deliberating, I decided that even the road could be eliminated. I decided to focus the painting on the gorgeous peonies with just a suggestion of background to give the scene a sense of place.

**Antiques and Peonies**
Oil on linen
18" × 24" (46cm × 61cm)
Private collection

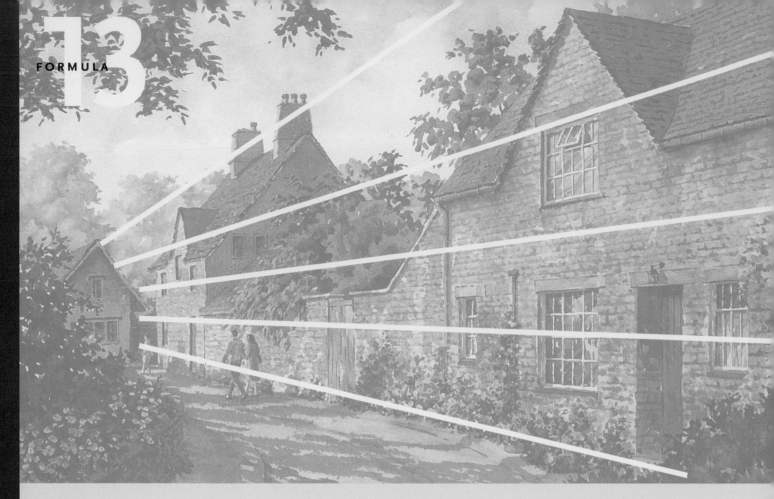

# THE
# RADIATING
# LINES FORMAT

USE THIS EASY FORMAT TO COMPOSE A SCENE

CONTAINING NUMEROUS LINES—A ROAD,

A FENCE, HILLS, MOUNTAINS—EMANATING

FROM A POINT OF INTEREST OR

ONE COMMON VANISHING POINT.

Some years ago, my husband and I traveled to the Cotswolds in England to visit family members who happily volunteered to be our personal tour guides. Knowing that I was eager to photograph this unfamiliar territory for use in future paintings, they shared their favorite nooks and crannies of this enchanting historic region. The whirlwind tour included exploring little neighboring villages boasting the unique Cotswold stone.

Burford was the number-one village on the "must see" list. With cameras slung around our necks, we scoured little side streets, checked out quaint shops with wares spreading onto the sidewalks and marveled at the singular architecture of the Cotswold stone. Fortunately, on this one day in Burford, the sun was out and the sky was clear. I photographed everything possible in hopes of capturing this one little corner of England.

This narrow Burford street epitomizes the character of the Cotswolds, but it was impossible to photograph it in one shot because of the intrusive stone wall. Photographing bits and pieces of it was my only choice. I later developed a painting in my studio inspired by these photos, capturing the cozy feeling of a narrow Cotswold street.

# Reference Photos

Include the whole scene with mostly road.

Focus down the street.

Focus on the Cotswold street-side landscaping.

Peer around the obstructive stone wall.

Capture a sidewalk petunia planter.

Zoom in on the chimney details.

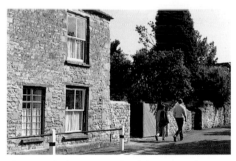

Photograph the sunny side of the street, showing cast shadows from unseen trees and a reference for figures.

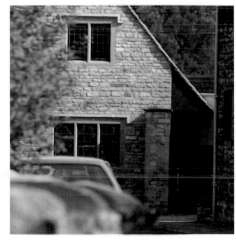

Photograph the stonework at the end of the street.

# First Sketches

### FIRST VALUE SKETCH

Lay out the photos and conceptualize the scene. Replace the straight road with a curved one and include other elements from the various photos. The whole-scene photo shows a long stone wall and little of the houses. Scrunch the houses together by deleting yards of wall, and substitute a short stone wall for the intrusive one. Now the houses and street are visible, but the sunny spots on the stone wall, the area of greatest value contrast, are of little interest. The interesting areas are in the shadows.

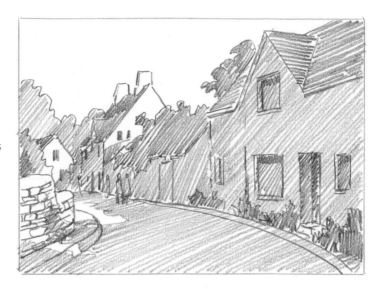

### SECOND VALUE SKETCH

Reverse the sunshine to bathe the houses and stone wall in bright sunlight. Cast shadows from unseen trees create a sun-dappled street, adding visual interest to an otherwise boring area. The large sunlit shape grabs the viewer's eye and leads it down this narrow Cotswold street, allowing the viewer to enjoy its unique character and ultimately arrive at the walking figures.

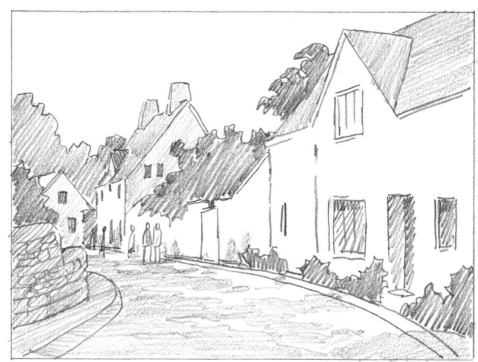

## Problems with the second value sketch

In this case, no field sketch was done on location, so evaluate the second pencil sketch:

- A wide, boring street is a common problem in street scene paintings and is the obvious problem here. Creatively adjusting the street will solve this problem effectively.

- A minor adjustment will place the people in a pleasing position.

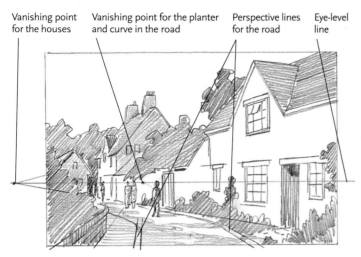

Vanishing point for the houses | Vanishing point for the planter and curve in the road | Perspective lines for the road | Eye-level line

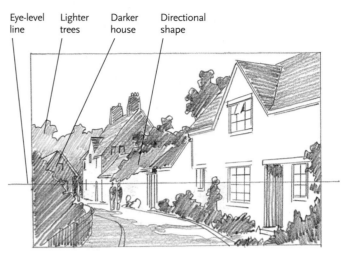

Eye-level line | Lighter trees | Darker house | Directional shape

### DESIGN SOLUTION: NARROW THE ROAD

Elongate the sketch to fit a half-sheet of watercolor paper by adding on to the right side of the sketch. Redraw the houses in correct perspective using a left vanishing point. When you draw the chimneys and the windows in the distant houses, consider the right vanishing point, which is out of the picture at a considerable distance.

To accurately draw the angled road and the planter, establish a new vanishing point on the eye-level line. Where the road curves away from the house, fill in with shrubbery and flowers.

### DESIGN SOLUTION: THREE IS NOT A CROWD

Reduce the number of figures to a pleasing group of three: a single person plus a pair with their heads all on the eye-level line. The perspective lines direct the viewer's eye to the lone figure where the planter's foliage serves as a stop.

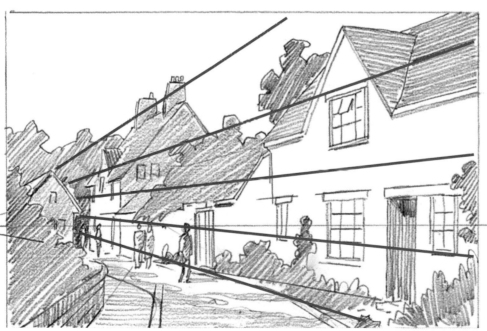

### FINAL PENCIL DRAWING

Introduce overhead branches to add an intimate feeling and a logical reason for the cast shadows on the road. Add another tree behind the large house to soften the sharp roof angles.

Sometimes you will paint a building in one-point perspective, where only one side shows, but more often you will paint in two-point perspective, where two sides are visible. To create buildings that appear convincingly three-dimensional and recede into the distance, remember two easy rules. First, there is only one eye-level in any one picture. Second, all actual parallel lines converge at the same point on the eye-level line, called a vanishing point.

In two-point perspective, buildings are more appealing if their sides are shown unequally. In this situation, applying perspective to details can be tricky, but the details need to be as convincing as the overall perspective of the building they belong to. Use the following tips to make sure your windows, chimneys and other details look correct.

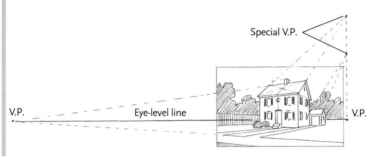

### A House in Two-Point Perspective

Draw a house at an angle so that both the front and one side are visible. Locate the two vanishing points on the eye-level line far enough apart to avoid distortion. (Distortion occurs when a true right angle is drawn as less than a right angle.) All the horizontal lines of the door, windows, steps, roof and chimney on the front of the house converge at the left vanishing point. The horizontal lines of the windows, chimney, garage and sidewalk on the right side of the house converge at the right vanishing point.

Make the roof by drawing an arbitrary pitch line upward until it reaches a point exactly above the right vanishing point. This new point is a special vanishing point to which the other roof pitch line extends. The pitch lines for the garage roof also have their own special vanishing point. To center the chimney on the roof, draw diagonals across the roof plane and draw a line through the center toward the special vanishing point. Place the chimney at this point.

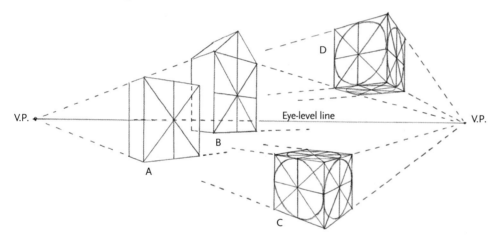

### Drawing the Details

To find the centers of windows, doors or any other rectangular plane, first find the center of rectangle **A** by drawing diagonals from the corners. The center is where the diagonals cross; draw a vertical line through this point. To form a gable (**B**), extend the rectangle's centerline vertically to an arbitrary point, and then join that point to the top two points of the rectangle.

For circular structures or details such as wheels, silos and pipes, make circles on the side of cubes **C** and **D** by first drawing the diagonals. Then draw vertical and horizontal lines through this intersection. On the cubes' top and bottom planes, draw through the center points to both vanishing points. These lines bisect the outside lines of the plane, creating four points. Connect these points by drawing an ellipse (a perfect oval touching only those four points). For arches in windows and bridges, construct the circle and then use only the top half of it.

# Reversing the Sunshine

*The primary challenge of this step-by-step demonstration is to paint convincing sunlight and shadow areas with only suggestive reference photos. In reversing the sunshine, devise shadow patterns that are an integral part of the design and serve the purpose of contrasting with the light areas of interest.*

## MATERIALS

| | |
|---|---|
| **SURFACE** | Arches 140-lb. (300gsm) cold-press watercolor paper, stretched, 12" × 19" (31cm × 49cm) |
| **BRUSHES** | Winsor & Newton Series 7 rounds: nos. 3, 5, 7 and 9 ▪ Mop brush |
| **WATERCOLORS** | Burnt Sienna ▪ Cadmium Orange ▪ Cadmium Red Light ▪ Cadmium Yellow Medium ▪ Cerulean Blue ▪ Chromium Oxide Green ▪ Cobalt Blue ▪ Payne's Gray ▪ Quinacridone Red ▪ Raw Sienna ▪ Sap Green ▪ Ultramarine Blue ▪ Winsor Violet ▪ Yellow Ochre |
| **OTHER** | Craft knife ▪ Incredible Nib ▪ Masking fluid ▪ Rubber cement pickup ▪ Plastic eraser |

## 1 Make Your Drawing and Apply the Masking

Enlarge your drawing to the final size by either gridding it or using the enlarging function on a copier or scanner. A final drawing on a separate sheet can prove invaluable for later reference. Place this final-size drawing over your watercolor paper with a graphite transfer sheet between them. With a ballpoint pen, trace the drawing onto the watercolor paper. Carefully apply masking to the figures, petunias, window frames and mullions.

## 2 Bathe the Stone in Sunshine and Establish the Sky

Underpaint the sky area with a wash of Cadmium Orange. For the golden glow on the buildings and street, combine Quinacridone Red with Cadmium Yellow. Splash in Cerulean Blue sky shapes in a gentle, erratic pattern. Drop in some Quinacridone Red in parts of the sky for variation. Design an irregular negative shape between the clouds and the rooflines of the buildings.

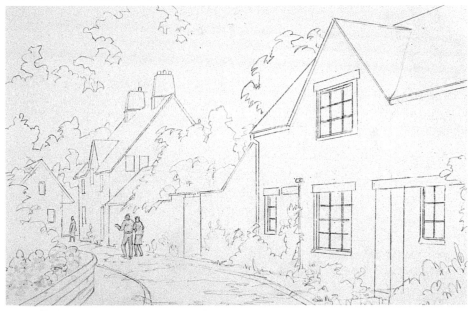

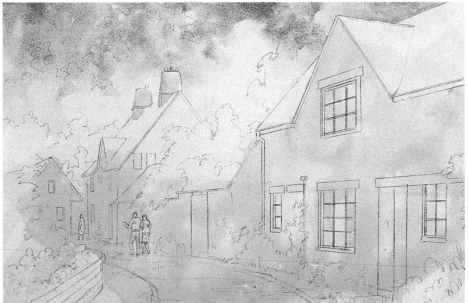

### 3 ADD SUNNY BACKGROUND TREES AND MIDDLE-GROUND TREES

Paint the trees behind the buildings with a middle-value Cobalt Blue and Cadmium Yellow. Continue adding color to build up the shapes, keeping the darker shadow values on the right.

Begin the trees and bushes behind the stone wall with a medium-value Sap Green and Payne's Gray. Add another layer of the same to define the shadow areas. Use Sap Green and Burnt Sienna in the darkest areas. Where the foliage catches the sun, add dabs of Cadmium Yellow. To make chiseled leaf shapes, flatten your round sable brushes with your fingertips.

### 4 BEGIN THE HOUSES

To the sunlit underpainted areas, add a slightly darker value of Yellow Ochre to suggest irregular stones, following the perspective of the building. Keep the underpainting as highlights on the stone.

To make glowing areas on the shadow side of the houses, use a yummy mixture of Winsor Violet and Raw Sienna. Where these areas receive reflected light, add a hint of Cadmium Orange. Use a mixture of Winsor Violet, Raw Sienna and Ultramarine Blue for the roofs. To increase the value contrast between the trees behind the stone wall and the shadow side of the house, lift off areas of some of the leaves with the Incredible Nib and add Cadmium Yellow to those areas to suggest brighter sunlight hitting them. Add more distant trees behind the houses using the same combinations as in step three.

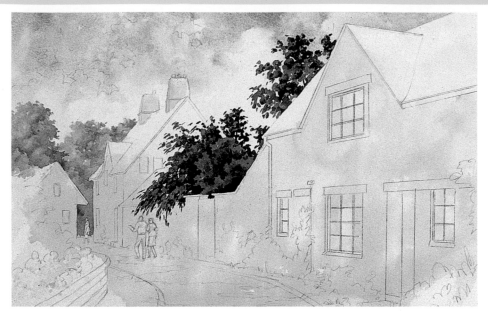

## 5 FINISH THE COTSWOLD STONE

With an irregular stroke following the perspective lines to the vanishing point, suggest subtle stone shadows. Later, put darker shadows under the stones.

Lightly pencil in perspective lines to the vanishing point as guidelines for laying the stone. The stones must diminish in size along with the buildings for convincing perspective. Using Yellow Ochre mixed with a tad of Winsor Violet, paint irregular stone shapes.

To accurately lay the shingles on the roof, lightly pencil in more perspective guidelines. Paint the roof with combinations of Cerulean Blue, Burnt Sienna and Ultramarine Blue, leaving little specks of sunlight. Then define the shingle shadows with a darker value of the roof mixture.

## 6 PAVE THE ROAD AND BEGIN OTHER FOREGROUND AREAS

First redraw the figures and apply masking to the new shapes. Apply masking to the shrubbery along the stone wall to leave space for bright flowers. With Winsor Violet and Raw Sienna on damp paper, design the shadow pattern on the road. Shape the flowering shrubs along the side of the stone house with light greens of Sap Green and Yellow Ochre. Paint a bright yellow shape above the stone wall to represent sunny background spots between the leaves that will eventually be painted there.

Design the flowers to cascade over the stone wall. Paint this foliage and the wall with a shadow color of Winsor Violet and Burnt Sienna, with spots of Ultramarine Blue to vary the color.

## 7 FINISH THE WALL AND DEVELOP THE HOUSE-SIDE SHRUBBERY

Refine the cast shadows on the road. Continue to develop the shrubs using a variety of greens made with Cadmium Yellow, Sap Green and Ultramarine Blue. For the stone wall, add shadows with Winsor Violet and Raw Sienna. For more opaque leaves, use Chromium Oxide Green varied with Cadmium Yellow.

## 8 PAINT THE FLOWERS AND OVERHEAD BRANCHES AND CONTINUE THE SHRUBS

Remove the flower masking from the stone planter and lay in a shadow tone with Winsor Violet and Cerulean Blue. Add Quinacridone Red to some of the areas for the red flowers. Paint interesting negative areas around the flowers to accentuate them.

Develop the shrubs in front of the stone house. With a shadow green of Sap Green and Ultramarine Blue, paint branches with protruding leaf shapes. Add more of the same color to paint negative spaces between and under individual leaves.

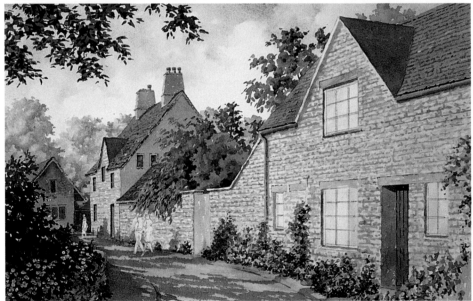

126

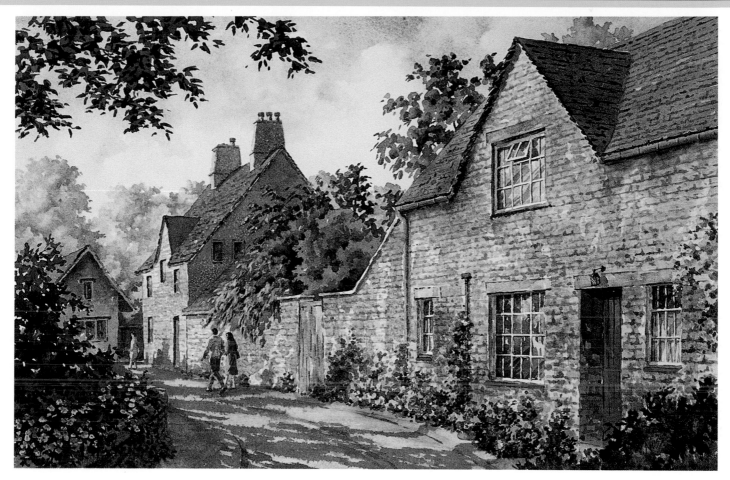

## 9 THE FINISH

Use a light wash of Payne's Gray and Quinacridone Red to add some streaks to the house. Toss in some salt for textured areas. Define some of the individual stones to break up the massive house. Add some shadows to the shingles on the shadow side of the roof. Add the light over the door and scratch out some highlights with the craft knife.

Paint the windows to reflect the sky and trees, with curtains added to the bottom windows. Then remove the masking from the window frames and mullions. On the right and underneath side of the mullions and window frames, paint shadows with a mixture of Winsor Violet and Cerulean Blue. The detail of the open window indicates someone is home. Reverse the two walking figures from the reference material. Paint the back figure light against dark and the couple dark against light. Dress the woman in red using Quinacridone Red and Cadmium Red Light for a bright accent. Carefully erase pencil lines.

The sunlight illuminating this Cotswold scene gives a warm feeling of intimacy on a clear, crisp day. Contributing to this impression are the overhead tree and dappled light on the road. The curved road leads the viewer's eye into the picture along the radiating lines toward the single illuminated figure. The end house, with its arrow-shaped gable, points up and leads the viewer's eye directly to the overhanging tree, pointing the viewer's eye back into the scene.

**The Sunny Side of the Street**
Watercolor
12" × 19" (31cm × 49cm)

# THE
# T<small>IC</small>-T<small>AC</small>-T<small>OE</small>
## FORMAT

A VARIATION ON THE GOLDEN MEAN,

THIS IS A CLASSIC FORMAT USED BY MANY

OLD MASTERS TO POSITION THE CENTER OF

INTEREST IN AN OFF-CENTER LOCATION.

USE THE TIC-TAC-TOE FORMAT TO

ARTISTICALLY PLACE FIGURES

IN YOUR PAINTING.

A nearby county carefully maintains this large, colorful azalea garden offering numerous twisting paths and wooden benches to entice walkers to explore and enjoy the wide variety of plantings. One glorious May day, I headed out with my painting gear, entered the garden and set out to find an effective way to present these colorful flowering bushes. Since the hilly garden overlooks a reservoir, I decided to use the water and the distant shore as a backdrop for the abundant azaleas. I hiked all around the winding paths, checking out various compositions with my viewfinder to see what worked well.

# Reference Photos

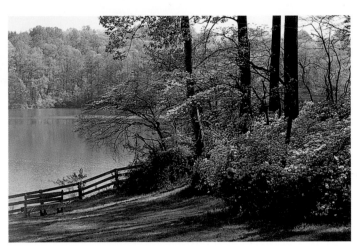

**PHOTOGRAPH THE LEFT AND RIGHT SIDES OF THE SCENE**
Since it was difficult to get all of the scene in one shot, these two adjoining shots show how the fence connects the two areas.

**FOCUS ON THE BACKGROUND SHORE**
Though there's a lot of middle-ground foliage obscuring the shore, this view illustrates the fresh spring pinks and greens in the distance.

**ZOOM IN FOR DETAIL**
This shot clarifies the clumps of blossoms and the undergrowth of the bushes.

**AZALEA DETAIL**
From another section of the county park, a close-up of a blooming bush shows off its brilliant splendor.

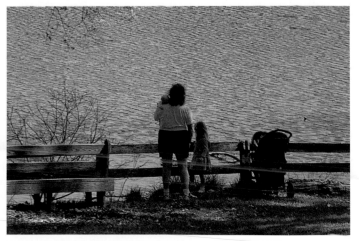

**FOCUS ON SOME FIGURES**
These figures, a mother and her two children enjoying the view, might be a perfect addition to the final painting. The photo helps to determine the size of the figures relative to the size of the fence.

# First Sketches

### FIRST VALUE SKETCH

Sketch a vertical view with the tall trees on the left emerging from a large mass of azalea blooms. Line up two trees along the left grid line and add another smaller one farther to the left. Keep the water and sky areas simple. The overhanging foliage at the top of the sketch will direct the viewer's eye down toward the fence and then back toward the bright azaleas.

### SECOND VALUE SKETCH

Try a horizontal format, adding more azaleas and more trees on the left for a more comprehensive view. Place all the vertical trees in the left third of the sketch indicated by the left grid line. On the right, place the delicate white dogwood along the right vertical grid line and add more fence posts and rails silhouetted against the sparkling water. Include a fallen rail to relieve boredom. Sprinkle patterns of light and shadow across the foreground grass to accentuate the feeling of a sunny spring morning.

### THE FIELD SKETCH

With a deep cool brown, rough in your drawing. Exaggerate the bushes on the left and the slant of the background trees for point and counterpoint, using as many diagonal shapes as you can. Diagonals are less static than horizontal shapes, though the waterline is one horizontal line that must stay.

In this field sketch, focus on accurately depicting the fresh spring colors, especially the ones on the background shore where the difference between sunlit colors and shadow colors is extremely subtle. These are difficult colors to paint since atmospheric perspective is a significant factor, and it is critical to keep the sunlit greens cool without being too cool. Also, there is little value difference between the shadow areas and sunlit areas.

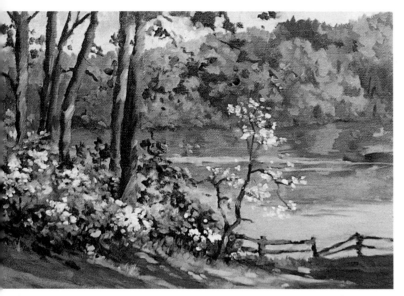

## Problems with the field sketch

Consider adding people to this park scene, not only for a sense of scale but also to give it life.

Putting figures in a painting is a common dilemma. In street scenes, their inclusion is obviously natural. In secluded country scenes, their inclusion is unnatural and not usually desirable. In some scenes, people are only included by implication. In a scene such as this where the park is designed with people's enjoyment in mind, their inclusion is a matter of personal opinion. There is no right or wrong, only a matter of taste and deciding what you want to say using your artistic license.

# Solve Design Problems and Finalize Your Composition

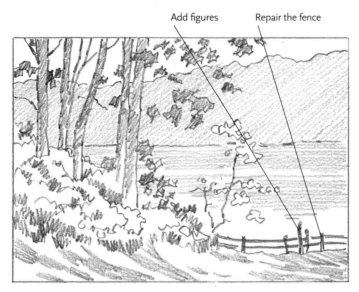

Add figures    Repair the fence

## DESIGN SOLUTION: INCLUDE PEOPLE

Place two figures facing the water by the fence, referring to your reference photo for their relative size. Eliminate the baby that the woman is holding over her shoulder because in this small scale the baby looks more like a big blob. Including the fallen fence rail was acceptable when there were no people in the scene, but it doesn't work with the figures.

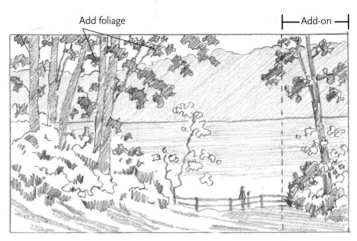

Add foliage    Add-on

## DESIGN SOLUTION: ELONGATE THE SKETCH

Include a tree and more azaleas on the right to balance the ones on the left, effectively framing the figures in a "U" format. Add only enough on the right to place the figures one-third of the distance in from the right edge.

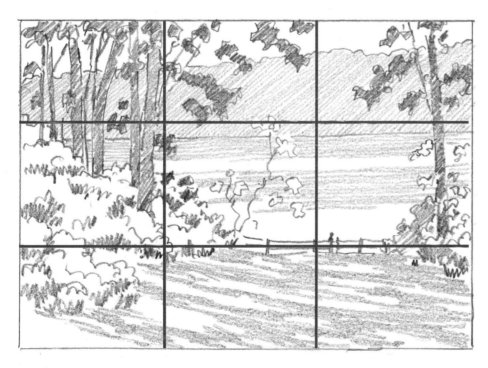

## FINAL PENCIL DRAWING

Increase the foreground area so the figures are one-third of the distance from the bottom. Placing them in this optimum position using the tic-tac-toe format prevents them from looking squeezed. Draw a tic-tac-toe grid over your sketch to check that the figures are at the lower right intersection of the bottom line and the right-hand line of the tic-tac-toe.

On the left, add another clump of azaleas to break up the foreground in addition to more shadow and light patterns on the grass.

# Harmonizing the Delicate Hues of Spring

*In this step-by-step demonstration, you will concentrate on harmonizing the cool colors of spring as well as integrating the figures into this landscape. Many combinations of Phthalo Green, Quinacridone Red with white and other colors added will keep the painting unified.*

| MATERIALS | |
|---|---|
| SURFACE | Stretched linen canvas, 20" × 28" (51cm × 72cm) |
| BRUSHES | Robert Simmons filberts: nos. 8, 6, 4 and 2 ■ Winsor & Newton Monarch filberts: no. 2 ■ Winsor & Newton Monarch round no. 0 |
| OILS | Cadmium Orange ■ Cadmium Red Light ■ Cadmium Yellow Light ■ Ivory Black ■ Phthalo Blue ■ Phthalo Green ■ Quinacridone Red ■ Ultramarine Blue ■ Yellow Ochre ■ White |
| OTHER | Soft vine charcoal ■ Mahlstick ■ Cotton rags ■ Odorless turpentine ■ Liquin |

## 1 BLOCK IN THE DRAWING AND VALUES

Grid your sketch to enlarge it onto your canvas with soft charcoal. With a blue-gray paint made with Ivory Black, Ultramarine Blue and white, follow along your charcoal lines and wipe away the charcoal as you proceed. Dilute your paint with a mixture of one part Liquin to two parts Turpenoid.

## 2 BEGIN THE FOUNDATION LAYER

Rough in the foundation color for the background and middle-ground areas. With luscious cool tones of Quinacridone Red, Phthalo Green and white, paint a variegated area for the shadow tones on the background shore. Use this harmonious color scheme to suggest the delicate hues of the blooming dogwoods and the new leaf greens. Add a smidgen of Cadmium Yellow Light to warm up some areas caught in the sunlight. Paint the reflection on the water with similar colors.

With a slightly warmer green mixed with Phthalo Green and Cadmium Red Light, mass in the foreground foliage silhouetted against the shore, reflections and sky. Paint the sky around the trunks, branches and just-painted foliage using white and Yellow Ochre to suggest a cloudbank. Use a mixture of white and a tad of Phthalo Blue for the rest of the sky and the sky reflections in the water.

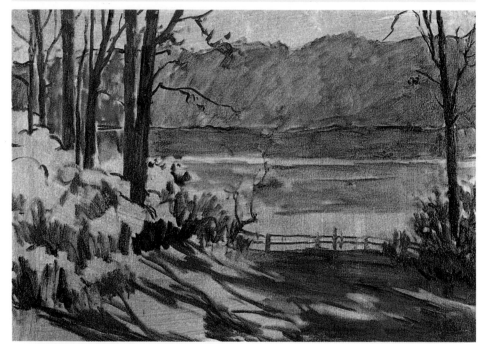

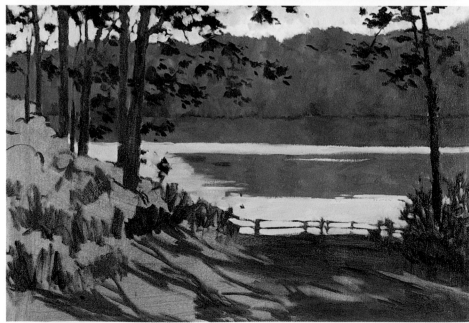

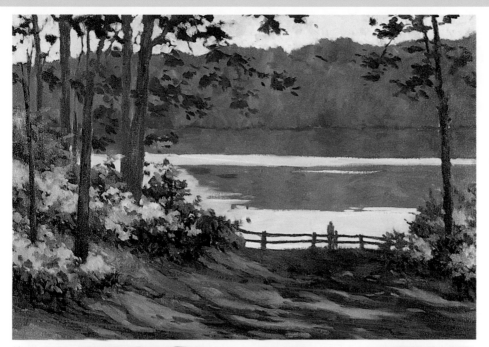

### 3 Finish the Foundation Layer

With a no. 4 filbert, add the darks under the azalea bushes with a brown made of Phthalo Blue and Cadmium Red Light. With this same color, restate the fence and rough in the figures, referring to the reference photo for their accurate size. Bring two trees forward and plant them in the front clump of azalea bushes to add depth and variety.

Define the shadow patterns on the grassy areas with a cool-green color of Ultramarine Blue, Cadmium Yellow Light, a smidgen of Quinacridone Red and a tad of white. With this same green, rough in some shadow foliage under the azalea bushes. Add more yellow and white to the green mixture to paint the sun streaks on the grass area. Also add a few to the bushes.

For the shadow areas in the azalea blooms, make a gray of Ivory Black and white for the white blooms and a cool red of Ivory Black, Quinacridone Red and white for the pink blooms. Add some highlights to the pink blooms using white tinted with Quinacridone Red.

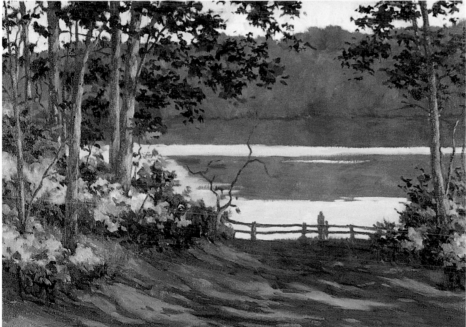

### 4 Paint the Trees

With a warm-gray shadow tone of Phthalo Blue, Cadmium Red Light and white, restate the shadow sides of the trees. Introduce some branches, skinny trees and the white dogwood tree. With a lighter and warmer tone of the same colors, paint the lighter side of the trees, painting the warms against cools and lights against darks. This will ensure that the trees will stand away from the azalea bushes and the background. Add Cadmium Orange and white to the mixture for the bright spots of sunlight.

With a dark green of Phthalo Green and Cadmium Orange, paint the shadow areas of the foliage, mostly the underneath areas and the sides of the leaves. Add Ultramarine Blue to this mixture for variety. Add white and Cadmium Yellow Light to the green mixtures for some lighter tones on the leaves.

133

## 5 RESTATE THE BACKGROUND TREES

Suggest spring-colored foliage and dog-woods in pink and white on the far bank with various soft cool combinations of Phthalo Green, Phthalo Blue, Quinacridone Red, Cadmium Yellow Light and white. With tones that are lighter than the foundation color, delineate the tree foliage that you painted in step four by carefully cutting into the shapes, making interesting holes and identifying an occasional individual leaf.

With a darker combination of Phthalo Green, Quinacridone Red and white, add skinny tree trunks and branches into the darker areas of the bank using a Monarch no. 2 filbert. Soften the edges to make the shapes indistinct. Clarify the trees just enough to explain this area as blooming with dogwood trees and other early spring foliage.

Paint a narrow strip of sky just above the top edge of the trees with a light value of Yellow Ochre, Phthalo Blue and white. Gently drag this paint down over the treetops to soften the edges, while shaping some individual trees.

## 6 PAINT REFLECTIONS ON THE WATER

Using the same colors as in step five, paint the reflections of the trees on the water. First simulate an almost mirror image of the trees, making it only a hair darker since the water is reflecting the underneath parts of the leaves rather than the side values that you are seeing. After laying in the colors vertically, use a dry bristle brush to make horizontal lines to softly blend the colors. Bring the paint carefully over the edge of the dogwood tree, being careful not to obliterate the drawing.

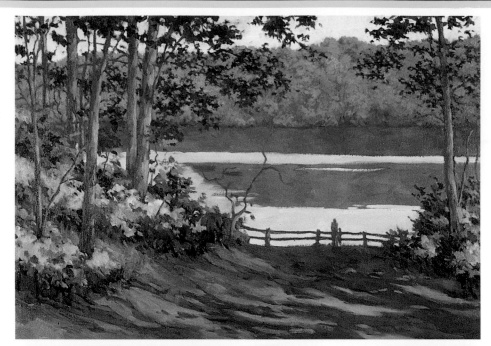

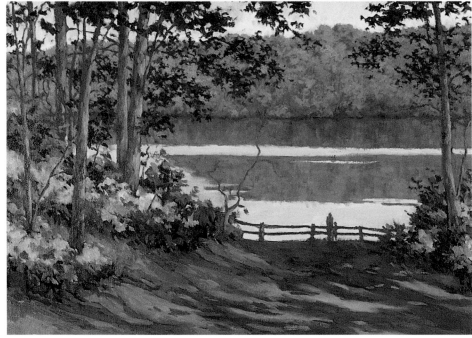

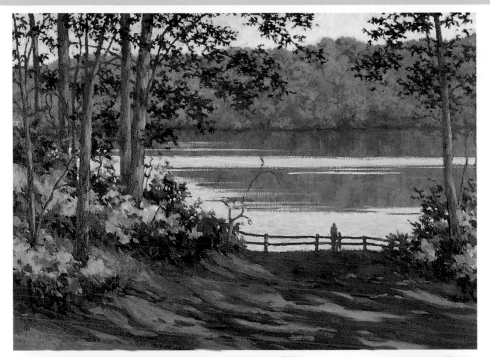

## 7 PAINT THE SKY AND SKY REFLECTIONS

Overlap the strip of sky painted in step five. Use a no. 2 filbert so you can maneuver in and around the leaves, cutting into them to make interesting lacy, leafy shapes. Since the sun is on the right side, paint that side of the sky slightly lighter as well as the sky color closer to the horizon. Use various combinations of white, Phthalo Blue and Yellow Ochre. To make soft tree trunk edges, paint into the forms rather than alongside them.

With a mixture of Phthalo Green and Cadmium Red Light, paint a few isolated leaves to add a realistic touch. For the sparkles in the water, paint over the foundation paint with a pale mixture of white and Phthalo Blue. Drag the brush across to leave bits of paint on the raised surface of the canvas. With this pale blue paint, define the fence and the bushes and add strategic "water holes" in the foliage.

## 8 PAINT THE AZALEA BUSHES

Dab some brown made with Phthalo Blue and Cadmium Red Light underneath the bushes and in the mulch. With a mixture of Quinacridone Red, white and a tad of Ivory Black, paint the shadow sides of the clumps of pink azalea blooms, adding a few wayward blooms in the dark brown areas. With a lighter combination of Quinacridone Red, white and a tad of Cadmium Yellow Light, paint the lighter sides of the pink azaleas. Also add a few wayward light pink blooms.

For the shadows on the white azalea blooms, use white with a bit of Ivory Black. For the light sunlit sides, use white warmed with a tad of Cadmium Orange. Add a white dogwood and a redbud tree on the right side to introduce these colors to a new area that helps move the viewer's eye around the painting. Add foliage from scraggly bushes with green combinations of Ultramarine Blue, Quinacridone Red, white and Cadmium Yellow Light.

## 9 DEVELOP THE GRASSY FOREGROUND

Make up some puddles of dirt-colored paint with Phthalo Blue and Cadmium Red Light with white. Vary the puddles with tads of Cadmium Yellow Light. Put dabs of "dirt" around the base of the bushes and intersperse throughout the grassy areas. Add some lighter "dirt" with a mixture of Ivory Black and Cadmium Orange.

With shadow greens mixed with Ultramarine Blue, Cadmium Yellow Light, Quinacridone Red and white, establish the shadow pattern from the unseen tall trees on the right. With sunlight gold greens mixed with Cadmium Yellow Light, Quinacridone Red, Ultramarine Blue and white, fill in the sunshine patterns. As the sunlit patterns recede toward the fence, reduce the width of the streaks and the color intensity by reducing the yellow.

In the foreground, vertically scumble the edges of the sunlight paint onto the darker shadow areas and vice versa to simulate grass and keep the edges soft. With a smaller brush, add some zesty highlights to the grass with a mixture of Cadmium Yellow Light, white and a tad of Ultramarine Blue. Add some similar highlights made with Cadmium Orange and tads of Ivory Black and white to indicate dried blades of grass.

## Save your paint

When you paint, squeeze out about a half-inch (1.3cm) glob of paint from each color tube and about a three-quarters inch (2cm) glob of white onto your palette. This is enough to keep you from being stingy while painting.

When you have finished your painting session, transfer your leftover paint into a shallow freezer container or sandwich saver that is about five inches (13cm) square. Since the freezer container has a lid, there is no need to lay plastic wrap over your paint, which makes a mess. Store it in your freezer. Since you are using Liquin, which speeds up drying time, it is important to clean your palette to be ready for your next painting session.

The next time you paint, reverse the process and add more paint if needed. This paint should last a week or two in the freezer.

## 10 PAINT THE DOGWOOD TREE AND FENCE

Apply a thin coat of straight Liquin to the areas where you will be painting, which will make it easier to apply twigs and blooms. Using a no. 2 Monarch filbert, define the trunk and branches of the dogwood tree with a dark warm gray made with Phthalo Blue, Cadmium Red Light and a tad of white. Add Cadmium Orange and white to the mixture for the sunlit areas. Make graceful sprays of dogwood blossoms against the dark areas of water and background with a white tinged with Cadmium Orange, keeping your strokes soft and delicate.

Redraw the fence a bit smaller, and paint it with a gray that is cooler than the color on the dogwood trunk and branches. Paint over the new fence lines to keep the edges soft. Add sunlit areas to the fence with a lighter warm color. With sunlit sections, the fence doesn't seem as intimidating as before.

With the same light yellow-green that you used in the sunlit areas on the grass, paint new sun streaks to meet up with the sunlit areas on the fence. This creates strong eye movement from the right. The viewer's eye follows along the sunlit streaks on the grass toward the fence, which then leads the viewer's eye over to the figures standing in the shadows.

## 11 PAINT THE FIGURES

Spread a thin layer of straight Liquin across the figures to give you a "wet" surface on which to paint. The object in painting the figures is to finish them just enough to say "figures in shadow looking at the water." There is no need for extraneous detail. Make the adult figure at least eight or nine heads tall. Rather than painting her holding a baby as in the reference photo, paint her holding her hat, suggesting a slight breeze coming off the water. Don't paint the figure's feet, as the blades of grass obscure them. Make a blended transition from hair to blouse to skirt to legs. Paint the child following the reference photo, with vague transitions between the legs, dress, face and hair.

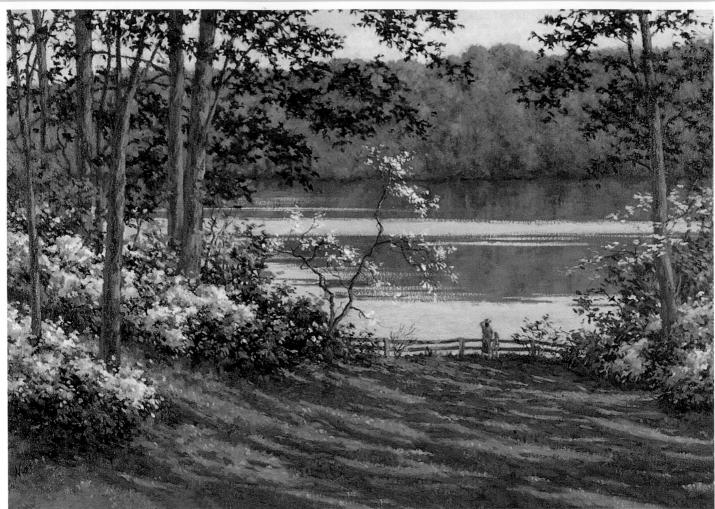

# 12 ADD THE FINISHING TOUCHES

Apply a thin coat of straight Liquin to the top third of the painting and all the tree trunks. Begin with the dark foliage and add a variety of medium and dark-green leaves. On the right side of the tree trunks, add warm reflected light made with Ivory Black and Cadmium Red Light to make the trunks cylindrical. Add highlights to the trunks with a warm gray made of Ivory Black, white and Cadmium Orange. With a no. 0 Monarch brush, add little branches and twigs to the trees to connect areas of foliage.

On the background foliage with an assortment of tints of Phthalo Green, Quinacridone Red, white and sparse tads of Cadmium Yellow Light, lighten the areas where the sunlight is hitting the trees. Use these colors to paint over the dark foliage that is kissing the top dogwood tree branch. Add more azalea blooms and cover the small, slanted tree between the two large foreground trees. Individual sunlit blossoms will add sparkle.

The tic-tac-toe format is effective in determining an optimal place for figures in this spring-time painting. The viewer's eye follows the streaks of sunlit grass toward the pink and the white azaleas on the left, climbs up the tree trunks and across to the white dogwood blooms and then moves down toward the figures standing in the shadows. Without the figures, the painting suggests the "U" format with the large masses of trees and bushes framing the dog-wood tree, which would then be the center of interest.

**Azalea Time**
Oil on linen
20" × 28" (50cm × 72cm)

DETAIL
Refine the figures with cooler colors, using Phthalo Green and Quinacridone Red combinations that will harmonize with the other areas of the painting.

# Presenting and Critiquing Your Work

## HOW TO CHOOSE A FRAME

Simple, classic framing will allow your painting to fit into any type of décor. Visit galleries and frame shops to see what the current trends are and what is on the market. Beware of decorator frames and mats. If you are going to enter your paintings in local, regional or national shows or display them in commercial galleries, you will want a tasteful, elegant and inoffensive presentation. The frame is the visual separation between the painting and the wall. It should never overwhelm the painting or be what viewers remember.

Frame your oil paintings with a generous, simple gold or wood frame. Linen liners are optional depending on your personal taste. One current trend is to have a wide, seamless linen liner with a narrow frame. A more traditional approach uses a three-quarter to one-inch (1.9cm to 2.5cm) linen liner with a wider gold or wood frame. Many options are available, so choose what looks best with your paintings.

Mat your watercolor with a generous white or off-white single or double mat. Use a professional mat cutter for neat square corners that are not overcut. Add a piece of glass or acrylic and finish the piece with a gold, wood or metal frame.

## LET CRITIQUES HELP YOU BECOME A BETTER PAINTER

In a perfect world, you would have an art critic sitting on your shoulder to analyze your painting from step to step. However, since that is not the case, you must learn to objectively critique your own work to the best of your ability.

This book presents steps from the initial field sketch on location to the finished painting. Changes and thought processes in developing a painting are explained. You should consciously and continuously analyze your work using these steps,

### Things to avoid

Some landscape elements that may get you into trouble are:

- bright red buildings

- perfectly straight vertical lines (tree trunks, telephone poles and so on)

- straight shorelines(break them up with little juts of land)

- straight roads and streams that lead the viewer's eye too quickly into the painting

- lines and fences running parallel to the picture plane

- buildings with equal sides showing

- static geometric shapes (squares, rectangles, circles and triangles)

- lines, such as edges of roads or streams, that bisect a corner and create two arrows pointing out of the picture

### Critique checklist

Look to see if your painting has:

✓ a dominant focal point

✓ a variety of soft and hard edges

✓ rhythm and movement from one element to another

✓ an aesthetic division of space

✓ an effective entry into and exit from the painting

✓ interesting negative spaces where the viewer's eye can rest

✓ overlapping shapes

✓ no tangent lines where the edge of one shape, perhaps in the foreground, will line up or touch another shape in the background (This causes confusion in depth perception and can be corrected by overlapping the shapes.)

✓ color harmony

✓ correct values and atmospheric perspective

✓ variety in repetitious elements (i.e., do all of the trees, windows and so on look the same or different?)

✓ four corners that are all different

focusing on the design and composition. When you are finished with your painting, you want everything in its place. You don't want to wish that a tree or other area of interest were moved two inches to the left.

The most important tool in your self-critique is a hand mirror; it substitutes as a fresh pair of eyes. Stand far enough away from your work to fill the mirror with the entire image to see what attracts your attention. The areas that you will see first are the ones that need work. Many errors in drawing and composition can be easily discerned by using this simple method.

Join art groups and get a sense of the local art world and its activities. Enter their nonjuried shows and find out what wins prizes. Enter their juried shows and see what is accepted and rejected. Go to their meetings and hear their programs. Be

active and embrace the membership for camaraderie.

If they don't have a critique group, help to start one. Have six to eight painters each bring a few nearly-finished paintings to a member's home. These unfinished paintings may be at the stage of development when your next step is obscure, or when you may see something that is not right but can't identify it. Critiquing each other's work will not only help you improve as a painter, but it will help you better articulate what works and doesn't work in a specific painting.

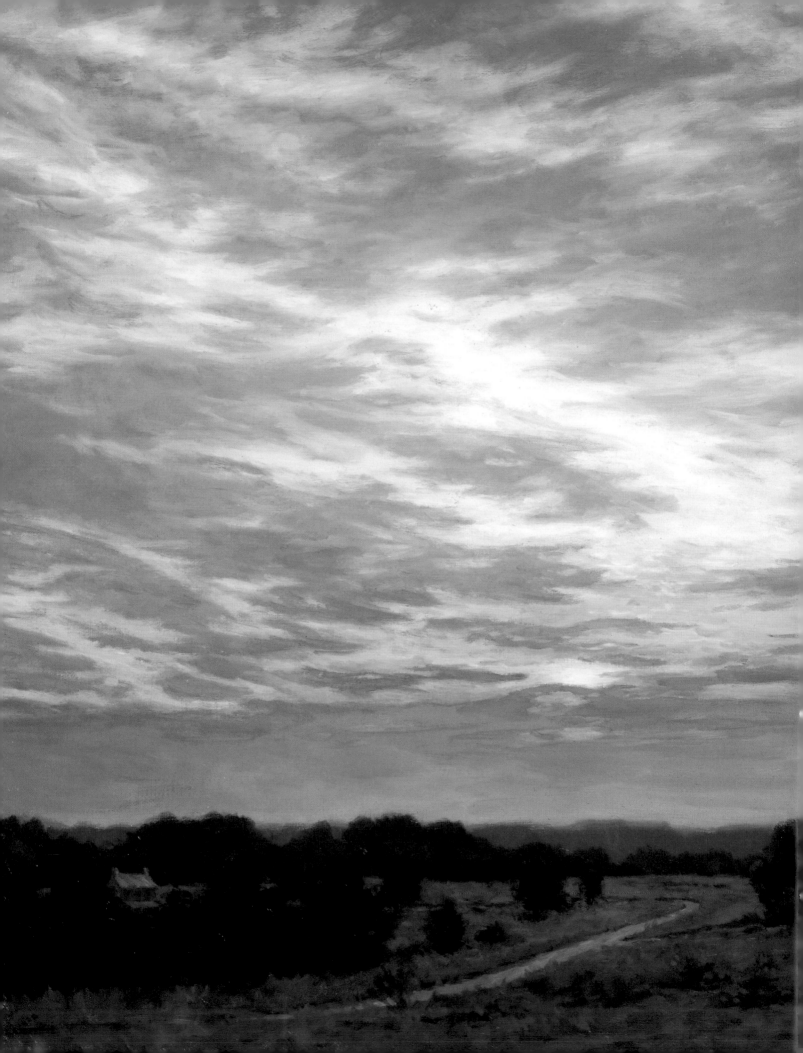

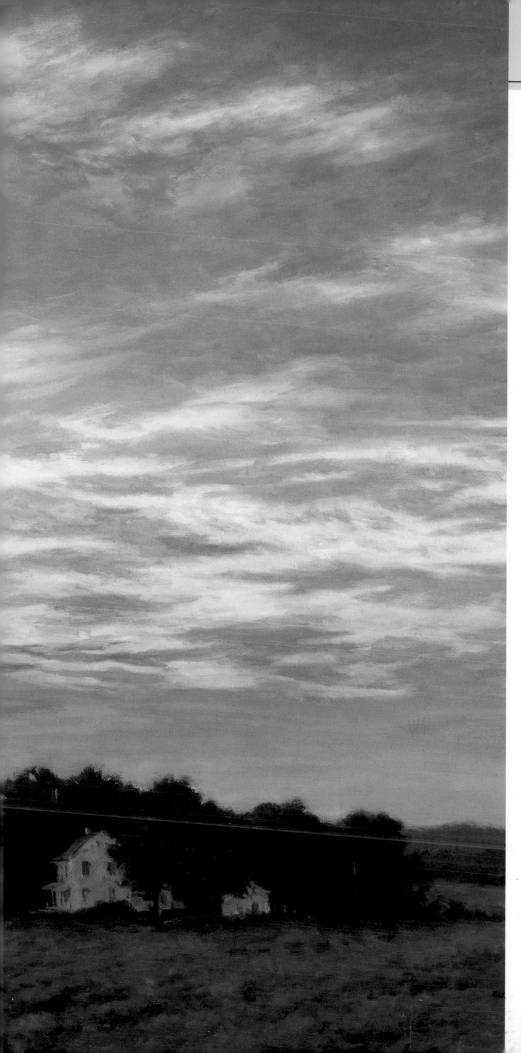

Painting effective landscapes is a challenging aspiration because it involves so many different bits of knowledge and experience. The growth is slow and basically comes with mileage. The more miles on the odometer, the better you'll get at it. Don't give up. The journey is fun and worth the effort.

One approach is to spend at least ten hours a week painting, more if possible. One three-hour class a week isn't going to help much unless you paint more at home. Establish a studio or extra room with adequate light and storage just for your painting materials, books and miscellaneous gear. Make it a private space free from interruptions—a place where you can leave everything and shut the door on it. This is your special space where you can develop into the landscape painter that you want to be.

There are many aspects of a successful painting and learning them comes in increments. Mileage counts. Be patient. Have fun with each formula, each step, each procedure and enjoy the process. With the enjoyment, you'll be successful.

**August Twilight**
Oil on linen
21" × 30" (53cm × 76cm)

## Bibliography

Caddell, Foster. *Keys to Successful Landscape Painting.* Cincinnati: North Light Books, 1993.

Couch, Tony. *Watercolor: You Can Do It.* Cincinnati: North Light Books, 1996.

D'Amelio, Joseph. *Perspective Drawing Handbook.* New York: Tudor Publishing Company, 1964.

Etter, Howard and Margit Malmstrom. *Perspective for Painters.* New York: Watson-Guptill Publications, 1990.

Kessler, Margaret. *Painting Better Landscapes.* New York: Watson-Guptill Publications, 1987.

Macpherson, Kevin. *Fill Your Oil Paintings With Light & Color.* Cincinnati: North Light Books, 1997.

Palluth, William. *Composition Made Easy.* Tustin, California: Walter Foster Publishing, 1989.

Parramon, Jose M. *The Big Book of Watercolor.* New York: Watson-Guptill Publications, 1985.

Stern, Arthur. *How to See Color and Paint It.* New York: Watson-Guptill Publications, 1984.

Strisik, Paul. *Capturing Light in Oils.* Cincinnati: North Light Books, 1995.

Strisik, Paul and Charles Movalli. *The Art of Landscape Painting.* New York: Watson-Guptill Publications, 1980.

# Discover Just How Much Fun Painting Can Be!

Here's the information you need to master the exciting medium of water-soluble oils! You'll learn what water-soluble oil color is, its unique characteristics and why it's generating so much enthusiasm among artists. Water-soluble oils make oil painting easier and more fun than ever before, plus you get gorgeous results. You may never go back to traditional oils again!

ISBN 1-58180-033-9, hardcover, 144 pages, #31676-K

Mastering basic brushwork is easy with Mark Christopher Weber's step-by-step instructions and big, detailed artwork. See each brushstroke up close, just as it appears on the canvas! You'll learn how to mix and load paint, shape your brush and apply a variety of intriguing strokes in seven easy-to-follow demonstrations.

ISBN 1-58180-168-8, hardcover, 144 pages, #31918-K

Create your own artist's journal and capture those fleeting moments of inspiration and beauty! Erin O'Toole's friendly, fun-to-read advice makes getting started easy. You'll learn how to observe and record what you see, compose images that come alive with color and movement, and make a travel kit for creating art anywhere, at any time.

ISBN 1-58180-170-X, hardcover, 128 pages, #31921-K

These books and other fine North Light titles are available from your local art & craft retailer, bookstore, online supplier or by calling 1-800-448-0915 in North America or 0870 2200220 in the UK.

This book shows you how to develop the skills you need to express yourself no matter what unusual approach your creations call for! Experiment with and explore your favorite medium through dozens of step-by-step mini-demos. No matter what your level of skill, *Celebrate Your Creative Self* can help make your artistic dreams a reality!

ISBN 1-58180-102-5, hardcover, 144 pages, #31790-K